THIRTEEN WAYS OF LOOKING AT LATINO ART

THIRTEEN WAYS OF LOOKING AT LATINO ART

Ilan Stavans and Jorge J. E. Gracia

DUKE UNIVERSITY PRESS *Durham and London* 2014

Printed in the United States of America on acid-free paper ⊚
Interior designed by Kristina Kachele Design, LLC
Typeset in Scala by Tseng Information Systems, Inc.

Library of Congress Cataloging-in-Publication Data
Stavans, Ilan.
Thirteen ways of looking at Latino art / Ilan Stavans
and Jorge J. E. Gracia.
pages cm
Includes bibliographical references and index.
ISBN 978-0-8223-5627-1 (cloth : alk. paper)
ISBN 978-0-8223-5634-9 (pbk. : alk. paper)
1. Art, Latin American—20th century. 2. Art criticism.
I. Gracia, Jorge J. E. II. Title.
N6502.5.S73 2014
709.8′0904—dc23
2013026382

Duke University Press gratefully acknowledges the support of
The Research Foundation for the State University of New York,
which provided funds toward the publication of this book.

CONTENTS

ACKNOWLEDGMENTS

Miriam Angress, at Duke University Press, has been a passionate supporter of this project since its inception: a wholehearted gracias. Derek García deserves an *aplauso* for his indefatigable pursuit of the rights to use the gallery of thirteen images. Susan Albury, during the copyediting process, streamlined the manuscript admirably. Amherst College and the University at Buffalo offered a generous subvention to produce a high-quality publication.

THIRTEEN

Ilan Stavans: Jorge Luis Borges, in his book *El hacedor* (1960), offers this parable: "A man sets out to draw the world. As the years go by, he peoples a space with images of provinces, kingdoms, bays, ships, islands, fishes, rooms, instruments, stars, horses, and individuals. A short time before he dies, he discovers that the patient labyrinth of lines traces the lineaments of his own face." Art is the face we give to our emotions, the map of our identity. That map isn't always easy to survey.

The vortex of these conversations is the nature of human expression. The conversations delve deeply into the cultural lens through which people understand themselves, in particular in the context of Hispanic civilization (from the Patagonia to the U.S.-Mexico border), where looks are connected with authenticity. These conversations are born at the crossroads where art and thought meet. Each of them uses as springboard a visual piece (a painting, a photograph, an installation, etc.) produced by a Latino artist in the United States. I say *Latino* and not *Hispanic*. I am a veteran of the culture wars. There is no reason to rehash well-worn arguments. For our purposes, I use *Latino* to mean a person of Hispanic descent (from

Latin America, the Spanish-speaking Caribbean, or the Iberian Peninsula) who was either born in the United States or moved here.

The dialogue is carried out through a variety of media, with electronic correspondence serving as the primary channel, supported by telephone, earth mail, but—quite apropos—not in tête-à-tête encounters, that is, *cara a cara*, for while I have been a reader of your oeuvre, you and I have never met. Ultimately, the objective is to elucidate Borges's meaningful question: To what extent is art a map of our environment? Is it also a compass to interpret our dreams, not only as individuals but as members of various groups, from the family to the congregation, from the community to the nation?

For some time, I have been engaged in similar conversations with journalists, historians, translators, and theologians. I am a passionate lover of the dialogue as a revealing form of intellectual engagement. There is something Talmudic in dialogues. Rabbinical discussion thrives in the exercise of give and take. The assumption is that no individual mind is capable of full knowledge unless and until it connects with other like-minded minds, through which it is able to probe into a topic not only by means of erudition but through what, to my mind, is the central force defining knowledge at all times: chance. The encounter with other minds precipitates an improvisational dance arousing the participants' epistemic acuteness.

These conversations follow the same approach, although the parameters here are somewhat different. You are a philosopher. I am an essayist, translator, fabulist, and cultural commentator. I have never seen you *en persona*; that is, I don't know how your face looks. I have never even seen your likeness in a photograph. Nevertheless, I am able to imagine it, based on what I have read of yours. Does one's work, hence, produce a map of one's identity? Do we look like what our words say about us?

For starters, an anecdote. Years ago, when I was in my early thirties, I met Carlos Fuentes on a Mexico-New York flight. I had read him consistently throughout my youth. And I followed him on TV and in printed media. It wasn't difficult for me to identify him. Obviously, he didn't have the same referent. He shook my hand with puzzlement, then said: "Ah, but I thought you were a woman. I imagine you with an altogether different face. Are you sure it's you? What kind of name is Ilan? Isn't it Ilana?

And I visualized you in your sixties." I asked Fuentes why. He said it was the tone of my voice on the page that had given him a certain impression. The impression of a wise, elderly woman.

There's a gap between who we are and what we say. Being and saying are different dimensions. That's because words are tools to configure the world according to our own will. Everyone uses the same reservoir of words but no one uses them in the same way. Words are our ID, a statement of identity. In any case, once death erases us all, once we exit the stage, we no longer are. The present tense of the verb has become unusable. Only the past tense is applicable. And what were we? What we were is what we left behind: our actions, our ideas, the memory of us that survives in others. And, in equal measure, what we said.

This reminds me of the last two pages of *The Eye* (1930), a short, perhaps the shortest, novel by Vladimir Nabokov. It states: "The two boys, those two pupils of mine, will grow old, and some image or other of me will live within them like a tenacious parasite. And then will come the day when the last person who remembers me will die. A fetus in reverse, my image, too, will dwindle and die within the last witness of the crime I committed by the mere fact of living." Words, words, words: for writers, the word is our epigraph as well as our epitaph. Let me return to the topic of dialogues. What I love about a dialogue is the interaction it fosters, the encounter of two minds who, through words—words in the present and also words that hopefully will last—discover something new about themselves and the other. The encounter provokes all sorts of reactions. Those reactions are serendipitous: they are the result of accident and cannot be replicated. Internal and outside circumstances come together in this mano a mano encounter. And they trigger fresh, spontaneous ideas.

Jorge Gracia: Yes, Ilan, dialogue for me is indispensable precisely because I am a philosopher. Philosophy is the only discipline in which dialogue is of the essence. In the West, philosophy began in Greece, and it was the Greek commitment to dialogue and talk that gave it birth. We have the finest example of philosophizing in the dialogues of Plato, where a teacher, Socrates, engages young minds in the pursuit of truth. And yet, seldom does a Platonic dialogue end with an answer to the problem posed in it. It is of the essence of dialogue to be open. The inquiry is what counts, not the

solution. Enlightenment results from a deeper understanding of a question explored in it, not from an answer reached. Answers tend to be final, dogmatic even, the ends of conversations and of inquiry. But a dialogue ends as it begins, open, without an answer, but with a more clear grasp of what is involved, what has been discussed. The end of a dialogue is a beginning.

There is something very significant about this, because knowledge is always in the process of revision, and understanding is progressive, even if it never progresses in the way it was designed to. To be a philosopher is to engage in this endless pursuit and to always end up wanting. It is as if one were thirsty, with a thirst that is compelling, all consuming, and needy. And yet, the water of knowledge that calms it is never found. There is no philosophical view or philosophical claim that has ever gone unchallenged or is universally accepted. So why do philosophers continue in a quest that has no end? It is difficult to be a philosopher. And not just difficult. It is devastating. Precisely because, although early in our lives philosophers tend to want answers and seek them desperately, eventually we realize that we will never find them. We understand better that it is not the end we crave, but the road toward it. This is the moment in which we understand our discipline and become true practitioners of it. Philosophy is ultimately a Faustian enterprise.

Socrates is without a doubt the epitome of the philosopher, and his life is the paradigm of the philosophical life. What did he do? He was a sort of bum. His wife supported him, and he spent his time talking to young men, challenging their views about the world and themselves in any way he could, demolishing the dogmatic structures that had been passed on to them by their parents, ancestors, and society at large. I hate to think what his wife said to him when he got home after a day of leisure while she was laboring as a midwife. And I am sure she did not appreciate that he would say to her that he was also a kind of midwife, although not of babies, but of ideas!

No wonder Socrates was ultimately condemned to death for corrupting the youth of Athens. Surely it is true that he was corrupting the youth, although this had nothing to do with sex. He was making them realize that what they thought they knew they did not know. This idea became a mantra: I only know that I know nothing. So, we may ask, if there are

no answers, what is the purpose of the search? Why engage in these dialogues? And does not the philosophical enterprise, as so many have argued, undermine the very bases of society? Does it not dynamite the foundations of religion, morality, and science?

The answer to the last two questions is the same: yes, of course it does. This is why not only Socrates, but other philosophers have been held in ridicule and abuse by the Social Establishment for their views. We need only think of Averroës, the greatest Islamic philosopher of all time, and Abelard, one of the shining lights of medieval thought. Both suffered dearly for being philosophers and living the philosophical life. The critics of philosophy do not realize that, even if philosophy may not provide any answers, it makes progress in other ways. For one thing, it makes us realize the unsupported evidence we have for views we regard as sacred cows. Getting rid of false beliefs or realizing the weak bases on which we hold them constitute, without a doubt, great improvement and progress. It is better to see, even if what we see is that we are perched on a rope over a precipice, than to not see at all and continue walking on the rope, not realizing where we are. The danger is that by seeing, we will more likely fall to the abyss. But do we really want to save ourselves through ignorance? It is better to die knowing than to live blindly. Why? Because that is our nature. As Aristotle so perspicaciously pointed out, curiosity is in the nature of humans. That curiosity separates us from the rest of nature. We are knowing animals and to shut ourselves in ignorance turns us not just into mere animals—they cannot do otherwise than they are—but into something much worse than animals. Dogmatic ignorance yields monsters.

A critical dimension is essential to philosophy and clearly flourishes in dialogue. A dialogue is a give and take. It is a way of opening us to others, to see another perspective, and to be challenged by the other. Inbreeding leads to deception. We need others, their perspectives, and their help. The confrontation with others in dialogue challenges our views, undermines our dogmas, and makes us human, because it is the nature of a dialogue to be open. Often I see people engaged in conversations that amount to nothing more than two monologues. This is not dialogue; true dialogue involves an exchange of views, an engagement with the other. Nor can we have a dialogue if what we say is not open to change. Dialogue requires that the parties that participate in it be willing to consider the views of the

interlocutors and, more than that, be willing to change their views when presented with better views.

Unfortunately, many philosophers, not just many people, live in dogmatic cages, conceptual structures they cannot escape. It is so comfortable to continue believing what one believes! This applies not just to religious beliefs, but to scientific theories and philosophical views. It applies even to our intercourse with our social groups, friends, and family. For those of us who function in the world of science and scholarship, it applies to the disciplines of learning we practice. We feel comfortable when we hear what we are used to hearing. Why should I, a philosopher, engage an artist, or a literary writer, or a physicist in dialogue? Isn't it more convenient to stay with those who think like we do, who share our assumptions and prejudices? Because it is in dialogue with them that we can more easily see how silly and wrong-headed some of our views are. This is my main reason for engaging in this dialogue with you, Ilan.

As a nonphilosopher, you pose to me challenges that other philosophers could not pose, challenges based on ideas and perspectives to which I have no access. The fact that you are a writer is already a tremendous challenge because you think along different lines from the ones along which I think. Where you see red, I see blue; where you see an unsupportable claim, I see a logical one. This leads to questions. Why did he say that? Why does he think in that way? We could, very easily, ignore each other in this dialogue. Go our merry ways, along the ruts we have been using for years. If we do this, the book will be a failure. We need to do something different. We need to engage each other and, through us, our different disciplines. We need to "cut the crap," as some would say, and get to the point. If we are successful in doing this, then the book will be successful.

We are engaged in a kind of struggle, but not a fight. The aim is understanding and enlightenment rather than victory. Only if both of us get a deeper grasp of the concerns that we voice will there be a victory, and it will be a victory for both. We have tools that we bring with us: some knowledge, a certain practice, and much experience. And just like wrestlers, we also have much we share. Apart from the fact that we are both human and males, we love art and we have an interest in exploring the experience of ethnic minorities, and in particular of Latinos, in the United

States. It also helps us that we have a neutral ground that serves as a field that circumscribes us and as a silent point of reference: the thirteen works of art on which the discussion is based. They provide parameters, limits, and possibilities. Looking at them we will see and think different things, but our visions and thoughts should crisscross in interesting and exciting ways. Sometimes we may bypass each other. We may go on tangents that to the other might appear irrelevant, but the art pieces will bring us back, forcing us to consider each other's responses. Meeting places and places apart will keep us nimble. Ultimately, it is who we are that will determine the course of the exchange.

I am a philosopher and you are a literary writer. Our ancestries and histories are very different, and yet we are both from Latin America, you from Mexico, with its rich Amerindian past, and I from Cuba, an island where Africa is ever present. You came here for reasons I ignore, but which are not in any way related to a phenomenon such as the Cuban Revolution. My training was in classical, medieval, and analytic philosophy; yours was in literature. How does all this affect what we see and think, and how we approach the art we have chosen to discuss?

IS: It's all a game. In your last paragraph you present experiential elements (Mexico's Amerindian heritage, the Cuban Revolution) as factors defining who we are. But does experience constitute biography? Are we always the sum of the elements that have shaped us as individuals? Yes and no. I've turned fifty recently. As one reaches middle age, fate becomes an imposing concept. Am I already fully defined? If so, is life over because at this point there is little room for change? To what degree does surprise—improvisation—play a role in our daily being? Are our responses predictable, not only to others but to ourselves?

Even though for the most part I've lived a stable, settled life, I've always lived it trying to surprise myself. No sooner do I succeed in one of my goals, than do I put it aside, looking for a different one. Repetition is what I have dreaded the most. How do I define the connection between repetition and the self? By invoking the work routine. Routine is behavior fixed into a set pattern. Of course, there is much comfort in routine. To have a fixed schedule, to know how one's day will look even before the day begins, grants us confidence.

But routine can become a prison if one's imagination isn't allowed to be free. My weekly schedule has been set for decades. So why hasn't it become boring? Because deep down that routine is a mirage. Aside from doing what I regularly do, I've left my mind loose, so as to engage all sorts of ideas. That engagement has been my primary diet all these years. The key to that diet is creating an assortment of endeavors where those ideas can be fully explored. And, most important, not allowing the ideas to become stilted, that is, being open to surprise. Not knowing something is never a deterrent. In short, for me, life is a game. There's chance, maybe even arbitrariness, in it. I do not know where I'm going. That keeps me intrigued. The game, in short, is about who I am, about my face in different moments, which is really different faces every one of those moments. It is about what I show of myself to others, what I hide for myself. I'm intrigued by our dialogue because it offers thirteen sessions of hide-and-seek. Thirteen opportunities for surprise.

JG: Faces, yes, the reader might expect that our conversation would be about them, for faces are what we hide and what we seek to see when we play a game. What do we do when we play hide-and-seek with a baby? We uncover our faces and say, "Pick a Boo, I see you!" But the works of art that are the bases of our conversations do not consist primarily in faces. Two works, those by Martin Ramírez and Adál, have no faces in them. Some others have faces but they do not seem to take center stage. Andres Serrano's *Piss Christ* consists of a photograph of a crucifix dipped in urine, and the Christ on the cross has a face, but it is small in comparison with the whole work, and almost lost in the turbidity of the urine that surrounds it. And in some other works we do not have a single face that is the focus of attention, but a plethora of them, suggesting perhaps that it is not the faces that are central but the assemblage.

Still, a face is what we see when we look at another person, or even when we look at a mirror. It is where we read persons, where we take their measure, where we encounter who we and others are. The face is paramount. Love and dislike originate on a face. Later, of course, after the first impression, we move to other areas of the body and consider, examine, and evaluate them. This applies even when there is something in the body of particular attraction. When we look at another as a source of sexual inter-

est, one would think that the first thing we would do would be to notice the erogenous zones of the body. But is this right? It seems that, although the whole ensemble may attract us, it is the face, the look in the eyes, the expression of intelligence and response that entices us and turns our innocent encounter into a fire of passion. It is the face, although identity can also reveal itself indirectly. The body, the arms, the torso, the bust, the feet and hands, lead us to the face. Perhaps more dramatically, the very speech we hear, the tone of voice, and the thoughts lead us there. A piece of writing, a sentence on a wall, is evidence of a face and coerces us, almost violently, to look for what is behind it. And what is that but a face?

Until we find that face and we encounter the eyes, reputed to reveal the soul, the stuff of which we are made, we cannot rest. But the face, even when found, marks only the beginning of a path of communication, understanding, and intercourse. Ultimately, what we want is to know the other, to enter into the other's world, so that we can see, compare, and share with him, or her, what we know and what we are. In our loneliness, we long for communication. The other's face is the beginning of the path to this secret knowledge, although the face does not have to be what we see first. Other parts of the vision lead to it, even if ultimately it is the face that we want to see.

Don't we find this in the mystics? From what they tell us, what is the beatific vision if not the encounter with God face to face? We are always looking for faces, whether our search is religious, intellectual, or physical. The face gives us what we desire and need. It is in the face that we consummate love.

IS: Throughout my adolescence, I frequently had trouble looking at my own face in the mirror. Whenever there was a mirror around—and, as of late, mirrors are everywhere: in department stores, supermarkets, gyms, restaurants, cars, let alone the privacy of our own home (happily, one of the only places where the mirror remains exiled is the classroom)—I avoided my own semblance. I didn't want to see myself. I didn't want to see the changes I was undergoing. I didn't want to focus on myself. That flight was ongoing.

I frequently dreamed of mirrors as a tormenting tool. This fear extended itself to photographs. To this day, I don't like looking at myself in

photographs because I always find something bizarre about myself. Still, when it comes to identity what matters to others isn't our body but our face. We are who we are because of our facial features. When those features are disfigured as a result of an accident, people are puzzled about us. They have trouble connecting us to the memory of how we looked. In concentrating on the face, our dialogue is about the sense of self we project. That sense of self manifests itself in different dimensions. We are individuals, of course, but we are also parents and siblings, and we're friends, and we're what our careers make of us: teachers, lawyers, doctors, entrepreneurs, etc. The face is the key to connect us to our various dimensions.

JG: So now we know that we are engaged in a game of hide-and-seek, where the end should be an encounter in which we face each other. But the encounter is vicarious, primarily through these pages, in which we are engaged in conversation. I have seen your photograph and one of your interviews on TV. And we have chosen as the basis of our game thirteen pieces of Latino art, most of which have faces in them. But why thirteen? Why art? Why Latino? And why these particular thirteen pieces?

IS: Ah, the crucial number. Wallace Stevens once wrote an insightful poem, "Thirteen Ways of Looking at a Blackbird." Divided into thirteen parts shaped in the form of haikus, the poem belongs to his first book, *Harmonium* (1923), and might be said to be an exercise in perspectivism. One section in particular I find striking:

> I do not know which to prefer,
> The beauty of inflections
> Or the beauty of innuendoes,
> The blackbird whistling
> Or just after.

Stevens's title has become emblematic of the relativist way of perceiving the universe á la *Rashomon*. There are multiple ways of appreciating a single event. So why thirteen? The answer is, why not? It could be ten, which is the amount of fingers we have on two hands and the reason our numerical system is decimal. Since Stevens published his poem, others

have used the same approach. I, too, love the image: nothing is what it seems at first sight; to understand its complexity, one must delve longer, deeper, with conviction. Thirteen is a metaphor, the way any number is. Needless to say, there are more ways to look at a face. But thirteen will do.

JG: My classical and medieval backgrounds do not let me rest with this explanation. I need more, for thirteen is also a number filled with connotations that go back to medieval numerology, the Jewish Kabbalah, and Christian mysticism, all the way back to Pythagoras. I can't think about this without recalling Isidore of Seville's *Book of Numbers* and the mystical insights of Pseudo-Dionysius the Areopagite, which ended up in the philosophy of Hegel.

Thirteen is composed of the first two positive numbers, one and three. One is the symbol of unity, identity, and permanence, whereas two is the symbol of duality, difference, and change. And three is the sum of one and two, the synthesis of unity and duality, and thus the beginning of plurality. Thirteen, in being composed of one and three, becomes a symbol of the universe, the whole, and the fact that one and three make four, an even number that is double the first even number, suggests the wholeness of the universe. It signifies completion and as such was used in the ancient religions of Egypt and Greece. So perhaps we can argue that in considering thirteen pieces of art we are considering the whole universe in small, a microcosm, another popular idea of the Greeks.

Thirteen has been an important number for a long time. It is the number of Christ and the Apostles in the Christian faith. It is considered both a lucky and an unlucky number. No one in our culture wants to have thirteen people sitting at a table, and no one wants to do something on the thirteenth day of the month. Tuesday the thirteenth is a very unlucky number for Latin Americans, but it is Friday the thirteenth that is unlucky in the Anglo-American world.

The metaphysics of numerology was first developed by Pythagoras and his disciples, who thought that numbers were the essence of the world. Everything was made up of numbers, and it was numerical proportions that gave the world and its components the characteristics they have. Pythagoras originally thought the universe was rational, just as numbers, but then one of his disciples discovered that there were irrational num-

bers and this undermined the Pythagoreans' trust in the rationality of the universe. The discovery marked a dramatic moment in the history of human thought, and led to anguish and worry. If numbers are irrational, then so is the world, and just as irrational numbers are unfinished, so is the universe. Pythagoreans tried to keep the secret of the existence of irrational numbers, thinking that this discovery would undermine everything they believed in, leading to irrationality and indeterminacy— something ancient Greeks abhorred—and ultimately to the demise of science. But, of course, they could not do it. Humans have a hard time keeping secrets, and particularly important ones.

If we were to adopt a Pythagorean way of looking at things, the number thirteen would have significance for us and for this book. Perhaps it is good, or perhaps it is bad. Maybe the book will not sell, or maybe it will be a best seller. And what does it say about its content? What do you think?

IS: By invoking Pythagoras, you've opened a dimension to the title, or at least to this portion of it, I was hoping we would address. Numbers are concrete, factual, and truthful. That, at least, is the perception embraced by our science-driven culture. But numbers are also deceitful, not to say mystical, and, needless to say, malleable. For instance, the number thirteen symbolizes bad luck among Christians. Buildings don't have a thirteenth floor. Yet for Jews the number is a good omen.

JG: We will have to wait until the end or even later to find out the meaning of the number for this book, then. So let us turn to the other questions that we have not yet discussed. One of these was: Why art? Why did we not choose something else? Maybe because we just like art. This is one of the reasons. But there is something more. I think the interpretation of art, what we understand and project in our interpretations, says as much about the art as about ourselves. Art is visual and visceral, and it affects us deeply. Sight is our primary sense, and visual art plays on this. If, as you say, ours is a game of hide-and-seek, a conversation through which we are revealing ourselves, what better than art to do it?

IS: Art never exists in a vacuum. The manuscript of a novel stored in a drawer that is never read doesn't exist. That is, it exists in an island, isolated, with-

out societal consequences. Nor does a painting that is only in the painter's mind. Art is actuality: it exists in dialogue. That dialogue is an encounter between the artist and the public. And the public is never static. Nor is it uniform. Different people react in different ways to the same dance piece.

JG: Now we have an idea of why we chose art as a means of communication. But why did we choose pieces of Latino art and the particular pieces of art we did? The use of the term *Latino* signals for me something more than for you, I think, from what you said earlier concerning *Latino* versus *Hispanic*. In both *Hispanic/Latino Identity* (2000) and *Latinos in America* (2008), I discussed extensively the significance of these terms. *Hispanic* is a more encompassing term that includes not only Latin Americans but also Iberians, whereas *Latino* excludes Iberians. Moreover, *Hispanic* has a stronger cultural connotation, whereas *Latino* connotes the political and social struggles of Latinos both in the United States and Latin America against the dominance of Anglo-Americans. We could answer that we chose *Latino* simply by saying that we did so because we are Latinos, members of at least two of the main groups of Latinos in the United States, Mexican Americans and Cuban Americans. And that we chose Latino rather than Hispanic art because of the political and social dimensions of our existence in the United States. But such narrow ethnicism is not persuasive to me, although it is surely true that these conversations will deal in part with issues of ethnic identity in general and Latino identity in particular. I think we had something more universal in mind, even if we are beginning with the particular.

IS: My answer is that we have chosen these thirteen pieces because their aggregate makes us feel whole. It allows us the opportunity to offer an assortment of insights that ultimately—it is my hope, at least—will amount to a total vision. A total vision of what? A total vision of our humanity, which, needless to say, is never total. Or, better, it is total only insofar as it is understood as an expression of the particular moment—the present—in which we exist now. Yesterday we had another total vision. Tomorrow will also have a different one.

The goal isn't for us to illuminate the meaning of Latino art through these thirteen pieces, but to use these thirteen pieces as a catalyst to reflect

on our human condition and on the specific culture that defines us. I too have a deep discomfort (a suspicion, really) with ethnicism. I don't like people being categorized by their ethnic profile. Still, I have spent my life studying the Hispanic world in all its facets. Every time I focus on another period, another region, another aspect, I'm humbled by how much I don't know. That humility isn't paralyzing. It puts me on my toes, making me want to know more. Hispanic art, from the colonial period to the present, including the work of Latinos in the United States, has been a fascination of mine for decades. I'm not a collector, but my houses, my private, domestic space, are filled with mementos. They also contain samples of the art I have bought throughout the years. This accumulation isn't done in any pragmatic way. I don't buy a piece of art as an investment. I acquire what I like. And I showcase what my friends have generously given to me. I find joy in looking at this art. It is a companion. It propels me to understand its origins, its context, the motivation behind it.

Along those lines, the thirteen pieces selected for these conversations are excuses. At the outset we had a few dozen possibilities, from which we narrowed our gallery. You narrowed yours down to fifteen or so and I did too. Serendipity played a role in the final selection. In fact, I dislike calling it a final selection. It surely was final for the purposes of this book, but it isn't final beyond it. Some of my personal choices have been companions throughout my life. I've thought at length about these images; I have used them for teaching. On occasion, I've even written about them before, in books like *The Hispanic Condition* (1995) and *Lengua fresca: Antología personal* (2012). I wouldn't dare to claim that any of these choices, yours or mine, are the best in Latino art. That's because the words *best* or *worst* have no place in the semantics of human expression. A certain painting by Tintoretto, say *Susanna and the Elders* (1556) or *Last Supper* (1592–94), isn't his best. It simply is. You will agree that we could easily replace any one of the thirteen images with another without much difficulty.

In any case, these are thirteen ways of looking at Latino art. And in so doing, these are thirteen ways of looking at ourselves, our origins, our thoughts, the culture we inhabit, and the abyss that is life.

JG: The miracle is that we agreed on those pieces, which brings to my mind another dimension of this enterprise: negotiation. This is the nature of

human society. Aristotle said a while back that humans are social animals, and I would add that it is in the essence of society to negotiate, to transact, to give and take, and to compromise. This is the key to finding a way to move forward among other humans that share commonalities and differences with us. You and I are individuals. We are different. Our ancestries are different and so are our histories, and yet we also share things in common. The miracle with so many chasms between us, not the least of which is that we have never met face to face, is that in spite of them we have been willing to engage in dialogue. For what? What is the payoff? What are we looking for?

I do not see anything other than understanding, understanding of each other, ourselves, the communities of which we are part, and the world that surrounds us. Can we make it? We have begun and not begun the dialogue at this point. And the future is yet to be determined. Perhaps, instead of understanding and enlightenment we will end up in misunderstanding and frustration. This is the origin of wars. But the fact that we have already agreed to have thirteen pieces of Latino art as the basis of our conversations, even though we are not entirely sure how or why, is a good omen. If we are successful, we will have gained something that we did not have before and readers will perhaps also gain something they did not anticipate. So, shall we begin? Shall we try for a miracle?

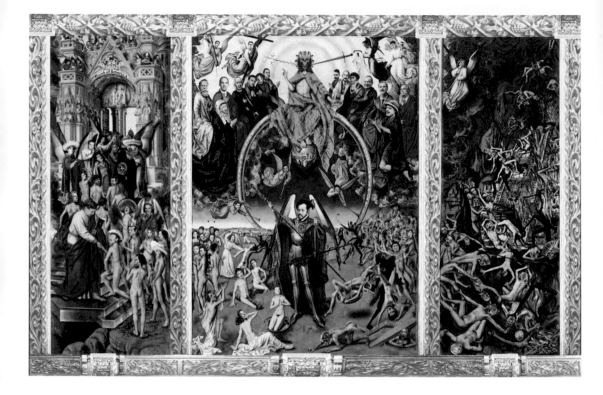

Einar and Jamex de la Torre, *La reconquista* (2010),
triptych, 61″ × 109″ × 4.5″, lenticular photographic image
on translucent medium. Used by permission of the artists.

THE LABYRINTH OF HISTORY

EINAR AND JAMEX DE LA TORRE *La reconquista*

Ilan Stavans: Let's start with an image I admire. It was used in the cover of *Lengua fresca* (2012), a Spanish-language personal anthology of my work. I chose it because it speaks to me loudly, as much by its postmodern style as by its symbolism. The image is actually three lenticular photographs that together constitute *La reconquista*, the art piece by the Mexican-born artists Einar and Jamex de la Torre. It is based on an altar piece by the Dutch painter Hans Memling called *Last Judgment,* made between 1466 and 1473. And it reminds me of the imagery of the Dutch painter of the Renaissance, Hieronymus Bosch, especially *The Garden of Earthly Delights,* which is housed at the Museo del Prado. Of course, that the de la Torre brothers depict the colonization of the Americas as an act of devastation is nothing new. But there is a plethora of things in this piece that need reflection.

Jorge Gracia: One that needs reflection is the very title of the piece. *La reconquista* harks back to the first *reconquista* undertaken by the Spaniards in the Iberian Peninsula. The Moors had crossed into the Visigothic king-

dom in 711 and defeated it. They overran the peninsula and threatened the rest of Europe until they were stopped at Poitiers by the forces of Charles Martel in a famous battle. After their defeat, they fell back, but at that moment began the reconquista of the territory by various peoples who inhabited Iberia before the Moors arrived. Two foci of resistance were established, one in the northeast, called the Marcha Hispánica, and the other in the north, in Asturias. The process of reconquering the land from the Islamic Moors took seven hundred years. It was bloody and cruel, although there were periods of peace and prosperity in which Christians, Jews, and Muslims lived in peace. The reconquista was a crusade, a war in the name of Christianity, a war to regain territory and privilege, and a war of vengeance for what the local inhabitants before the Moorish invasion considered the unjust act of foreigners.

Why call this work *La reconquista* when the context is America, then? Clearly, the territory that the Spaniards conquered when they arrived in the fifteenth century had never belonged to them. Nor did they have a claim to any of it, whether legal, moral, or religious. Not that they did not try. Juan Ginés de Sepúlveda developed arguments based on the philosophy of Aristotle to justify the conquest of America by the Spaniards. The Indians were barbarians, savages unable to rule themselves appropriately, and they needed salvation. But Fray Bartolomé de las Casas answered the arguments one by one, demolishing the conceptual rationalization Sepúlveda had built and exposing the true reason for the conquest: power and greed. In the case of the Americas, the victims were the Indians and the Spaniards were the foreign invaders, just the reverse of the Iberian reconquista, which means that what happened in America was no reconquista at all, but a *conquista*, a conquest. The reason for the title of the work of the de la Torre brothers, then, must be ironic, implying a denial of everything that the Iberian reconquista meant.

IS: It is ironic. What the de la Torre siblings have in mind is a reference to the Spanish conquest of the New World and the current reconfiguration of that conquest in terms of demographics. Their argument is based on the foolish Mexican idea that after centuries of colonization Mexicans are finally going to wake up to their own power. The idea was iterated by José Vasconcelos in his essay "Mestizaje," part of the book *The Cosmic Race* (1925).

JG: Mexico, in particular, and the Americas in general, are a cauldron in which a new people is being forged. This is why I called the collection of articles by various authors I recently edited *Forging People* (2011). Latin America is forging a new race, a new ethnicity, and a new nationality, or perhaps multiples of these. Vasconcelos wrote a book that has been the subject of great admiration and vituperation about this very topic. He may have been wrong about many things—he certainly was wrong about his pseudoscientific biological claims. Ethnicity and nationality are as important as biology in the process of *mestizaje* in Latin America. And he was wrong about the universality and unity of the people that is being formed in Latin America. It is not one people but many peoples united by diverse links that are contextual and diverse. But he was right about the mixture in his claim. There is mixing, a profuse mixing in Latin America.

La reconquista, then, is *una conquista*, a conquest, of the original conquista of America by the Iberians. It is the conquest by the mixed, resulting peoples of America of the Spaniard, and even beyond them, of Europeans in general. It is a prophecy, partly realized already, of the power of the mixed and marginal over the so-called pure and mainstream. In one sense, the irony in the title becomes clear if one thinks of the Iberian reconquista of the Moors. But in another sense there is no irony, for the title accurately describes the process whereby Americans (North and South Americans, not just gringos) are taking back what they originally owned.

But there is another catch, a wrinkle that prompts another consideration. Those taking back did not originally have what they are taking back. It is not the Aztecs, Maya, or Inca, that is, the Amerindians, who are now recovering what the Spaniards took from them, for the Aztecs, Maya, and Inca no longer exist, only remnants of them do. What exists in Latin America today is only a more or less mixed people. And the few members of the original peoples who still survive with little mixture, racial and cultural, in the Americas, have little power. They are not the ones reconquering. They are still conquered. This sounds political, but perhaps before we continue on this path, we need to look again at the work and explore other ways of looking at it.

IS: To begin, there is an irreverent act of copying an old master. By copying I mean usurping, upsetting, reimagining. *La reconquista* pushes the viewer to think of another work of art embedded in it. It is the same strategy per-

formed by parody, say a novel like *Don Quixote* (1605–15). In his story of the Knight of the Sorrowful Countenance, Cervantes rewrites chivalry novels. Readers of *Don Quixote* understood the critique he was performing because they were familiar with the original. For them the knight wasn't a hero but an antihero. You only become an antihero after the hero's path has been clearly marked.

The de la Torre brothers want the viewer to think of religious paintings. By doing so, we interpret the endeavor of colonization through the prism of faith. Yet they are subversive in their reimagining of the period; that is, they don't want us to look at *La reconquista* as a campaign justified by a divine plan but as a travesty.

JG: Aha! We should not forget the religious aspect. The Iberian reconquista was a crusade, *una guerra santa*, a holy war, and so was the war of the Spaniards against the Amerindians. Conversion and the spread of Christianity was one of the proclaimed aims of both processes. Of course, one can think this justification was a sham. But that is too easy. I think there was a religious motive, at least in some. This was part of what the Spaniards were all about. After seven hundred years of fighting against the Moors, they could not think in other terms than those that mixed religion, politics, power, and wealth.

IS: The religious aspect of the endeavor is accounted for in the de la Torre imagery. The left panel portrays the Catholic Church as the granter of holiness. A line of believers awaits the sacraments. The right panel offers the opposite view: the hell of the unbelievers. The dichotomy is typical of the Catholic afterlife promised in the Middle Ages. The tension between these two panels brings to mind Dante's triptych in the *Divine Comedy* (1308–21), suggesting the journey of the soul from inferno to purgatory and finally to heaven. Except that in *La reconquista*, the central panel plays a crucial role. It portrays the debacle that took place in the Americas after the arrival of the Spanish conquistadors and missionaries. The statement is clear: the wellbeing of the indigenous population depends on their conversion to Catholicism.

There is a caveat. The de la Torre brothers are twentieth-century Chicano artists. Chicanos because they work in San Diego, although they

were born in Ensenada. The style is ironic. Or maybe I should say paro-
dic, since it constantly reminds the viewer of an ur-text they ridicule. In
this case, the parody rotates around the hypocrisy of colonial chronicles
in the Americas. Again, for me, the travesty is essential. At the center of
the triptych is the conquistador, Hernán Cortés, whereas in Memling's
triptych there was the Archangel Michael. He is dressed in a golden suit
of armor. He also has a bat's wings, which inject a vampire element into
his character.

JG: The wings that Cortés has pose an interesting question. You see in them
the wings of a bat. This would take us on the route of Satan, for he has the
same kind of wings, as do the other devils that are grabbing, keeping in
line, and inflicting pain on humans. They populate the central and right
panels and their aim is to gather and torture the condemned. Bat wings
suggest both a bat, a blood-sucking animal, and the Devil—frequently
symbolized in the Middle Ages with such wings, ugly, disgusting, repul-
sive, evil. A Cortés with bat wings suggests satanic evil, and, as you in-
dicate, even a hint of vampirism. The conqueror who sucks the blood of
Amerindians.

 However, a second look at the original Memling reveals that Cortés's
wings are not different from those of the archangel. In fact, very little on
the work of Memling has been changed by the de la Torre brothers, except
for the faces, which they have substituted primarily for those of Mexican
historical figures. The only significant difference between the archangel
and Cortés is the face, and a Cortés with angelic wings gives us an entirely
different reading, making the irony of the work more pronounced.

IS: The travesty depends on humor. And here the presence of the face be-
comes crucial. But before I talk about it, I need to stress what is evi-
dent: the lost souls, the souls about to be converted, are depicted as naked
bodies in all three panels. These bodies are mostly white and are likely to
be redeemed because of their racial distinction. That is, they have a uni-
form ethnicity at odds with the demographics of the New World, and that
distinction will save them. There are just a handful of *mestizos* and blacks,
a symbol of lost souls. There are several monkeys, a reference, as you say,
to the political and philosophical debate that defined the period, in which

thinkers pondered if the Indians were fully human. Only the powerful—the conquistadors, the priests, those at the top of the social ladder—are dressed, sometimes in shining armor, others in cloths or with a white, green, or red tunic. At the top of the central panel is Jesus, fashioning a feather cape and a Quetzalcóatl mask.

Now to the faces. On the right panel, all the souls suffering in hell have what appear to be Aztec, Olmec, and Mayan indigenous masks. The message is unquestionable: for the Spaniards, the Indians were pagans. Perhaps their paganism was only a mask, that is, a façade, a pretense. The Spaniards sought to convert them but were unable to take away their masks. On the right panel, the faces come from Mexican popular culture. Three or four of them wear sombreros. One is carrying a microphone. Another, with long hair, looks like one of the de la Torre brothers. In this right panel, there are a couple of sanbenitos, the long cone hats heretics, many of them former Jews, were forced to wear by the Inquisition as a way to differentiate them. At the top of the cathedral, there's a sign looking like the Medici logo: Bank of Amexica, a shrewd reference to white economic power over the Chicano community. The Medicis are credited for spurring modern banking in the Renaissance. They were also influential patrons of the arts. In fact, they commissioned Hans Memling's depiction of the Last Judgment. And in the above echelons of the cathedral are a series of icons, from Che Guevara to Carlos Santana.

In the central panel, the face game is more emphatic. Several of the faces are recognizable. At the bottom, actress María Félix and perhaps Frida Kahlo. At the top, a cadre of historical figures in Mexican politics, from Father Miguel Hidalgo y Costilla and Father José María Morelos y Pavón, rebels of the independence movement of 1810, to the first Indian president, Benito Juárez. Also present are Emiliano Zapata, Pancho Villa, and Venustiano Carranza. The artists include in the set of apostles Carlos Slim, the richest man in Mexico, as well as presidents Vicente Fox and Carlos Salinas de Gortari, the most detested politician in modern Mexico.

JG: The point that you make about the homogeneity of humans in the work is important. I don't really see anyone who is black, except for the devils. Keep in mind that the only changes that the de la Torre brothers made to the Memling are the faces. The work appears to be homogeneous, the

people in it are European and white. The contrast between this and the reality of Latin America is brutal. What can we make of it? Perhaps the superimposition of a Latin American population on a European world can be taken as the reverse of what has happened, namely, that the European world crushed Latin America. But it is also possible to see the work as a superimposition of the Mexican reality in particular on the European world. The de la Torre vision trumps the Memling vision. Mestizos trump whites. This is something similar to what happens with the title. The work is playing on this double entendre, a duplicity of meaning and significance.

A point that merits repetition is the importance of the theme of the painting that functions as a model for this work, Memling's *Last Judgment*. *La reconquista* is about the conquest of the Americas, but it is also a last judgment on that event and its consequences. The de la Torre brothers are giving us final judgments on the conquest and the characters that somehow have played a part in it, from the Amerindians to recent politicians and leaders. But the judgments are unclear, ambiguous, in that the victims of the conquest are confined to hell and the members of elites are either in heaven or sit in judgment over humankind. We cannot easily figure out the criteria for inclusion in the three panels, although money and power seem quite determining. Is the panel on the left reserved for those that are, or will be, rewarded for their actions and the ones on the right those who deserve punishment? Is the one in the center reserved for the judges? Or is the whole thing to be taken ironically. The play is unclear and adds to the complexity of the piece and the variety of interpretive conjectures that it may give rise to.

The central panel is particularly suggestive. In the Memling, Christ is at the center, sitting on a rainbow with his feet resting on the earth. On his sides are the twelve Apostles, the Virgin and probably Joseph. Angels carry symbols of his sacrifice for humankind. Below him is the last battle between good and evil in the world, with devils trying to get as many human souls as possible, and in some instances fighting for them with angels. By changing the faces of the angels and even some devils into the faces of well-known football players, the ground becomes a field game. The faces of the Apostles have become those of powerful figures in Mexico, and as you say, Christ wears a mask of Quetzalcóatl. This is sig-

nificant because this deity, the feathered serpent, was the god of knowledge and wisdom and thus appropriately identified with Christ, who in Christian theology becomes *sophia*, wisdom. The faces can be recognized by Mexicans because they are the faces of people they frequently see in popular media. The whole thing becomes a joke on what was supposed to be the most important event in the history of humanity, the final judgment, and also one of the most tragic events of that history, the conquest of Mexico by Hernán Cortés.

IS: Robert Browning, the nineteenth-century British poet, once stated that the present "is the time in which the future crashes into the past." The de la Torre brothers skillfully play with time through their travesty in *La reconquista*.

JG: From the point of view of the divinity, according to Augustine, time is always in the present. For God everything is happening at the same time—the creation and the last judgment are simultaneously present for God. This is why in the Middle Ages it was common to mix different times in the same depiction. And so are they in this work. The entire history of the conquest and its people are represented in the divine present in which everyone will be given what he or she deserves.

IS: The material the piece is made of is fascinating. Lenticular printing is used in popular souvenirs such as post cards. According to the de la Torre brothers, it is a strategic placing of the color inks behind a lenticular lens to produce the "flip image" effect on the side panels and the 3D effect on the central panel. The lenticular lens is a think acrylic panel with grooves that act like prisms. One of the elements that fascinates me about *La reconquista* is its palimpsest nature. It is a replica and, as such, finds originality in imitation, an aspect that in my mind is ingrained in Hispanic civilization: we are a copy of European models yet we're able to be authentic, to find a sense of uniqueness in our own derivative nature.

JG: A palimpsest is a manuscript in which different texts are written on top of one another, on the same parchment. Palimpsests became common in the Middle Ages, when writing surfaces were scarce and expensive. Medi-

eval scribes did not have paper, so they used instead the skins of animals, the most coveted of which was the skin of a young calf. Scarcity forced them to write small and to reuse the parchment. Before writing a new, more prized text on an already used parchment, scribes tried to erase the text previously written on it. The result gives a manuscript a certain visual texture, in which traces of the texts written under occasionally surface through the text written over them. The effect is one of complexity, the underscript bleeding through the superscript and the superscript disappearing in the underscript.

A palimpsest is quite an apropos image of *La reconquista* in particular and of Latin America as a whole, both of its peoples and its cultures, in that it captures that superimposed character of the conquista. The Spaniards came and superimposed both their genes and cultures on the peoples and cultures of pre-conquista America. They mixed with the indigenous inhabitants, bringing together peoples, previously separate, under one general umbrella that promoted genetic and cultural mixing. In a palimpsest, you see the latest writing more clearly, but you have also a glimpse of underlying writing. The page becomes a curious instrument that records various texts, ideas, and lives. It is not always possible to fully see the writings underneath, but we know that they somehow support and undermine posterior writings. Sometimes they help us read the manuscript, and sometimes they make it more difficult. But it is also interesting that in a palimpsest there is generally no fusion, whereas the mestizaje of the Latin American peoples and cultures has often yielded fusion. This is what Vasconcelos had in mind. By putting the faces of Spaniards and Latin Americans from various times on the bodies of Memling's work, the de la Torre brothers have created a field of texts that one can read in many ways. To this must be added that the lenticular technique emphasizes the fluidity of the work and its possible manifold meanings and interpretations. A lenticular work does not present us with a fixed image; what we see depends on the perspective from which we look at it.

IS: The other elements I find mesmerizing about the piece by the de la Torre brothers is their labyrinthine quality. *La reconquista* is a meditation on baroque art. Baroque art, typical in sixteenth-century Spain, is by definition intricate. Borges once described it as the style that seeks to become a

caricature of itself—and achieves the task. The triptych is a caricature of Hans Memling's *Last Judgment* but it is also a commentary on the baroque quality of popular culture today, in which we are bombarded with images and messages imposed over other images and messages.

JG: The Baroque takes its name from a certain type of pearl, a pearl that, unlike the most desirable kind, is not perfectly round, but has an odd form. In the baroque, the highest symbol of perfection is not a circle, but an oval. Baroque writers and artists do not produce diaphanous works, but complex and difficult to understand pieces that require perspicacity and sometimes knowledge of special subjects to pierce their meaning. The world is not as it appears; it is hidden from us and only those who have a special knowledge can decipher it. This is an art for the sophisticated and learned, heavy with resonance.

You aptly characterize it as labyrinthine, for it is not clear where we will end up when we begin the process of interpreting it. We are trapped in a maze, with many options, none of which is clear. *La reconquista* involves too many variables to receive a simple, straightforward interpretation: the Memling painting, the use of characters from the history of Mexico, the process of production, the ambiguous title, and more, all pull in what at first appear to be different directions. Is chaos the inevitable result? Where does it take us?

IS: One of the initial reactions to baroque art is paralysis. What we have before us appears too complex to be sorted out easily. That appearance has much to do with the lack of a diaphanous perspective. But let's not be deceived. The baroque is a style that attempts to imitate the vast complexities of the universe. Why endorse simplicity if the reality that surrounds us is sophisticated? The plan behind that reality, according to this style, is perfectly intelligible. That is, things might appear challenging for the mind to sort out but that challenge isn't about disorder but about chaos. And here I want to connect it with your question about chaos. As you well know, chaos isn't the opposite of order. The opposite of order is disorder. Chaos is a different type of order. Dictionaries frequently deceive us by suggesting that chaos is "the disordered state of unformed matter and infinite space supposed in some cosmogonic views to have existed before

the ordered universe." But mathematicians have opposed this view. Those endorsing a theory of chaos state that chaos is a dynamic system that has a clear and sensitive organization, even though that organization might appear alien to the human mind's attempt to organize things.

In truth, we're in the wrong realm here. Nothing in baroque art is chaotic. Think of J. S. Bach's concertos, of Christian architecture in Europe during the Renaissance, of J. Escher's depictions of labyrinthine structures. Think, also, of the sonnets of Lope de Vega, Luis de Góngora, and Francisco de Quevedo. Think of Diego Velázquez's painting *Las meninas* (1656), and, maybe, of Cervantes's *Don Quixote*, although, in all honestly, I've always thought of that novel as a reaction to baroque art and not as an example of it. This is a list that emerges from the Spanish Golden Age. We could also talk about the Italian and Flemish baroque. In any case, all these styles are about a strict endorsement of order. And, it is obvious to me, so is *La reconquista*.

Have you ever seen the books in the series *Where's Waldo?* In an overcrowded page, the reader must find Waldo. At times there are hundreds of Waldo look-alikes, in which case the real Waldo will keep a unique feature distinguishing him from the rest. One's eye needs to be trained in order to locate the actual Waldo. That training is what baroque art seeks in us: patience, attention to detail, recognition of unique features. In *La reconquista*, each of the items is in a strategic place. The artists have built the composite with meticulous care and they want us to scrutinize it with equal attention. For instance, each of the faces I mentioned to you comes from Mexican politics and culture. It seems to me that Einar and Jamex de la Torre have analyzed the Memling original closely and replaced Memling's faces with their equivalents today. This is clear because they've decided what sections of the painting represent heaven and hell.

But I want to add another dimension. In my book *The Riddle of Cantinflas* (1998, exp. edition, 2012), I maintain that one of the features of Latin American culture is its derivative dimension. We're prone to copy foreign models, to adapt them. That process of copying and adapting them makes us Menardists. Yes, I'm invoking the ghost of Pierre Menard, Borges's famous creation. Menard doesn't quite copy a classic; he rewrites it, which is even better. That is, he doesn't have Cervantes's *Don Quixote* before him when he creates. His theory is that if Cervantes could write that book

from scratch, so can Menard. That's what we're good at: creating art that already exists.

JG: Still, important differences between Menard and the de la Torre brothers can be detected. Menard produces a work that is exactly like the work of Cervantes. The text is supposed to be indistinguishable from it. So what could be the difference between them? Is Menard's *Don Quixote* the same as Cervantes's *Don Quixote*? If the texts are indistinguishable, how could they be different works? And yet, what Menard produces is something very different, according to the story. For one thing, it has an archaic style, which *Don Quixote* does not share. When I read the work of Menard, I feel that I am reading something affected, the work of a writer who is infinitely, to use a favorite adjective of Borges, sophisticated. But when I read Cervantes's work, I do not find the style archaic; I find it to be what it is supposed to be for a work produced in the seventeenth century. So how is the work of Menard different from Cervantes'?

The key is to understand that there is a difference between a work and a text. A text is the meaningful script we have in front of us, which happens to be the same in the work of Menard and the work of Cervantes. The work is not the script I have in front of me, but the script with a specific meaning. The texts of Menard and Cervantes are the same, but the fact that they were produced at different times gives them different meanings. The words they use have changed meanings over time, having different denotations and connotations. So when I read the work of Menard, I understand it differently than when I read the one by Cervantes. This is why I can think that Menard's work has an archaic style. It was written in the twentieth century and so its text functions, feels, and means something different from the work of Cervantes.

Now, if we go back to *La reconquista* and Memling's work we see something very different from this. An exact parallel would exist only if the de la Torre brothers had created a work that was exactly like the work of Memling, one that would not be able to be visually distinguished from it in any way. But the work of the brothers is actually quite different and easily distinguishable, for they modified the images created by Memling in very substantial ways. For example, the change of Christ into a figure with a mask of Quetzalcóatl creates a dimension for the work that is com-

pletely foreign to the original. It is not just that the art piece has been created at a different time and thus has a different meaning. We do not have the same texts, as it were, since the art is not composed of texts but images. Instead, we have both different texts (and images) and different works, that is, different artifacts and different meanings.

And what is the significance of this for the issue you raise, namely, the derivative character of Latin American culture and art in particular? I would argue that, although much of Latin American culture and art is a copy of some other culture, in the vein of Menard, as an appropriation of something other than what it is, *La reconquista* is not derivative in this sense. The work takes off from Memling's piece, but what it does with it is revolutionary and shocking, even irreverent. In so doing, it can be considered in the same vein as the work of other artists in Europe and elsewhere who have emulated the work of previous artists. Artists have often used the work of other artists to create art. There is, for example, the great piece by the Cuban artist Emilio Falero, *Across* (2006), in which he represents the plight of Cubans who cross the sea to get to the United States in rafts, by superimposing over a raft a copy, painted by him, of the dead Christ of one of the great Spanish baroque masters. Still, the point you raise is important and perhaps we could dwell further on it.

IS: You have a different approach to Menard's attempt to rewrite *Don Quixote*. Yes, Menard's work is archaic because, produced as it is in the early twentieth century, and in Spanish, a language the French author needed to learn in order to do his rewriting, it doesn't belong to the present. By the present I mean Menard's present. That is, it doesn't reflect the language used at the time. Cervantes, in contrast, in a seventeenth-century novelist writing as a seventeenth-century novelist, meaning that his own present, the way the Spanish language was used then, is filtered through him. But that's Borges's point: that a writer simultaneously belongs and does not belong to the time in which he lives. Borges himself wrote in an archaic Spanish. He often said he would feel more comfortable in a period like the Spanish Golden Age than in his own time. His later oeuvre, from the time blindness took over, when he was around fifty, onward, feels stilted, because Borges didn't quite write it himself; he dictated it. And in order to dictate a new sonnet, he first needed to compose it and then to memorize

it. Writing and memorization go hand in hand in him, especially in his adult years. The sonnet is his favorite poetic form, and not the free verse practiced by his hero, Walt Whitman, because it is far easier to handle in memory: it is precise, mathematical. Free verse, in contrast, is arbitrary, its devices based on randomness. Menard isn't the only derivative writer in "Pierre Menard, Author of the *Quixote*" (1939); Cervantes is also. Menard copies Cervantes almost the way Cervantes copies the genre of chivalry novels. Of course, Don Quixote isn't a rewriting of *Amadis of Gaul* (fourteenth century), but a loose copy, whereas Menard's version is more than a loose copy. It is a replica.

You talked about text and work, distinguishing them through meaning. But meaning also comes out from replicas. My argument is that Cervantes's *Don Quixote* is astonishingly original but so is Menard's. Both are works of supreme genius. And both are essential to our understanding of culture in general and of Hispanic civilization in particular. In his essay "On the Mimetic Faculty" (*Reflections*, 1984), the German cultural critic Walter Benjamin talks about the role that imitation plays in life. From an early age, everything we do results from our biological need to imitate. The child imitates the gestures his mother makes, the student imitates her teacher, and so on. Imitation is socialization. Art pushes this faculty a step further because art imitates, or at least emerges from, our desire to reflect what we see through our own creativity. All this is to say that the mimetic quality of human beings is universal. However, at the cultural level, civilizations have a different approach to imitation. What I mean to say is that the value civilizations place on originality varies. I don't believe Andy Warhol's genius would have been possible in Europe. On the contrary, Warhol's originality—or lack thereof—is contingent to his American self. Only an American of the twentieth century could have made art of copying dozens of times a picture of a Campbell's Soup can or Marilyn Monroe's face. He was a byproduct of a time in American art in which creativity and consumerism were married in a society defined by mass publicity campaigns. Likewise, only an Argentine of Borges's vision could have been able to come up with a story—or is it an essay?—like that of Pierre Menard. Not a Cuban, not a Mexican, and certainly not a Spaniard; only an Argentine. You know why? Because an Argentine's a European living at the end of the world.

Derivativeness is present everywhere. But Hispanic civilization makes derivativeness a character trait. By the way, I find it significant that in your counterargument to my view on Menard you use as an example a Cuban artist, Emilio Falero.

JG: I don't quite understand your response, Ilan. You seem to think that we disagree, in that I do not think derivativeness is everywhere. But I have not claimed that derivativeness is everywhere. My claim is that the work by the de la Torre brothers is as derivative as the work of other European artists whose work is not considered to be any less original because of it. And from this I argue that your suggestion, if I understood you correctly, that the work is Latin American or Hispanic because it is derivative, can be criticized precisely because derivativeness is everywhere and cannot be regarded as something idiosyncratic to Latin America or the Hispanic world.

IS: We misunderstand each other. My argument is that while derivativeness is a sine qua non of the human condition, it is more acute in certain cultures, such as Latin America, where originality is a troubled value since colonial times.

JG: Your arguments and examples actually support my point, although toward the end of your remarks you add that what is characteristic of Hispanic civilization is that "it makes derivativeness a character trait." This is a different claim and one for which I do not find that you give any arguments or evidence. In fact, I think it would be very difficult to find any conclusive support for it. How would one go about proving that derivativeness is a character trait of Hispanic civilization? By giving some examples of derivativeness in Hispanic civilization, such as this or that work of art? I think we agree that there are also many examples of derivativeness in other civilizations, and even if there were not, such examples would not warrant calling derivativeness a character trait of the civilization. Another possible way would be by showing that all aspects of Hispanic civilization involve derivativeness? But that certainly would be impossible, considering that the task would turn out to be, again as Borges would say, infinite. No one could complete it.

I am uneasy about your talk of Hispanic civilization in terms of character traits, because I do not think that one can find any trait that is common to all phenomena that are classified as Hispanic. The reason is that what we call Hispanic civilization is not something that has an essence, that is a set of properties that are common to all things called Hispanic. Rather, Hispanic civilization is more like a family, the members of which share a family resemblance. Some parts of the civilization may in fact have derivativeness as a character trait, but others do not, and thus we cannot expect that everything, or even most, that falls within what we call Hispanic civilization will have this character trait.

This is not a new idea for me, as you know. When I was writing about Hispanic identity several years ago, I tried hard to find some common property, something that would characterize everything Hispanic, and failed miserably. But I did find that this was not an obstacle to the view that there is such a thing as a Hispanic identity, and also, if you will, a Hispanic culture and a Hispanic civilization, although I often favor the use of these terms in the plural — Hispanic cultures and Hispanic civilizations — to deflate any claim of essentialism, because being Hispanic is like being part of a family, in which every member shares some property with some other member or members, but no member need share some property with all other members. So we, as Hispanics, have an identity, just as the members of my family have one as members of the family.

In short, I do not see that Hispanic civilization can be accurately described as derivative, any more than other civilizations. Civilizations cannot be described as having essential traits that make them to be what they are throughout their existence. To do that would require that they have essences, that is, sets of properties that extend to every member of the civilization, and that is just not the case. I also do not believe that the de la Torre brothers have created a work that, because it uses the work of Memling, is any different from what many other artists have produced in practically every civilization that exists or we know has existed.

IS: We are of different minds. I, in contrast, believe there are distinctive traits pertaining individual countries as well as civilizations. Argentines, Italians, Japanese, and other peoples share a common worldview. Within those worldviews there are individuals with unique characteristics. This

means that we can talk about Argentine literature, Italian soccer, Japanese manga, and so on. And if we can do so, we can also talk about artists expressing that particular worldview. Now we've added another element that is equally important: a civilization, say, Arab, Hispanic, or Jewish. I have no doubt in my mind that such large entities exist, with distinctive qualities. Hispanics might come in different shapes, but they share an essence. That essence, in my view, tends toward the melodramatic and is frequently derivative. Does this mean that other civilizations don't have these qualities? They certainly may have them. But Hispanic civilization has a peculiar combination of them, and this combination, this formula, is ours. Again, derivativeness is present everywhere, but it has a distinctive tone and tune among us.

JG: We certainly disagree on this point. It is very inspiring to talk about countries, nations, societies, and civilizations as having essences. It creates a sense of security and identity. But I do not see that this talk is justified empirically. Consider the case of your own country, Mexico. Where are the common traits common to all Mexicans throughout the history of the peoples who have lived in the territory that is today known as Mexico? Can we really say that the Tarahumara, the Maya, the white Spanish conqueror, and the upper-class child of German immigrants in the DF share even one thing that marks them as Mexican? I do not think so. Of course, they are nationally Mexican; that is, they live in a political unit that is Mexican, and they are human beings, and so on. But none of these are characteristics that make them Mexican in a deeper, cultural or ethnic, sense. The Mexican government has tried for more than a century to forge a Mexican people out of the disparate elements that constitute the so-called Mexican population, but in spite of this the result is anything but homogeneous. And it is important that it is not because of individual differences, which is what you seem to refer to, but of social and group differences.

The idea of a Mexican essence, just like that of a Cuban essence, or a Russian essence, or an American essence, satisfies certain desires and even political and class aims, but is no more than a myth. Still, there is something that is not a myth and that justifies talking about Mexicans as more than a random collection of human beings. Mexicans are related to each other, indeed, as are the members of a family whose members are

tied differently but share a history. That history creates common bonds, and even properties, shared at certain times and places by part, or all, of the Mexican population at those times and places, but that is neither an essence nor does it consist of properties that are common to all Mexicans.

Perhaps this is a good time to stop our conversation, for it leaves readers with two alternatives, two points of view, which they can explore further. After all, our task is not to agree with each other or to convince anyone, but to make readers think about ideas to which they perhaps had not paid enough attention before in order to enrich their own understanding of themselves and the world. In this I think we would be following the example of Socrates in the Platonic dialogues, which is a good example indeed, and one on which we both agree, I think!

THE IMPOSTOR'S MASK

MARÍA BRITO *Conversation*

Jorge Gracia: Three women sit at a table, in front of me. Three. Why not four, or one, or two? Three is the third most significant number. One stands for unity, indivisibility, and individuality. It is the first odd number, different from everything else. It ignores the other because it does not need it. It is self-contained, separate, alone, but also lonely and abstract. Since Plato's time, it is also the basis of all other numbers, and for Pythagoras of everything in the universe, insofar as numbers are the stuff out of which the world is made. For some, one is convertible with being and good, but for the Neoplatonists it stood for what is beyond them. One is beyond being and good; it transcends them. It is altogether something different. It is even beyond thought, because thought, like its object, involves plurality, and one is beyond plurality, being the basis of it. In Jewish theology as elaborated by Philo, it is God, who cannot be named and cannot be thought, because to reproduce or imagine God is to fall into idolatry, to make God something he is not, another, an object. Names come from what we know in the world, as Maimonides so well understood, and that is not what God is. We cannot use our language, derived from our experience of the world, to name God, who is beyond. God merely is.

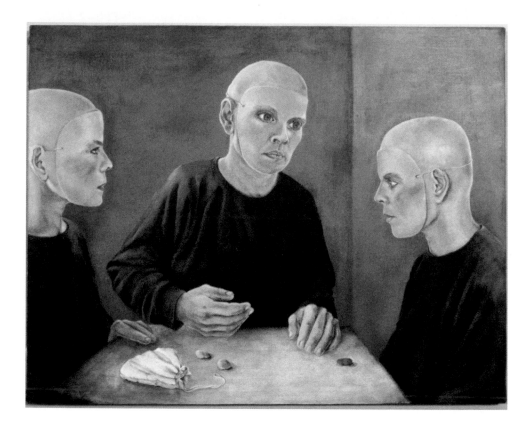

María Brito, *Conversation* (1984),
16″ × 20″, oil on canvas. Used by
permission of the artist.

Two is the first of the even numbers. It is a couple, one and one, or one and the other. It stands for dividuality, divisibility, and thus companionship, love or hate, friendship or war. It introduces the other, a relation, dependence, and union rather than unity. To be one is different than to be united. To be united requires being at least two, but this does not apply to one. Two is the beginning of thought, of dialogue and conversation, discussion, perspective. For the Neoplatonists it is the Nous, or Mind, the reflection of the One on itself. While the One is beyond thought, two is intelligence, intellect, and thought, at war with itself and the other. Thinking always presupposes two, the one who thinks and the object of thought.

Three is plurality, the fusion of one and two, division and movement. It is evolution, progress, intrigue, and complication instead of simplicity. It means dialectic, synthesis of one and two. A third perspective, alliances, and betrayal. But it also integrates and mediates. For Neoplatonists it introduced the universe, and in Christian theology it is the basis of everything else, as the Trinity: one substance and three persons, one God and three manifestations. God the creator, Christ the redeemer and Wisdom of God, and the Holy Spirit the love between them.

Three women sitting around a table, with us in fourth place. Are they playing a game? Are we part of it? Two women are in profile and one is facing us. Two, the one on our left and the one facing us, are intently looking at the woman on the right, perhaps with concern, expecting something. One of the hands of the woman facing us forms a gesture, as if she were saying, "Look here, consider that . . . ," but she isn't speaking. The woman on the right appears to be the center of attention, but she is lost in thought, with her eyes intent but unfocussed on anything, lost in space, perhaps worried about something we cannot fathom. A small, cloth handbag lies on the table, closed with a string, and three pebbles are scattered beyond it; two left of center and one close to, and in front of, the woman who is the center of attention. Why three, like the women we see? The first two are colored gray, but the isolated one is brown. Is this a game? Perhaps the women picked them from the bag, and the woman on the left got the brown one. By chance, determining an uncertain future. It is not a prize, but of concern to the other women. She picked the brown pebble and this carries with it a task. It is her turn to do something. But is the task a matter of worry? Does the color indicate it? Or is this the result of a

vote, in which the brown pebble signifies no and the other two signify yes, as nonblack and black pebbles meant in Athenian democracy?

The women are dressed in simple, black, long-sleeve T-shirts, their heads shaved, and they are wearing ostensibly identical masks. The masks prevent us from determining whether the figures are the same person. At first one infers that the masks are the same and thus intended as a unifying factor, forced or voluntary, to the identity of the three women. But minor differences take away from our certainty. The one worn by the figure facing us makes room for large eyes, but the eyes on the figure on the left appear smaller, perhaps as a result of differences in the mask. Still, subtle differences in coloring and shape could be the result of lightening or the position of the wearers. The purpose of a mask is twofold: to hide and to tell—to hide an identity and to suggest a fake one. Do they hide, suggest, or both in this ménage à trois?

The women are in a room of which we see only a corner and part of two intersecting walls. The color, perhaps an institutional blue, blends easily with the gray of the table cover and the black of the T-shirts, but contrasts sharply with the bright skin colors of the faces and masks. No windows or doors are visible. They are trapped; there is no exit, as Sartre would put it. Who are these women? Are they the same person or different hypostases of the same person? And where are they? Are they locked up? Is this a prison? Is this a mind? Is it the universe? Are the walls that surround them of their own making or imposed on them by forces outside them? And what game are they playing? Or is it a game at all?

The title of the painting, *Conversation*, suggests that the artist had in mind a dialogue among the three women with which she has presented us. This could provide a clue for an understanding of the work: it is about self-identity. What do you think, Ilan?

Ilan Stavans: The first thing for me to say about this painting is that it exists. It is stating the obvious, but identity needs to be framed in those terms: it exists because we are in need of defining ourselves. And the way to do it is through those who are in front of us. In other words, we are who we are because we live among others. That interaction is a game of mirrors: we see others and others see us. Or, better, we see ourselves through others and others see themselves through us.

I have been fascinated by masks ever since I was child. This is no surprise, because my father is an actor. Actors traffic with identity. And the currency of identity is the mask. In discussing *La reconquista*, by the de la Torre brothers, I talked about masks. During a theatrical performance, my father would pretend to be someone else. The hiatus from his own self lasted a couple of hours, more or less. As an actor, he would not actually use a mask, not in the literal sense of the term. But he would disguise himself by pretending to be someone else: a vengeful prince, a disgruntled husband, a parsimonious hotel manager. I could see my father on stage. More concretely, I could see the public looking at him: his face gesticulating, his body moving dynamically. Yet while that face and body belonged to my father, for me he was as if inhabited—temporarily, by choice—by a *dybbuk*. In Hebrew, the term *dybbuk* means "spiritual possession." In the famous play by S. Ansky, *The Dybbuk, or Between Two Worlds*, a bride scheduled to marry a groom she doesn't care for is possessed by the spirit of the young man she actually loved but who died in fury after the father of the bride decides to separate them.

Not too long ago, I heard a prominent British actor complain in a radio interview that actors aren't liars. His explanation was somewhat arbitrary. Liars twist things, he said. They come up with stories they can't believe. In contrast, actors come up with stories in which they wholeheartedly believe. I say the distinction was unfair because liars, particularly trustworthy liars, do believe in the lies they come up with. This means that, in my view at least, liars and actors engage in the same type of deception. If that's the case, it follows that my father is a liar. And he unquestionably is. He gets paid to lie, to pretend to have for a short time a self that isn't his.

Let me take the argument further. All of us are actors. We are owners of a self that is the product of years of decantation. We reach our zenith, the center of who we are, in our twenties, after nature and society have shaped us in a variety of ways. What is that zenith? The moment in which one becomes convinced that we are someone concrete, that our psychological features—our character—is now a set of predictable responses. Yet it would be absurd to believe that that character is unmovable. We are who we are because we've reached a certain degree of certainty that our responses to the environment are fixed and, because the environment also trusts that those responses belong to us, that they are us. Our face, the way

we walk and eat and dress, our modes of speech, have become branded. Still, there is room for surprise. Every so often even we are amazed by something we do, for instance by a reaction to a friend's comment.

Identity, therefore, is the mask we have built, the one nature and society have helped us carve. But that mask is flexible. It can change suddenly. If we drink too much alcohol, for instance, we're likely to act foolishly. One could say that those foolish acts are part of our set character. Or they can be seen as the interruption of that character, a hiatus. And actors show that putting on and taking off of the mask is an even more malleable act than we are ready to recognize. I love the fact that the etymology of the word *mask* is ambiguous: it might come from the French masque meaning "covering or hiding one's face"; it could also come from *masca*, meaning "nightmare, specter"; or else from the Arabic *maskarah*, meaning "buffoon." The majority of us are highly functional buffoons capable of controlling, manipulating our masks, maybe even replacing them with other ones if such replacement becomes necessary. Not to control our mask, being unable to be the master of our selves, becomes abnormal—an illness—according to the status quo.

To me, Brito's *Conversation*, and her work in general, is extraordinarily theatrical. The three figures are performing for one another and for us. And their performances have at least a couple layers: the performers are present around the table as individuals, but they are also actors of their own selves. Their faces are hidden because they've agreed to add a degree of foreignness to their encounter.

JG: I am not surprised that you are fascinated by masks, Ilan, not just because of your father, but also because you are Mexican, and Mexican cultures (there is not just one, but many) are permeated also by the use of masks. Mexicans have used masks to reenact their history, with its tremendous ups and downs, its glory and its misery, its self exploitation and exploitation by others. It takes only a short visit to the magnificent Rafael Coronel Museo de Máscaras Mexicanas, in Zacatecas, to understand the pivotal role that masks have played and still play in the Mexican self-narrative. But the connection to your father's acting is also interesting because it takes us back to the fact that the very term we use to talk about ourselves, *person*, is related to the theater. A mask for the Greeks was that through

which actors talked, which was translated into Latin as *per sona*, to sound through. No question we are all actors, but one thing that I find fascinating in Brito's work is that the masks for the three persons in the painting, which are Brito herself, are identical, except for what appear to be minor, inconsequential details.

IS: Three identical masks. Here we have yet another labyrinth, one based not on difference but on similarity.

JG: Indeed! Why do we need three identical masks to hide the same person? This is curious, because one would think that identical masks would be necessary only if the three persons were not the same. So the question is, are they the same person or not? The answer, like any good answer, is yes and no. They surely are the same person. They are Brito. But they must also be different persons, and it is hiding the differences between them that requires the three identical masks.

In appearance, thanks to the three masks, the three images appear to be images of the same person. But in reality, hidden from the observer, the three persons are not the same Brito. But who are they? What does the painting tell us? The painting does not say anything about this or anything else. Paintings do not speak or tell. It is Brito through the painting, or we through it, that tell. Let's go back to the number three, because Brito could have painted any number of images, two, four, five, but she painted three. Why?

The understanding of a human being as a composite of three is quite old. We find it in Plato's tripartite conception of the soul. And we must remember that for him the soul was the human being; the body was not part of us at all but an unwelcome distraction. In a famous metaphor, he referred to the soul as the pilot in a ship, the ship being the body. We are our souls and the soul is composed of a rational part, an appetitive part, and a spirited part. The relations among these parts are explained with the analogy of the charioteer and the chariot. Reason is the charioteer, and the appetitive and spirited parts are the horses in the chariot. Each horse is trying to go its own way, but reason's function is to keep them in line, going in the right direction. Humans are complex entities, they are fellowships, not single beings. This explains the inconsistence of our ac-

tions, the indecision, the confusion, and both our glory and misery. We tend to think of ourselves as one person, who we are, but Plato tells us that we are in fact a community that, more often than not, is at war within itself, and with the body in which we are trapped.

The tripartite idea of the self was picked up by Christian theology and was used to read the Bible. Humans are supposed to have been created as images of God, according to Genesis, so God must also be one and three. But how can we explain the unity and diversity of a human being? How can I explain that I am one and yet that there are forces, parts, and roles that I play that sometimes conflict with each other and at other times complement each other? Whence the idea that God is a Father, a Son, and a Holy Spirit. The Father is the creator, the Son is the sacrificial lamb that saved humanity from itself, and the Holy Spirit is the love that unites Father and Son. In Christian theology, this translated into three roles that each of these persons plays. And so we, as humans, also are tripartite, actors playing roles we choose or are assigned to us in the drama of life. Going back to Brito's *Conversation*, she is three, because of the roles she plays, even though she appears to the world as one because of the mask that both her plural self and the world have helped create.

But we may ask, what are her roles? I would not go along with Plato or Christian doctrine in this. I think that Brito's context is a better gage of the roles that constitute the identity of the three images we see: perhaps a woman, a mother, and an artist. There are many more. The use of three might just indicate that the self is a plurality, without dogmatically claiming that it is three and no more. Three signifies that Brito is more than just one or two, that she is many, perhaps even an infinite number, depending on the circumstances. She is certainly a wife, a lover, a daughter, a grandmother, and a teacher. Unlike the Cartesian view of the self as a substance, one and only, what we have here is a pictorial rendition of the conception of the self as a community.

IS: The conception of the self as a community fits our current views on psychology and sociology. Whereas in the past, as you suggest, there was a strong, even repressive, emphasis on the unity of the self, everything out of that unity being considered abnormal, today the idea of plurality is a bit more comfortable. I say *a bit* because we have yet to be as flexible as

possible in defining the self. Social norms continue to impose on us the sense that we, the many *we*s that exist within us, must be unified, synchronized, coordinated. But thanks to thinkers like Michel Foucault, we no longer push the idea of abnormality. Or, better, we are more elastic toward normality, seeing it as a fluid state in which the various selves of a single person interact, some selves more harmoniously than others.

I've been teaching in recent years a course called "Impostors." The approach is interdisciplinary. Students—I usually have a large number—read Plato and Freud, Montaigne and Cervantes, Emily Dickinson and Mark Twain. They analyze Lewis Carroll's *Alice in Wonderland* and Robert Louis Stevenson's *Doctor Jekyll and Mister Hyde*. They discuss Philip Roth's *Operation Shylock*. We talk about translators as impostors. The list also includes immigrants, actors, and, of course, criminals whose crime depends on stealing someone else's identity. But how do you steal another person's identity? It's far easier than one would think. Identity is a driver's license, a Facebook password, a credit card. The age of the Internet and of fast-paced technology makes it far easier to steal an identity than ever before. But in order to steal an identity, one first needs to recognize that identity is capable of being stolen. And if it can be stolen, then it is transferable, meaning that it is temporary, even ephemeral. My identity today isn't necessary my identity tomorrow. That's what I mean by the multiplicity inhabiting our own selves. We're not always aware of the many that live inside us. Walt Whitman's verse, "I'm immense. I contain multitudes," couldn't be more prescient.

JG: You bring up a significant point, namely, that identity is fluid, flexible, malleable, that it is always in an almost Heraclitean process of change. It is like fire, always different and always the same. But how can this be? How can we be changing and being the same simultaneously? This smacks of contradiction, and although contradiction has become fashionable among postmodernist philosophers and literary critics, no serious philosopher can rest holding a contradiction. The reason is very simple: from a contradiction everything follows and that is intolerable. So how do we solve this apparent conundrum? Theology resolved it in the case of the deity by saying that God is both one and three. But the doctrine of the Trinity is a mystery and philosophers detest mysteries as much as they de-

test contradictions. Besides, what applies to God surely does not apply to us, even if we were to accept the divine existence, which is another issue philosophers argue about. So what can we say about our identity that will help us solve the conundrum?

A first step is to have some idea of what an identity is and how an identity is formed. In short, we need answers to two questions: First, who am I? Second, how did I come to be the person I am?

The first question frequently gets one of two answers, both of which are quite misguided, in my view. One states that we are who we are because we have an essence, something we are. And this is unpacked in terms of certain properties that make us who we are. Sometimes this is explained in terms of one property, but most often it is a bundle of properties that is involved. So I am Jorge Gracia because I am a philosopher, a male, Cuban in origin, and like to write, among other things. And you are Ilan Stavans because you are a literary writer, a male, Mexican and Jewish in origin, and like to write, among other things. Obviously we share some properties but not others. The ones we do not share explain our differences in our identities: I am I, and you are you. And the ones we share explain the similarities. The entire package of properties explains who each of us is. Presumably if I were not a philosopher or a male I would not be who I am. And likewise, mutatis mutandis, with you.

The problem with this answer should be obvious: this theory, which goes by the label "essentialism," does not work—I referred to it in the previous chapter in a different context. But we agreed that a human being and his or her identity is constantly changing, and flexible. This precludes that there be any group of properties that we have throughout our lives that make us who we are—the properties mutate with time and circumstances—leading others to argue that there is no such set of essential properties to identity. I could cease to be a philosopher, have a sexual change, find out that actually I was mistaken about my Cuban origin, gain weight, and hate to write and still I would be in some sense both different from you and the same as I was. There would still be some continuity and difference involved in who I am. This is the kind of view that is sometimes called eliminativism because it eliminates the idea of an essence to the self.

But then, what are we left with? We are left in the place a philosopher

loves to be. With a dilemma that needs solution, but which appears un-solvable. Do you have an answer?

IS: You pose a fascinating dilemma. Let me respond to it with yet another anecdote. I know an attractive Argentine woman who is in her late for-ties. She has had plastic surgery a number of times. If you were to see photographs of her when she was young, you—and anyone else—would be struck by her beauty. It was a natural beauty that needed no help from any surgeon. She was simply born that way. But it was a strange beauty in that she always felt foreign in Argentina. (Her parents are Italian.) By foreign I mean Scandinavian. From somewhere in Denmark or Norway. When she was still in high school, my friend was cast in a play. There was a role of a witch and the teacher gave it to her. The teacher said that witches in Europe looked like her, thus the part would fit perfectly. My friend always remembered that conversation. She hated the fact that her teacher thought of her as a witch and chose her to play the role in front of everyone. When, years later, my friend began to age, her husband encour-aged her to seek a plastic surgeon.

In any case, the knife has deformed—or it has "improved," as she would say—my friend's looks. She hasn't aged the way I have because a doctor has attenuated certain facial elements and accentuated others. My point here is that nature no longer is the sole shaper of her features; human input also plays a role. And so I ask: Is my friend's face her own? Is it a mask? Is it fair even to ask the question? I confess to you that every time I see her I feel sorry. Not that the plastic surgeon didn't perform his job professionally. My friend, for one, has been happy with the changes as they have been implemented over time. But to me the act of looking at her generates discomfort. I look askance. I have conflicted feelings. I feel pain. That pain is a response to a dissatisfaction: I wished she had let na-ture run its course. Still—and this is the key point I want to make—she no longer feels like a witch. Instead, she feels beautiful. I might not think she's beautiful anymore but she does. Isn't that what matters, that she's comfortable with herself?

I bring this anecdote to mind because of its implications. Plastic sur-geons are considered artists: they create. They might also be said to be in the business of mask-making. We could think of nature as a plastic

surgeon as well. Isn't that what aging does, not with a physical knife but with time as a metaphor for the same instrument? And if that's the case, aren't we all always hiding behind a mask? When I see myself in front of the mirror, I see a middle-aged man. Curiously, I also see the face I no longer have of the child I was in the sixties and the adolescent I was in the seventies. And I can imagine—I can foresee—the face I will have if fate is benign and I live until the age of eighty. That face will have deeper wrinkles around the eyes and mouth, the skin will be not only softer but baggier, and the hair will be even sparser than it is now. Am I the Ilan I will be? Certainly, just as I am the Ilan that I was. Or maybe not. Maybe we are successive, yet unrelated, presences of the same self.

JG: This raises the question of who you are and I am, which you wisely asked in the prologue. Who are we, really? The painting by Brito is about her identity. Who is she? This question is one that all of us face. Are we what we see? What others see? Because each of us looks at the image from a different perspective and sees a different thing. You think of yourself as middle aged but others will think of you as old and still others as young. Indeed, I thought my father was old when I was a child, and now I think he died young at fifty nine—the case was different with my mother, for I always thought she was young and beautiful. Are we what we or others feel we are?

Yesterday my wife and I went to the ninetieth birthday of a dear friend, and she was as lovely as always. Her children had hung a picture of her when she was young on the porch and her image was of a terrifically beautiful woman, a movie star. Quite a difference from what she looked to me yesterday. And yet I didn't think of her as old. She was not only still beautiful, but perhaps even more beautiful than the image in the photo, in that she had a weathered look. The wrinkles on her kind face were like the paths she had traveled, the life she had led, and that life was not finished but in many ways beginning—she still had miles to go before she sleeps. She is still young.

Brito's painting raises for us a cluster of questions about our identity: who we are, who we pretend to be, what others thinks we are, and the roles we play, or try to play. Am I the image I see in the mirror when I shave in the morning? Am I the mysterious self that functions as the

subject of my thoughts? Am I the object of your thought when you think about me as the respondent to your remarks in this conversation? But there are no definitive answers in the painting, perhaps echoing reality. We remain a mystery to ourselves, always trying to define who we are, and what we should be. Will this process ever end? Surely not, precisely because we are nothing definite. What is it to be a human being? What is it to be Jorge Gracia or Ilan Stavans? What possible answer to that question could be given that would capture everything that, or perhaps even a fraction of what, we are? If someone were to ask, we can only say, "Let me count the ways," knowing quite well that the counting has no end. Even death cannot bring it to an end, because then it is not we who will be asking, but others who want to know who we were.

We are in the making. Everything we do changes us to some extent. Writing this very book is changing you and me, and it will change every reader that reads it, whether he or she likes it or not. We are who we were before we started it, and we will also be so after we finish it, but we will also be something we were not at the beginning and will become at the end. Identity does not reside in anything that we can assert truthfully, but rather in the link between all the phases we go through. So at every turn we are entitled to ask who we are at that moment and to search and look for an adequate answer that will escape us the moment we reach it. Heraclitus wins, but Parmenides does not lose. This is the paradox of identity. We are what we are and we are not what we are, even though we are also not what we are and we are what we are not. This is the thrill of life, the challenge, and the reason some of us, like your friend, seek to construct themselves, even artificially. It is a way of working the anxiety of those who do not understand. The theme of identity will no doubt return in other chapters, but perhaps we should leave the matter rest for the moment, with more questions than answers, and turn to another topic that I'm sure will be as challenging.

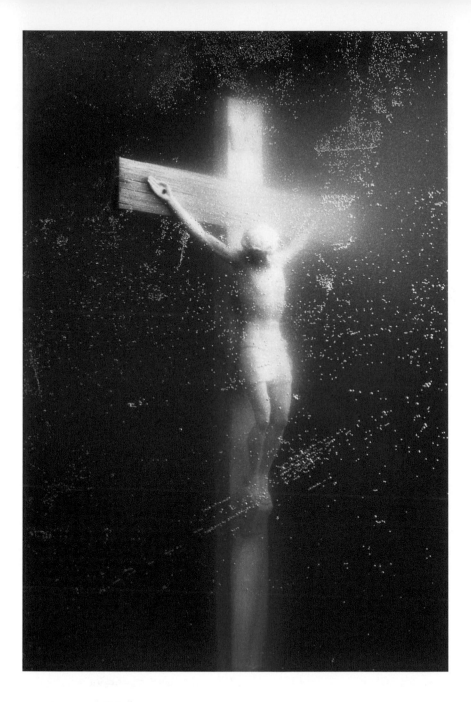

Andres Serrano, *Piss Christ* (1987),
type c photographic print. Used by
permission of the artist.

ON DESECRATION

ANDRES SERRANO *Piss Christ*

Jorge Gracia: Serrano's *Piss Christ* is perhaps one of the most controversial pieces of art that has been produced in recent times, and for reasons that are quite different from the reasons that other works of art have proved controversial in the past. Picasso's *Les demoiselles d'Avignon* (1907) was controversial because it revolutionized the art of the early twentieth century. The representation of a wild assemblage of women engaged in some primitive rite, with faces that look like African masks depicted in the style that later developed as Cubism, was more than the art world at the time could take, used as it was to the relatively harmless canvases of the impressionists, dealing frequently with landscapes and flowers. It created an uproar and changed forever the course of painting and art. One can easily speak of art before and after this work. And then we have the scandal caused by the pictures by Mapplethorpe. His explicitly sexual nudes, documenting ideas that the bourgeoisie hardly dared to dream, were again too much for the art world to absorb quickly. It took considerable digestion, aided by plenty of antacid medication, to get the art community to accept them—the general public is still hostile. But the case with the Serrano was different.

Not that Serrano did not innovate in the purely artistic dimension in his work. He specializes in humors, liquids, secretions, and the like, and *Piss Christ* follows this original line. But in it he went beyond formality and technique to present us with something that challenges some of the most deeply rooted beliefs of the western community. Or does he? Perhaps, in spite of all the noise that his work caused, he did not say anything that posed a challenge to those who protested against it and who had accused it of posing. Perhaps the message of the work is in perfect accordance with the beliefs he has been accused of undermining. Either way, whether it does or does not, the doubt remains, and that in itself challenges the observer.

The charge is that Serrano did not show proper respect for Christ, the son of God. He committed a sacrilege, a desecration. This is what some members of the Christian community, particularly members of the clergy, accused him of doing. But one could easily argue that the lack of respect in *Piss Christ* is not for the divinity, but for the Christian faith. In one way he is regarded as having sinned against God, in the other against Christianity. In either case, the claim is that he went too far. Taking a picture of a crucifix immersed in urine and exhibiting it as a piece of art indicates a complete disregard both for Christ and those who believe in him. Even in a society where freedom of expression is accepted, this is intolerable, and surely not prudent. Some argue that it should not be tolerated. What makes it worse is that the work was shown publicly and that this was made possible through a subsidy from public funds, funds derived from taxes paid by the very religious people whose beliefs the work allegedly mocks and insults.

Ilan Stavans: Have you ever pissed on a crucifix, Jorge?

JG: I'm sure I've done it, although I don't remember. After all, I come from Cuba and my family was nominally Catholic when I was born. I was baptized and there were crucifixes everywhere. I do not have photos of myself with a crucifix hanging from my neck when I was a baby, but I am sure I had one at some point, and I am also sure that I pissed and the crucifix got part of it. But I guess that does not count, does it? That's not what you mean. You are asking me whether I, with full intent and as an adult, have ever pissed on a crucifix, or perhaps even whether I have considered doing it.

This is a very serious question that raises the matter of whether Serrano's piece is sacrilegious, and thus whether the scandal that it caused was justified. For those who hold that pissing on a crucifix is a sacrilege, a major sin, there has to be an intention, and I could not have any intention to piss on the crucifix when I was a baby. But does Serrano's painting have to be interpreted as pissing on Christ or on the faith and thus as committing a sacrilege?

I think we need to break down what we are talking about in various ways. For one, it is important to pinpoint the identity of the pisser. Is the pisser a Christian, and if a Christian, is the person in question Catholic or Protestant? Or is he or she a non-Christian, a Muslim, a Jew, a Confucian, a Hindu? Apart from this we need to think also about motive. Why would someone piss on a crucifix? Because of personal animosity toward Christianity in general or toward Catholic Christianity in particular? Resentment against the excesses and abuses carried out in the last 2,000 years by Catholics against other Christians, and by Christians against other religions? Still further we need to ask what we are talking about when you say *pissing*. For, Ilan, although you have focused on pissing, what we have in Serrano's work is not pissing at all. Pissing is an act that involves excretion. It is comparable to defecating, although since we are using *pissing* perhaps we should not have any qualms about saying *shitting*. In both instances we are getting rid of refuse from our body.

The act of pissing has important connotations that have to do with power. More in the case of men, whose act is a kind of challenge. It involves holding your penis and pointing it outward, exhibiting the most private part of the male body, and doing it without qualms. Just showing off. Here I have something powerful, a symbol of my machismo. Let me show it to you, the proof of my virility and power as a man. Even when a small, naked child takes his little instrument, arching his back, and points it, there is something impudent about it. We need only look at the famous *Manneken Pis*, to get the sense of impish shamelessness. It is charming in a child, but in a grown man, it is much more than that. The act, when done in public, becomes a sign of defiance. And when the piss is directed toward someone or something, it says: "Hey, see, I do it on you because you are of the same quality as the piss. You are disposable, worthless, like piss." To piss on someone is to humiliate him or her, to crush

the ego, to put him or her in the proper place, a subservient place, a place of inferiority. It is almost like saying: "You're shit!"

But the work by Serrano does not present us with an act of pissing! It is a crucifix immersed in piss. Indeed, the title is not *Pissed Christ* or *Piss on Christ*, or *Pissed Christianity* or *Piss on Christianity*, but *Piss Christ*. So the piece need not be interpreted as implying that the crucifix, Christ, or Christianity are being pissed on. The meaning of the work could be quite different. It could mean that Christ, and perhaps Christianity as a whole, is immersed in piss, which is something very different. Because then the work does not entail an insult to Christ or even Christianity, but a criticism of Christians, of the Christian community. The art work could then become a cry against those who have soiled the cross and the faith, not a soiling of the cross or the faith. But before we go any further, I'd like to know why you asked me the question you did.

IS: I ask the question as I wonder if I could do the same on a Torah scroll, the most sacred artifact in Judaism. The Torah, as you know, is a book. Well, not just a book but the Book of Books, meaning the Bible. What makes the Bible essential is not only its religious grounding—it purports to tell the history of the world from creation to the present—but its moral authority. The Ten Commandments are in it, not quoted once but several times. Their delivery from Mount Sinai by Moses, the religious leader of the people of Israel, the successful people who embraced monotheism at a time of military and theological trifle, is presented as a cinematic scene of cosmic proportions. The Torah is written in Hebrew with portions in Aramaic. The text is supposedly written by God in a human tongue, *lashon b'nei Adam*. Again, would I piss on the Torah? No.

Yet I understand Serrano's drive. It's a drive defined by anger. Anger at religion for curtailing human freedom. Anger at what the Catholic Church has turned the crucifix into, an object of oppression. For me the Torah isn't an object of oppression. I know for sure that orthodoxy in Judaism is about extremes. The ultraorthodox are against abortion, reduce women to little more than caretakers, and resist modernity as a distraction from the ways dictated by God. They reject scientific, technological, and, in general, social progress. But a large portion of Jews today have pushed aside the oppressiveness of religions by endorsing a secular view of the world. That break occurred during the Enlightenment, as the French Encyclo-

pedists like Robespierre, Diderot, and others were reassessing human knowledge beyond the confines of the church and as the fighters in the French Revolution of 1789 sought to establish an antimonarchic, republican system of government. Secularism is not the end of religion. It is simply another modality, even if that modality is categorically denied by the ultraorthodox, who believe they alone are the keepers of the flame.

Again, secularism isn't antireligious. Personally, the topic of God is central to my worldview. I'm a weak believer, although I'm not an unbeliever. I'm a rationalist who champions the mind as the map and tool for everything. Faith comes second, but it has a role. What is the function of art in a secular society? To help us define ourselves. To test the waters. Someone like Andres Serrano is important. But so is the reaction against him. They are part of the same coin. It's that coin, with its two sides, that interests me.

JG: I follow you, but I'd want to distinguish between two works of art: one is the one we have in front of us and the other is a photograph of Serrano pissing on a crucifix. It would be difficult to interpret the last one in a way that wouldn't be insulting to the Christian faith, or as has been said, a desecration. But the Serrano that we have could very well be interpreted as an indictment of the present state of Christianity, and not even, as you seem to suggest, an indictment of Christianity as a whole, but of Catholic Christianity. Serrano is a Latino and Latino society is predominantly Catholic. I have no idea whether Serrano is a believer or not, and I don't think it matters either way, for we are not talking about Serrano, but about *Piss Christ*. What matters is that the context of the work is Catholic. The use of the crucifix with the image of Christ on it makes this clear, because most Protestants are iconoclasts. They do not accept images, a doctrine they share with Judaism and Islam. It is primarily Catholic Christians, and particularly Roman and Orthodox Catholics, who accept images in religious rituals. Catholics kneel in front of images and pray to them. In Catholic theology this is supposed to mean that they are praying to the realities that the images represent, not to the images themselves—that's how they circumvent the charge of idolatry. Yet, Protestants generally regard what Catholics do with images as idolatry and abhor the practice of adoring and praying to images.

Now, if you are a Catholic and you are concerned about the present

state of the Catholic hierarchy—the endless scandals about pedophilia, the hierarchy's alliance and support of cruel dictators in places like Argentina and Chile for example, the banking scandals in the Vatican, and other excesses—the Serrano could become an extraordinarily pious work of art. Its meaning becomes a criticism of the Catholic hierarchy for engaging in, and the Catholic community as a whole for silently condoning, corrupt and anti-Christian behavior. The work turns into a criticism from within, an instrument of the faith, very much in the vain in which Christ behaved toward Pharisees in the Gospels, his cleaning of the Temple and his insults against their greed and disrespect for holy ground. Instead of being sacrilegious, the work turns into a work of piety, a defense of a true Christian faith, unsoiled by the accretions of corruption. But if you are not Catholic, then your criticism, although perhaps valid, might be hostile not just to the present condition of the Catholic community and its hierarchy, but to the Christian community and the very faith. This brings me to the point of asking whether you have pissed on a crucifix, and what doing so would have meant in your case.

IS: I haven't pissed on a crucifix, nor would I. But I have burnt a Bible. And not only a Bible but several other major works belonging to the Western canon. Why, you may ask. My answers are manifold. In my memoir *On Borrowed Words* (2001), I talk about burning Borges's book in my house's backyard. This doesn't have much to do with religion. Or perhaps it does, if one considers parricide an aspect of religion. When I was a young writer, I sought two paths: my freedom as a creator and the absolute, uncompromising knowledge of the writers I admired. Borges was one of them. I had a solid personal library that included every single book of his, sometimes in first editions. I also had some signed copies, original copies of Sur, the journal in which he published many of his essays and stories, and so on. One day, as I was trying to find my own voice, I grew frustrated. The frustration came from the realization that I admired Borges too much. A while back you talked about Socrates. Borges was my personal Socrates. Not only did I know everything there was to know about him, I also dreamed with him. As a result, he controlled me. My writing was an extension of his. So, unhappy with myself—and with him—one day I decided it was time to be born. By this I mean to become myself.

The only way I could do it was to exorcize my demons. I did the exorcism like the Holy Office of the Inquisition did: using fire. I profoundly regret the incident. And yet, it set me free. From then on, my relationship with Borges was less tyrannical.

My burning of the Bible is an altogether different story. It has to do with exploring the limits of censorship and the tricks censors employ. You see, we get worked up by the burning of important books. Kristallnacht was a ritualistic act: the destruction of Jewish books by the Nazis. Such destructions are as old as the book as a conveyer of information. As you know, the same emperor who built the Chinese Wall also destroyed all the books in the kingdom. His objective was to start time again, with him at the center, while separating his kingdom from the rest of humankind. In *Don Quixote* there's a scene in which books are burnt. In Elias Canetti's *Auto-da-fe* a similar site is included. And, of course, Ray Bradbury's *Fahrenheit 451*. Anyway, burning books is bad, right? Especially burning canonical books. Yet we're always getting rid of books. That's because our culture produces all sorts of replaceable items and books are part of this evanescent shelf. So why do we get mad if the Bible is burnt but not if the Bible is thrown away? As an experiment, a few years ago I decided to burn a bunch of extra copies of the Bible that had been sitting in my personal library for a long time. I could have donated them to a local library, which is something I always do with the surplus of books I have. But I wanted to burn them precisely because the act is supposedly forbidden. And do you know what happened? Nothing. That's right: nothing happened. Maybe because the Bible means much to me—it is a book I constantly reread, and about which I've written much, including the book *With All Thine Heart* (2010)—the act was ridiculous. Because the burning of books isn't what gets us angry. It's the hatred that prompts that burning. Hate is what burns books, not fire. I didn't hate the Bibles I burned. I simply burned them as if they were disposable trash.

Now I ask myself: how about pissing on the Bible? My answer is, sure. I don't see any problem with that act either, for the exact same reason I've just given to you. Pissing is a natural act. We do it all the time. It is considered immoral for some to pee on a sacred object. But not for me. Pissing isn't immoral and, thus, pissing on the Bible would be fine. And yet, I wonder: What if someone took a photograph of me in the act of peeing

on the Bible? My response would be so be it. Still, my act of peeing on the Bible would now be a public performance, meaning it would have larger implications than a simple anatomical act. I can see myself causing an uproar, needing to explain my action, and so on. Would that stop me? No, it would not. On the other hand, I would not pee on the Bible specifically so that my photograph would be taken while the act is performed. That, in my view, would be reprehensible. Why? Because I wouldn't be peeing on the Bible; instead, I would be performing in front of a camera. And if I'm performing, then I must be conscious of the acts I engage in because they carry larger implications.

I can empathize with Serrano for peeing on a crucifix if his sense was that the Church was so oppressive it needed to be criticized. His critique is valid, although it crosses the line of amorality. In turn, let me ask: Why is it controversial for Muslims to see representations of Mohammed in cartoons? The answer is that they feel their God is being desecrated. Are they right? Well, they are. But just as I can pee on the Bible and Serrano can pee on the crucifix, with the implications of both acts reaching far beyond us, Muslims need to recognize that a pluralistic world, one in which democracy is part of the equation, allows for dissent. And dissent often takes a nasty turn. This cannot be an excuse for violence. The only acceptable response is dialogue.

JG: You bring up another dimension of the topic that is also well illustrated by the Serrano. This is the destruction of objects—in your case, books, the Bible, in the case of Serrano's work, its destruction by a mob in Avignon, where it was being exhibited. By the way, the destruction of art works is not unusual. We have the case of the Taliban destroying old carvings and statues in Afghanistan in their zeal to adhere to an uncompromising form of Islam. And we have the case of the breaking of a work by Leon Ferrari in Buenos Aires by a mob of the faithful guided by a priest.

The law is quite clear in most of these cases. A lawsuit was brought by Ferrari in Argentinean courts and he won the case. The case of the Taliban was generally condemned by the international community. But I do not know what happened in the case of *Piss Christ*. In any case, the law punishes the destruction of private property belonging to others who are not the destroyer. We destroy all kinds of things we own, as you did with

the Bible, and I've done with photographs, personal memorabilia, papers I've written, and so on. And the law, of course, does not interfere. Legally, no one has the right to destroy the *Piss Christ* but Serrano. So those who did destroy it are guilty of an unlawful act. But the interesting question is the moral one, for the law is rather limited in its scope, and we frequently consider it right to break laws that prevent us from doing something we believe is right. The question is whether it is right for us to destroy objects that insult our beliefs and our persons when they do not belong to us. Do I have the right to destroy a caricature of me that some artist made, when I take it to be insulting and prejudicial? Perhaps, but only if it is proven that the caricature harms me in some way, and it was intended to harm me. What about religion? For Protestants and Jews, the depiction of God in some image is a sin. Idols are unacceptable, and following Moses's example, it would seem that they are entitled, morally, to destroy them, aren't they?

From this it follows that those who do will be rewarded in heaven for their courage in standing fast on their principles, even if they are punished by human laws for the destruction of property they do not own. Accordingly, the Taliban are to be praised, and so would be Protestants, if all of a sudden they went on a rampage destroying images and statues in Catholic churches. After all, aren't they behaving according to the mandates of God, as they see it? And should we punish them for acting according to their conscience?

If I follow you, you think that they ought to be punished for acting on their beliefs. And your suggestion is that they need to understand that living in a pluralistic and democratic society entails both abstaining from actions such as the ones mentioned as well as being punished for those actions when they commit them. But this reason will not sound good enough to those who are ardent believers. It certainly did not prevent the mob in Avignon from destroying the Serrano. Tolerance and democracy did not seem enough.

IS: They might not seem enough but that's the only thing we have: tolerance as a value that fosters coexistence. Yes, the destruction of art is a feature in human history. This is as it should be. The same Darwinian laws that govern the animal world govern the artistic world. What survives is the re-

sult of a number of factors. Had every single artistic piece ever produced endured through time, we would not be capable of appreciating what we have. Just as forgetting is an essential component of remembering, destruction is needed for creation.

In this regard, I want to invoke one of my favorite novels, one that along with *Don Quixote* is, in my view, the best Hispanic civilization has ever produced: *One Hundred Years of Solitude*, another contingent work that defines who we are. One of the leitmotifs in García Márquez's novel is the tension between *hacer* and *deshacer*. The characters, both male and female, create in order to destroy, and destroy in order to create. It's an eternal cycle, as old as Penelope's sowing in *The Odyssey*.

But I want to take exception with something you said: the only person who has the right to destroy *Piss Christ* is Andres Serrano, the artist who created the piece. I disagree with you wholeheartedly. Once a work of art is created, it no longer belongs to its creator. It is part of the human heritage. That is, it has no individual owner, only a collective owner. Yes, Jorge, while I believe in artists as owners of their oeuvre in economic terms (art is private property and the copyright is in the hands of the artist), I don't believe that artists, once their work is out and about, are any longer the owners of what they produced. They were the conduit—the secretaries, if you want to use that image. They allowed the work to materialize. But that materialization, once it is part of the public domain, leaves them out of it. Their name is only a reference: ah, Serrano, the artist who made *Piss Christ*! That's the way of seeing it, and not: ah, Serrano, the artist who owns *Piss Christ*!

JG: Now we are getting into areas in which the dialogue is becoming heated because we may disagree. So let me start where you started. You mentioned earlier that tolerance and democracy are sufficient for preventing the destruction that iconoclasts bring about, to which I responded with an argument to the effect that they do not, because tolerance and democracy are not convincing goals to those who engage in wanton destruction of art pieces that have messages with which they disagree or that they perceive to undermine their beliefs. To this you answered that "they might not seem enough but that's the only thing we have: tolerance as a value that fosters coexistence." I think that by actually saying this you have al-

ready gone beyond tolerance; that is, you are providing grounds for the desirability of tolerance. Tolerance becomes desirable because it is a value that fosters human existence. The reason for tolerance is not tolerance for its own sake, but because it is the key to something more basic, human existence. And this is where I wanted us to go, for human existence is certainly a value that should appeal to everyone. I say *should* because it does not actually appeal to some people, either because they are crazy or because they have been corrupted by indoctrination to such a degree that they have forgotten that existence is a prerequisite of any other good. Think of suicidal bombers, for example.

But I would like to refine the point you make by noting that the only way to convince iconoclasts is by making them see that what they do goes against their own interests. I do not think arguing with them that destruction is bad will do any good. But showing them how their destruction of what they hate can bring about the destruction of what they love, including their own lives, I think has a chance of being persuasive. And the point you make about Darwinism emphasizes it. The survival of the fittest is the law of nature and so it also rules humans and the artifacts we create. This is why showing that certain behavior is against our basic drive to live is the best way to convince us to change it.

So perhaps our disagreement did not turn out to be a disagreement after all. In fact, that also goes for the other disagreement that you mentioned, namely, that the artist is the owner of a piece of art and, therefore, the only one who has the right to destroy it. The reason I believe there is no disagreement is that you grant that "economically" the artist is the owner of the piece and therefore has the right to destroy it. After all, I followed my remarks by saying that the interesting point is the moral one, not the one ruled by law. By law, only the owner of something has the right to destroy it, be it art or something else, as long as the artist has not sold it, that is, passed on the right of possession to someone else. When artists sell their works, they lose the right to them. To repeat, though, the interesting question concerns the moral issue: Who has the moral right to destroy an art piece, regardless of who owns it?

You seem to suggest it is the "real" owner—what I would call the moral owner—of a work of art, to which you add that it is a collective, although you do not specify the collective in question. And you do not for a reason,

for humankind is both a collective and composed of many collectives. The overall collective is the human race. But this would not solve the problem of the right to the destruction of certain pieces of art insofar as the human race as a whole does not agree with the destruction of particular pieces of art, as the outcry against the Taliban showed. Then it must be particular collectives, but which? A nation, an ethnic group, males, females, members of a religious group, transsexuals, those who value the piece, those who understand it? What if the piece of art was created and has never been shown? Where is the collective then? Maybe only the author knows of the piece's existence. Another possibility favored by idealists, romantics, and some of the religious is that the real owner is a kind of divinity, but this is surely not acceptable. In short, I am afraid I have more questions than answers. As Socrates would say, I have reached a state of perplexity. He claimed this to be the beginning of wisdom, but at the moment I feel as if I knew only one thing, that I do not know.

IS: I, instead, do know. I'm thrilled that you've invoked—and done so eloquently—the concept of the moral owner of art. In my view, all of us might be morally connected and morally reflected in the work of art, yet none of us have the moral right to destroy it, no matter how offensive that art might be. The moral argument collapses when the legal question is put forth: only the artist has the right to destroy his work. Not even a collector who has bought it has that right. For even though the acquisition of the work has made it pass hands from the artist to the collector, the artist remains responsible for it. A collector of Serrano's *Piss Christ* might have bought it because she loves the piece. Or she might have bought it because she hates it and wants to keep it away from other people's eyes. At any rate, it would be false to suggest that because that collector owns it the ideas represented in the work are also hers. They are solely the artist's. So what happens when the artist dies? No one is entitled to destroy the work. It belongs to everybody. Its durability is sealed in the human consciousness.

THE DEATH GAME

FRANCISCO OLLER *El velorio*

Jorge Gracia: Plato said that philosophy is the study of death, and he was right to the extent that death is the end of our lives. We toy with immortality, but the only thing of which we are certain is the reality of death. Death is inevitable and informs our existence from the moment we are born. Death restores the symmetry to our lives: from nothing we return to nothing, after a brief intermission. Death is an intrinsic part of life, perhaps Martin Heidegger's most sagacious insight. Until we experience death, we are incomplete. A good man cannot be judged good until he is dead, and a bad life cannot be judged bad until it has ended. Before the end, no judgment is final, for matters could change, as Aristotle put it. Death brings closure to our open-ended existence.

Cultures the world over recognize the importance of death and surround its occurrence with rituals. These not only reveal the significance those cultures attach to death, but also uncover the inner springs of the cultures, their assumptions and presuppositions, fears and beliefs, and superstitions as well as the details of daily lives. If we want to learn something about ancient Egyptian culture, it is to the rituals for the dead that

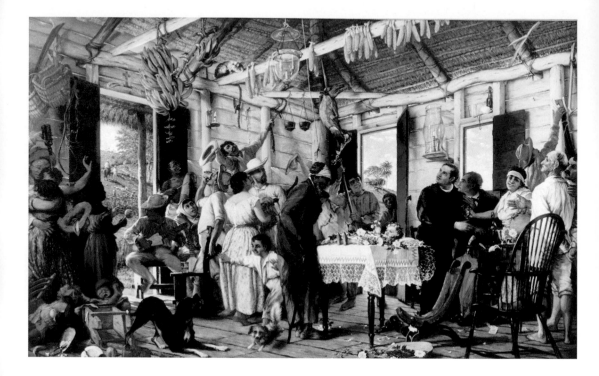

Francisco Oller, *El velorio* (1893), 96″ × 156.5″, oil on canvas. Collection Museum
of History, Anthropology and Art, University of Puerto Rico. Photograph by
Jesús E. Marrero. Used by permission of the University of Puerto Rico.

we turn. Everything is in the tombs, the frescoes, the artifacts, the historical records with which Egyptians buried their dead.

The title of Oller's famous painting, *El velorio*, means the "wake." The word derives from the verb *velar*, which signifies "to keep a vigil," and is related to *vela*, "candle," dating to the time when candles were used in vigils. The custom of the *velorio* goes deep into the past. It is a final farewell to the dead. It is also a period of waiting, to make sure the dead is dead, and of thinking about an imminent future without those who died. It marks a moment of enormous importance in the lives of both the dead and the living. It closes a life for the dead and marks the beginning of new lives for those who remain. It identifies a pause, a moment of remembrance and expectation. What is the significance of the dead, and what is the significance of the living? How is life going to proceed? Death is truly about the living, the living who died and the living that survive the dead; it is about a living past and a living future, about regrets and fears; it is about sorrow and happiness.

The way cultures handle death says much about the living, about who they are, and who they will be. It tells us about their places in society, about their deepest feelings. Oller's painting is a testament to Puerto Rican society at the time the painting was created because it presents us with a picture of the ritual for the dead. It is particularly revealing as a fine example of *costumbrismo*, a cultural movement in the nineteenth century that sought to use the depiction of the customs of society to explore human experience and nature.

The first impression we receive when we approach Oller's painting, if we disregard its title, is that it is a record of a party, a feast. In a rather poor farm house, people are celebrating an important event. Some are smiling; a couple are dancing on a corner; music is being played; a musician has stopped playing and is conspicuously drinking; a child is playing with dogs; and the focus of attention is a pig hanging from the ceiling, about to be consumed. If we are not careful, we may miss the centerpiece of the picture, a table covered with a white cloth, elaborately decorated with lace and embroidery, on which lies a small child whose body is covered with flowers except for the little feet and the head. The head rests on a pillow and the only person looking at him is an old, sick man, with dark skin, who leans on his walking stick and intensely peers at the child. The con-

trast is obvious, the frustrated life of a young, beautiful child, at the beginning of a promising life, and the old and ugly man at the end of his. But no one is paying attention to either. Everyone is focused on the pig and the antics of those who are handling it, except for the musicians, the dancing couple, and the child playing with a dog.

On the right, next to a priest, we see a woman smiling, perhaps sadly, perhaps embarrassedly, looking at us. She must be the mother because she is next to a priest. Some men surround her, but they are not smiling or laughing; they are intently observing the action. At the fringes we see some blacks. A woman outside the house looks in through the door located at the entrance depicted in the picture, with curiosity. Next to the guitarist, a black woman plays the maracas and a black man plays another instrument.

The scene recorded by Oller is known as a *florón*. It is a feast that celebrates the death of a white child. There was also a celebration for the death of a black child, but it was known as *baquiné*. A baptized child who dies before the age of seven is free of sin, and therefore goes directly to heaven. Baptism makes a child a member of the Christian community and prevents him from going to limbo, the place where unbaptized children go after death. The florón celebrates this passage to heaven. One of the questions that most profoundly strikes us when we look at this scene is the shocking contrast between the tragedy of the dead child and the celebration of his death. What does this tell us about the society and about human nature? What does it tell us about the meaning of death and how societies regard it? Is death something to be celebrated, and under what conditions? Or is death something to be grieved? And what role does religion play in this?

Ilan Stavans: Death is the only theme that truly concerns humans, the theme of themes: the end of things, the interruption of who we are. It is in everything we do: in what we do, in what we eat, in our words and dreams. But it doesn't become a tangible concept until adolescence, when the young realize—hesitantly, incipiently—that nothing is forever, that their place in life is finite. Before that, everything is bliss. The recognition that we were thrown into life without our own volition is less consequential than the fact that at some point we will end and that that end, unless we our-

selves perform it, is not in our control. It is the product of randomness or perhaps of a higher being whose narrative we're part of. Suicide is the most emphatic pronunciation of the self an individual might engage in. Ironically, it is also the conclusion of that volition, its radical negation.

Yes, Oller's *El velorio* is emblematic because it showcases the way different cultures approach death. The dead child on the table is somewhat of a puzzle in the painting. Except for the black man holding the cane, who is closest to us as viewers, and perhaps the black viewer on the window looking inside the room, no one else present seems to focus on the reason why they're all in this fiesta: a gathering around the child's departure. What characterizes that departure, as you rightly said it, is the joy almost everyone involved is manifesting. Food, music, smiles. The collective goodbye isn't tears but merriment.

Is this in sharp contrast with the way we engage death—the death of others—in our society? Certainly it is different in the United States, where a wake is often defined by sorrow. People see death in this culture as the end of life. But Oller, a prominent nineteenth-century Puerto Rican artist whose role in the development of impressionism in the region is important, suggests otherwise. Death is presented as an opportunity for the living to enjoy themselves. It reminds me of the festivities of Día de los Muertos in my native Mexico, where the dead never truly leave. As you know, once a year, on November 22, people spend the day in cemeteries having a picnic and sleeping near the tomb of their beloved ones who died.

JG: The ambivalence with which humans regard death is more common than we would like to think. I am frequently surprised by the inconsistency of religious beliefs about death. Take, for example, the attitude of Christians who profess to believe that we live in a valley of tears and that there is an afterlife in which we are rewarded for our deeds (Catholics) or for our commitment (Protestants). From this it seems to follow that we should long for death. And much of the Christian literature expresses such longing. The mystics tell us that every day they are separate from their ultimate end and reunion with God, they are in pain. It is only in the mystical vision, as John of the Cross or Teresa of Avila describe it, that we can find a glimpse of the happiness that we will enjoy in the afterlife. Thomas Aqui-

nas, the greatest of all scholastics, tells us that all he did, his many brilliant philosophical and theological writings, are nothing if compared with that mystical revelation glimpsed in a mystical insight at the end of his earthly life. If we are to accept these accounts, we should have little hesitation about the goodness of death. In fact, one wonders why we should not all be committing suicide, were it not for the religious prohibition against it!

But who among us longs for death? And do we really celebrate death, even when we appear to be celebrating it, as in Oller's painting? Nominally, yes. The feast of the saints is not on the days of their births, but the days of their deaths. Do we really rejoice in death? We only rejoice in the death of those whom we hate or who stand in the way of what we want, not in the prospect of our own deaths or in the deaths of those whom we love. The paradox is obvious, for according to our beliefs we should be doing just the reverse.

Augustine put well our attitude toward death when he said that we love life dearly, and the life he was talking about was life on earth, not the afterlife. So, then, are religious believers hypocrites? To answer yes sounds too easy. The expression of the mother in Oller's painting tells the story. She is the hostess of this party to celebrate the death of her child. And she is doing what she can to appear merry, but her mirth is cracked. It is forced, and Oller has effectively captured it. She is bound by her culture and her people to put on a good face and a good show. She is going to wail and mourn her child, but not at this point. Publicly she must go along with what is expected. But the social expectation of happiness on the devastated mother strikes me as doing enormous violence to her and to all those who loved the child. This brings me to another suggestion, namely, that the painting echoes this sentiment. One way to think of the Oller is as a satire on the custom it portrays, rather than on the recording of it. Is the painting a criticism of a brutal custom that goes against our very nature?

IS: In both Mexican and Jewish cultures, the dead are also connected with food. The Día de los Muertos, on November 2, is a Mexican festival in which cemeteries are visited by those who want to commune with their beloved who have departed. The holiday is astonishing. Images in popular culture hardly ever do justice to its multifarious qualities. Families pack

sophisticated baskets of food and spend twenty-four hours sitting near a tombstone, eating and drinking. To eat and drink next to the deceased is considered a tribute to them. The statement is clear: the dead are not gone; they are still with us. And what do we do to engage them? We eat and drink. That is, we engage in the most earthly, most human of activities. We prove to them that we're alive. But that feeling of being alive requires their presence. By eating and drinking, we bring them back. We announce that this world and the next aren't separated. They are united. It is we who unite them.

In Jewish culture, the seven day *shiva*, or wake, also rotates around food. The home of the family of the deceased is visited by relatives and acquaintances that bring all sorts of dishes. They sit on the floor, on pillows, with all the mirrors in the house covered. While sitting, they eat and talk. The ritual is supposed to help the family cope with the loss. For an entire week, in prayer, the people most immediately connected with the dead person are distracted from the routine of being alive. That distraction includes food because food is a way to emphasize life, to reject death.

JG: Food is one of the basic necessities of life, and also one of its pleasures, better than any other pleasure, according to some. After all, the name of Epicurus has become associated with the pleasures of the table. Food is also closely tied to celebrations, camaraderie, familial events, religion, and death, as you mention. The pain of death is ameliorated by food, by the eating together that unites a community. Food reminds us of the best of life, comforting us, and reminding us of previous occasions where we have shared food with those who have died. In *El velorio*, a pig hangs from what looks like a rafter as several in the gathering look at it longingly.

IS: I want to draw your attention to the facial expressions in *El velorio*. This might be an expression of the time in which Oller lived (1883–1917), but everyone, with the exception of the woman in white on the right, seems to be expressionless. It doesn't look as if people are either sad or upset. They simply look like mannequins.

JG: This is perhaps a way in which the artist ironically criticizes the custom of celebrating the death of a young child. The participants, except for

the mother, are wearing masks that cover their real feelings. Only the mother reveals the anguish of her feelings, although under a grimace of merriment.

IS: And why is only the mother capable of expressing her emotions? There is nothing worse in life than the loss of a child. A parent, especially a mother, from whose womb the child came, experiences that loss in an immediate, unbearable fashion. But Oller is making a comment about the game, maybe even the carnival that a wake becomes. Expressing emotion for the deceased isn't easy. I for one am never sure what to say to someone who has just experienced a death in the family. I express my condolences, of course. Yet I know that words are insufficient, that something else is needed. And, thus, I feel like a fake.

JG: I see at least two games at play here. One is the game of death itself. Death is a game, the game of who dies and who lives. It is a matter of chance, and the element of chance is an essential component of games, although perhaps this statement is too strong, since there are games that appear not to involve chance. As Wittgenstein would say, games have nothing in common, they are related only in terms of family resemblance. Some may involve chance, but others do not. Still, a good number of games involve chance. This is true of cards. And even some games that do not ostensibly involve chance, like chess, involve it in an indirect way, for the players have different capacities even if they have been given the same set of pieces. They got these by chance, from birth. Who dies and who lives is a matter of chance, of where we are at a certain time, of the context and the circumstances.

The other game is social; it is the game we play after death has occurred. This game is quite evident in Oller's painting. The players are performing various roles, and they do them more or less convincingly. Even the dead child has a role to play. He has been dressed for the occasion. The horrible countenance of death has been erased from his face and he is presented in his best appearance. And the group tries its best to look as if they are having a good time, enjoying the occasion, for the boy is supposed to be in a happier place. But do any of them know this? Do any of them believe it? If they were honest with themselves, they would have to

say no. The only one that cannot fake the reality of what has happened is the mother. The rest can fake it.

IS: But art does precisely that: it makes us conscious, and even self-conscious, of the roles we play at various stages in life. I like your view, inspired by Wittgenstein, of death as a game. But death isn't a game, not in the least. I want to argue to the contrary: everything in us, for us, about us is a game *except* for death. For death is the end of everything, including, and especially, the possibility of games. Chance might define our fate. It might also define the moment we die and how we die. But after that, chance plays no role whatsoever. Death is an eternal silence. It is also the whole of nothingness. So, as long as we are alive, we perform. And we perform that we perform. The cast of characters in Oller's painting might be having a good time but regret doing so. Or they might not be having a good time and wished they did. But the depiction of the gathering makes us think about the degree of consciousness they have, and that is enough, don't you think? That is, art is not—or not *only*—about what we see but about what we feel. As far as I'm concerned, whenever a person close to me dies, and the experience is always heart-rending, my first reaction is, how am I going to continue with my own life? Is there meaning in my existence when this person I loved so much is no longer part of it? Yet soon after dwelling with these emotions, I come to the opposite conclusion: precisely because I'm still alive, it is my responsibility to be happy, to live life to its fullest.

JG: I still think there is a significant way death is part of the game of life. Let me explain. In most games the end is always present, controlling the game and its moves. When I lived in Miami for a few months shortly after I came from Cuba, I earned some money by playing cards. The U.S. government gave me a stipend of $75 a month, which I used to cover my basic expenses. I paid the landlady of a rooming house $65 a month for bed, breakfast, and one meal a day. That left me with $10 for everything else— food for the third meal of the day, transportation, clothing, telephone, and entertainment—which was quite insufficient. For the first time in my life I was hungry. And there were no jobs. With so many Cubans arriving every day in Miami, what could a nineteen-year-old without skills

do to earn a bit of money? I tried everything possible, including selling ice cream. I remember that the day I tried I sold one ice cream—to myself! That was the end of that adventure. But fortunately I had always been good at cards and so I played for money. Not big money, for I had no money to speak of. But for little money, twenty-five cents here and fifty there, so that at the end of every day I had sufficient money for a meal in a diner or at MacDonald's. Sometimes I was lucky and could splurge on a regular meal, and at other times I had to be content with a hamburger. And there were times, although rarely, in which I broke even, or even lost some money, and I had to go hungry. The end of the games I played every night was money for food.

Of course, there are countless other ends to games: pleasure, power, satisfaction. And in the game of life, the end is death. My father always used to say that gamblers appear to want to win, but ultimately what they want is to lose everything, so they can stop. The case of death may be similar. Our play is to fool death, but we know that it is there, and it will win in the end, at which time everything will stop. This is why I think death is part of life, although, as you point out, it is also the end of it. And I know well how the death of others affects those who remain, for there was a period in my life, seven years to be exact, in which seven members of my family died. It was a terrible time, sad, and devastating. Yet, I survived those years because the living want to live, and as Augustine said, life is sweet in spite of what we think is its bitterness. But those seven deaths still hang over me. I cannot forget them ever, as I cannot stop thinking about my own end.

IS: Death is always on the way. I think of it at all times. And I think of life as a game, one in which I pretend to know the rules but I actually don't. My obsession with words is a response to that game. I write in order to prove to myself that I'm not dead, that I'm still here, that every minute I have is mine and that I need to use it in the best possible way in order for the game not to be finished.

JG: Many of the things we do for the dead, the rituals surrounding burials, the disposition of the bodies, the many monuments we erect, are all part of this desire to overcome death, and to keep the dead living. Think about

the art and literature that are concerned with death and the afterlife, the monuments we erect to the dead, the mausoleums, the poems we write about them, and the meditations of philosophers on the meaning of death. As I said at the beginning, it was Plato, through Socrates's voice in the dialogues, who claimed that philosophy is the study of death. We are obsessed with death because, as you suggest, we want to make sure we are still alive and that those who have died and we loved are also alive somewhere.

I encountered one of the most curious customs about the preservation of the memory of the dead in Mexico years ago. I was traveling with my wife, visiting the wonderful colonial cities in Mexico, and when we arrived in Guanajuato there was a very special art exhibition. It was a particular genre that had become popular in Mexico in the nineteenth century. It consisted in paintings of dead children. After a child died, the family would ask an artist to paint the child. You can imagine the pathos and morbidity of the scenes. Children of all ages, painted in their best finery, prepared for burial, their little faces depicted in minute detail, with various expressions of peace, immobile, in subdued colors very different from the ones to which we are used in the Mexican folk arts common during the day of the dead.

And I wondered, where would the families hang these pictures, these reminders of a life gone, but whose presence was still with them? The custom was not very different from the European way of immortalizing the dead through the creation of death masks. Death masks are done only of famous people, but a painting of a child is not of anyone famous. It is a reminder of a life cut short at its beginning. Perhaps it echoes the famous line from John Donne, "Death be no proud," intimating that in the end death will after all be defeated. And in the meantime, those who loved the child will have a memento of that life.

The Mexican custom connects with Oller's painting, although in Oller the depiction of the feast suggests a different approach.

IS: Immortalizing death in a painting. Have you ever seen the pictorial artifacts called *ex-votos* that are an essential component of Mexican folklore? Through them, believers ask the Virgin of Guadalupe to protect them against a bad omen or to look for them in times of trouble. They are made

of a simple painting depicting the aspect the believer makes reference to and at the bottom they include a written statement. I love ex-votos because they are a prelude to comic strips and graphic novels: the juxtaposition of art and literature. And I love them with special devotion because they are by and from the people. Anyway, death is a permanent fixture in them. But what distinguishes them isn't the type of anxiety toward death present in Western civilization: death as the end. Instead, although the believers seek health and well-being for themselves and those they love, death isn't the end for them. It's a continuation. I thought of that when I heard your reference to John Donne's line. Death, in these artifacts, isn't defeated. Instead, it is appreciated for what it is: the next chapter. Oller's *El velorio* seems to me to feature that same sensibility: endurance in life and the recognition that death is another beginning.

JG: Yes, I know these ex-votos well, having been raised in the Roman Catholic tradition. This is based on a custom well entrenched in Europe and Latin America. The ex-votos (short for *ex voto suscepto*, "from the vow made"), or just *voto* (vow) for short, is either a pledge in exchange for a favor asked, or a token of thanks for a favor received. In some cases they consist in some artifact, such as a crutch (or a small copy of it) from a cripple who was healed and now is able to walk, for example. In other cases they are paintings or drawings of, for example, a ship that someone asking for the favor wishes to have returned safely from a trip. Votos take many forms, but Mexicans have made a popular art of them in the form of the small paintings and drawings you mention. They are not necessarily related to death, but you are right in pointing out that those concerned with death look upon it as a stage in a process, not as an end. In this sense, they are concordant with the Christian tradition that death is simply a moment in life, marking the passage from this life to the afterlife. Death is not an end, but a kind of transitional stage through which we go. Those who deserve it, go to heaven, and those that do not, go to hell. A few, of course, go to limbo, which in Catholicism is the place for all those who died before Christ sacrificed himself for humankind, and for children who die before they are baptized after he did.

In principle, then, no one who is a Christian should be sad for death, and in fact as I said earlier, the Catholic church celebrates as the feast days

of saints the days when they died, not the days when they were born. On the day of their death they meet their maker, and as saints, namely, people who are in heaven, the anniversary of their death is cause for celebration. But the truth is that no one is happy when someone he loves dies. This is the dilemma that the faithful face. On the one hand, their beliefs tell them that they should be celebrating the occasion, but on the other they do not feel like celebrating at all.

This dilemma is one of the things that Oller has captured so well in the painting. His depiction is particularly dramatic because the dead is a small child and the mother, who surely is the one who feels most strongly for the child, is present at the wake. This makes her the center of the painting. The child is the face of death, perhaps at peace because he is going to heaven. The others in the wake do not have to deal with the dilemma, for their love for the child was perhaps not strong enough. Some look as if they are having a good time. What do the neighbors care, really? They came for the food, the drink, and the music, and they can without difficulty pay lip service to the Christian doctrine. Some may feel some sadness for the mother and the child, but all this is probably objectively looked at and therefore lacks passion and pain. But the mother! Well, she is the one who suffers, and there is no way for her to seem otherwise.

The topic of Oller's painting, then, may not after all be death, or the customs that surround it in Puerto Rico. It may be the more universal issue concerned with the contradiction between what we believe and how we feel, between reason and feeling. The contest between the two Platonic horses that pull in opposite directions, one symbolizing reason (or in this case faith) and the other symbolizing the passions. The mother's face, with its grim smile, is a portrait of something terrible.

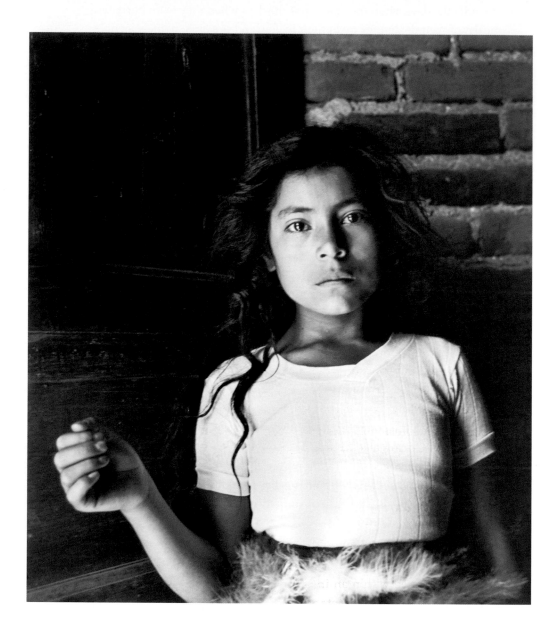

Mariana Yampolsky, *Elva* (1962) 10″ × 10″, photograph,
gelatin silver print. D.R. © Fundación Cultural Mariana
Yampolsky, A.C., Mexico. Used by permission.

A GIRL'S INNOCENCE

MARIANA YAMPOLSKY *Elva*

Ilan Stavans: For decades I have been an ardent reader of explorations of photography in society. I admire the essays by John Berger on the topic, the meditations by Susan Sontag, Janet Malcolm, Nancy Newhall, Walter Benjamin, and Roland Barthes. Photography takes a bet at verisimilitude. It claims to replicate—even to clone—the universe. But the replica is always limited, superficial, one-dimensional. That is, no matter how authentic the image on the photograph is, it is never the world itself. Still, photographs have had an enormous impact on our consciousness. There would be no modernity without the invention of the camera: by making us self-aware of our behavior, it reduces the role of spontaneity and maybe of authenticity. These days everything is a reflection. We are born to be framed within an image, to pose in front of a camera. Our lives are lived as a series of interrelated shorts. The past is remembered through photographs. iPhones, iPads, and other devices make snapshots of the present, which are quickly Photoshopped to make us look better. That corrective act—improving a fleeting image—turns us all into curators. And the future is imagined as a visual narrative: what we're likely

to look like, what the environment around us might become in terms of color, texture, etc.

By the way, not long ago I read about a study that shows that people have an easier time recognizing how they have changed and acknowledging that in the future they are likely to change as well. That is, they can reconcile who they were with the person they appear to be in a photograph, although they often dislike the image of themselves they see in photographs. But they think of their present self as the apex of their journey and have difficulty seeing that that present self will at some point become a thing of the past.

Jorge Gracia: No question, a photograph is, much like a painting, not the object that it represents. It is a representation, an artifact. A sunset is one thing, a painting or a picture of the sunset is another. They share certain characteristics: the color in the sunset might be predominantly red or orange, and so might it also be in the painting or the photograph. But some characteristics are not shared: the sunset is tridimensional and the painting and photographs are two dimensional. These are what might be called ontological or metaphysical properties, that is, properties of the objects themselves. But paintings, photographs, and sunsets also have epistemic properties, that is, properties that result from the way we see them. Indeed, I might see both the red of the sunset, the red of the painting, and the red of the photograph as the same red, but in fact someone more discerning than I might see them as different. Or there may be differences resulting from the context and perspective. These epistemic properties are the result of the viewers, they are mediated by humans.

One major difference between a sunset on the one hand and a painting or a photograph on the other is that the sunset is not the result of human activity or design. It is what it is, independent of who looks at it or whether anyone looks at it. But both paintings and photographs are the result of human action and design. There is some human being who planned and created the painting or took the photograph, whereas there is no human being who planned the sunset and made it. And there is more, for although a painted sunset and a photograph of the sunset share the fact that they have a human creator, they are very different because of their media. We do not have as much control over a photograph as over a paint-

ing. This is why we tend to think that photographs are more faithful, more true, to the objects they represent than a painting. The artist manipulates everything in a painting, but a photograph relies on a technology that is less controlled by the photographer. This is one reason why for a long time photography was not quite considered to be an art. But eventually the idea dawned on people that the photographer is as much an artist as the painter. Photographers not only select their subjects and frame them, but also modify them in many ways. As you suggest, Ilan, the question of verisimilitude pertains as much to a work of photography as to a work of painting. So, what do you think is the truth that *Elva* reveals?

IS: Yampolsky's photograph *Elva*, shot in Huejotzingo, Puebla, in Mexico, in 1962, is an astonishing portrait of feminine innocence. I mean innocence frozen in time, which is perhaps the only type of innocence there is.

JG: This is what you see in the photograph, what it tells you. But what does it reveal to me? What is it that I see when I look at the picture? This seems an essential question, and prima facie it appears to be what I called "epistemic" above. I am not asking about the photograph as it is in itself, as philosophers used to say, but as one might say, about how the photograph affects me. Indeed, when I look at the photograph I impose conditions on it. And yet, the photograph itself also imposes conditions on me. These conditions are not completely independent of each other. Both function as filters so that everything goes through them in order for me to think anything about the photograph, which reminds me of Kant and his notorious categories, a priori structures that shape our experiences, allowing us to be aware of only what they allow to get through, as it were. They are like a pair of blue colored glasses through which I see the world, thus affecting everything I see in a particular way. Red becomes purple, and yellow becomes green in my experience.

Obviously the picture is something out there. One has to be a complete nut to think that the photograph is something that I have in my mind. This reminds me of G. E. Moore's famous proof of realism. While looking at his hands, he says, "Here is one hand and here is another." The world just does not function in this way, for you also see the photograph and we talk about it and we have common understandings of it. But I see through

my eyes and I think through my mind. My eyes might be better or worse than yours. I might be color blind and see everything in a poorer range of colors than you do. In fact I see the picture of Elva in black, white, and grays, but is it so? Maybe it is colored! What I see is a result of a confluence of two different sources, each of which imposes conditions on the ultimate result. Cats and flies see things differently than we do.

For you, this photo is "an astonishing portrait of feminine innocence." But I see it differently. I look at it and I am reminded of another picture I saw years ago on the cover of a magazine. It was a picture of a girl from Colombia, trapped in a mud slide. Her legs were stuck in the mud and rescuers were trying to get her out. They tried feverishly to do it for hours, racing against the clock, but eventually the girl died of a heart attack before they could pull her out. The picture was taken while the rescue was taking place and it was clear that her chances of survival were slim. She looked hopeful, but vulnerable, waiting patiently for destiny. She was not crying, or sad, or fearful. She was just there, accepting her fate, whatever it was to be. Her image has stayed with me over the years, like a soreness in my chest, and now that I see *Elva*, the first thing I think about is the image of the girl from Colombia. The memory of the earlier photograph and the events that surrounded them steer my understanding in ways that are different from yours. Yet, we are looking at the same photography, and we can agree that it is a picture of a girl, perhaps even that it is in black and white, that it was taken by Yampolsky, and so on.

The simplicity of the title of the work suggests that your take might be in harmony with the intention of the artist to present us with a classic rendition of feminine innocence. But I cannot help but think of it in a different way, a way that prompts me to pity and sadness. Here is a girl, innocent, yes, but more significantly alone, helpless, caught in a world she does not quite understand, at the mercy of forces that are beyond her power. Her surroundings indicate poverty, a trap different from the one of the Colombian girl, but not any less tragic. She is at the verge of puberty, of becoming a woman, and yet, is she prepared for the world in which she will live? Another trap. The intensity of the gaze opens a window to her thoughts. She has been caught off guard.

Are you right or am I right? Well, does it make sense to ask this question? Perhaps the interesting question is not about which understanding

is right, but about how we reached our understandings. If so, perhaps we can talk about the role of the author, the title, the image, the context, and the audience in interpretation.

IS: I want to take you up on that. Much more than in painting, in photography the artist forces on the world a certain view that, regardless of the outcome, does violence to reality itself. I say this in response to your question of who is right in his interpretation, you or I. It doesn't really matter, not to me at least. What matters is that Yampolsky, by pressing the camera button, appropriates what she sees. She tells us that the girl is called Elva. But is she? Not only does she picture her in a particular way: young, naive, innocent, whatever other adjectives one might want to add to this list, but she also names her. That is, she takes control of language to define what the eyes see. And whoever is in control of language (visual language, verbal language) is in control of meaning. Elva is no longer one more girl, she's now Elva. And she's not only Elva, she's Yampolsky's Elva. Another photographer, another female photographer, would have captured the girl differently: a different pose, with different clothes, in a different moment. By means of her photograph, Yampolsky has become an interpreter.

One could say that painting does the same, certainly realistic painting: by depicting reality, it individualizes it. For no depiction of reality can be objective. The eye that looks is also the eye that interprets. But in photography that imposition is more tyrannical because the canvas with which the artist works is the world itself: everything that surrounds us. By presenting an image in a photograph, that image is suddenly frozen. It no longer belongs to the natural current of things. It has now been abstracted, taken out of context, personalized. The camera's eye is thus a godlike instrument: it creates. And it also re-creates. It makes a double of a preexisting item, adding elements to it by stopping the current of time, abstracting the object from its time and place.

My fascination with photography only increases as time goes by. I use to like going to photography exhibits. I also have a large collection of photography books. What interests me, though, is the metaphysics of photography: what photography does to us viewers, to the objects it depicts, and to the photographer. In *Elva*, might one say that Yampolsky takes a paternalistic approach to the girl? I'm inclined to say yes. The reason might

have little to do with the photograph itself. I know that Mariana Yampol-sky's name is that of the daughter of Jewish immigrants to Mexico. I've seen a photograph of the photographer and know that she's white. She was also older than the girl Elva when this photograph was taken. All of this to me means that there's a racial—or, better, ethnic—difference, as well as an age and class difference, between the photographer and the person photographed, and those differences are crucial to our understanding of what we see. For instance, how likely would it have been that Elva would have the camera in hand and Yampolsky would have been the object being photographed? In 1962, when the image was taken, this was unlikely.

JG: One great difference between a painting and a photograph is that a photo-graph is more deceptive than a painting in this sense: the photograph gives the impression of being faithful to what is out there, to the world as it is. It appears to freeze a part of the world as it is presented to us in a moment. A photograph is taken as a faithful representation, an image, a copy of the world, but not even hyperrealists understand it to be a depiction of reality as it is. This contrasts with a painting because a painting is an artifact put together from scratch by a painter. Painters begin with a canvas, let's say, then draw on them, and then apply colors. A photograph is quite different. One gets the impression that the photographer takes a picture by merely pushing a button while the machine does the rest. It is like putting a mir-ror to something that gets reflected on it. But is this impression right? Is a photograph less of an artifact than a painting? Obviously the photogra-pher meddles less with his or her medium than the painter. At least that was the case before Photoshop and recent developments in photography. But even at that time did this make the photograph less of an artifact, of a creation, than a painting? I do not think so. I said that photography is de-ceptive because it presents itself as more realistic—I might even say "more natural"—than a painting. Yet it is as artificial as a painting, although its artificiality is different from that of a painting. Both the painter and the photographer are restricted by the media they use. The painter by the size of the canvas, the colors available to her, the skill she has mastered, and so on. The photographer by the frame of the camera, the film used, the per-spective from which the photograph is taken, and so on.

At its beginning, photography was thought to be an inferior art, or per-

haps not art at all, as I suggested earlier, precisely because of this deceptive character, that it represented itself as less of a creation, requiring less of the artist. But in time the recognition of what it requires has been realized. And those who, like yourself, are taken by photography, find it perhaps more interesting than other art forms. Why? Perhaps because, like nonfree verse, photography is subjected to more stringent conditions that other art forms, so that the photographer has to create within narrower parameters.

IS: But those narrow parameters are never as narrow as they seem. Yes, photography is a mimetic art. However, reality is complex and incomprehensible, so any attempt to copy it in superficial ways is a trap. Photography, in truth, is about the art of seeing. It is the capacity to freeze the convergence of time and space. It is the stamp a photographer is able to make on the ephemeral world.

JG: Here is where the strategy of appropriation comes in. You referred to appropriation earlier in passing, and I have discussed it in the context of the artistic interpretation of literature in my book *Painting Borges* (2012). Interpreting is a kind of understanding, and one of the things one does when one understands is to appropriate the object of understanding. But what is there to appropriate? The word has to do with property, that is, with making something part of one's belongings. To make it one's own. In order to do this we focus on those aspects of the object that appeal to us, or to which we can easily relate. This is what Yampolsky did with the subject of the photograph and what you and I have done with the photograph.

IS: The German writer W. S. Sebald, in novels—or perhaps I should called them collections of interrelated narratives—such as *The Emigrants* (1992), used to include apparently inane black-and-white photographs in his novels. Those photographs seldom have anything to do with the narrative. Yet by inserting them there—and most of them are depictions of solitude—the narrative opens up doors that lead to alternative universes.

JG: This is what happens when we appropriate something. We make it part of a world of which it was not a part, our world, a world of experiences,

thoughts, and objects foreign to it. We change it in a way that, as Sebald did, can involve adding to it things that already belong to us and that, by relating them to the object, make the object part of a reality of which it was not a part. I did this by bringing into my reading of the photograph another photograph of another girl that I remember vividly. This addition in turn altered the way I looked and understood Yampolsky's *Elva* in ways that you could not have imagined, because that other photograph was not part of your experiences, did not belong to you. The process involved is like that of creating a new *Gestalt* which opens many different and new understandings. You think of the girl as innocent, but for me the thought that occurs refers more to her situation than her character.

A question that comes up in this context involves the legitimacy of appropriating works of painters, writers, and philosophers. Is it legitimate to go beyond the parameters used by the authors and engage in a process that modifies what the author intended? Is it legitimate for us to understand this photograph in ways that are different from the way Yampolsky understood, or intended for us to understand, it? Making it our property seems to be taking it away from Yampolsky, who as author is supposed to own it.

This is a very controversial topic of discussion in hermeneutics today, as you know. For some, authors have proprietary rights over their works, and interpreters must respect them, otherwise their interpretations fail the test of legitimacy. Such interpreters become thieves, stealing the goods from their rightful owners. But others think that this charge makes no sense, and interpreters are free to understand the objects of their interpretations, that is, the *interpretanda*, as I like to call them, in any way they want. Where do you fall in this great divide?

IS: Unfortunately, I believe any interpretation within the realm of the plausible is acceptable. I say *unfortunately* because I'm well aware of the excesses hermeneutics are prone to; that's why I believe there are limits to the act of interpretation. If I look at Michelangelo's statue of the handsome king David, I can't suggest that he's about to be kidnapped by extraterrestrials who only like naked young men. The work of art doesn't allow for any of this nonsense. The interpretation needs to be organic to the work. It must consider the historical, social, economic, and cultural fac-

tors that shaped that work. In the age of the Internet, there are perhaps more outrageous interpretations of works of art and literature than there have been in the past. Although, I confess, this might be a mirage. Wacko views have always been a fixture of human interaction. The Internet does air them today in a prominent fashion. Plus, we live in the age of democracy and pluralism. Both terms are embattled. That is, they are under siege. Yet they define modernity more than any period in history. The marketplace of ideas, their test in a back-and-forth debate, keeps society healthy. When that marketplace is attacked, when a single viewpoint is made to prevail, the way of life we consider healthy comes to an end. But expressing one's ideas doesn't mean they are grounded on factual information. And that grounding is essential for the ideas to be taken seriously, for them to have they value they deserve. Interpretation is the assessment based on that grounding. Every person has the right to offer his views on a work of art. But an art connoisseur, an art critic, makes a career of those assessments and knows how to place the interpretation in context. Again, only an organic interpretation is worth the scrutiny.

JG: That sounds like a very tall order, Ilan. Who does, or even can, consider all those facts? Most interpretations are understandings here and now. And what did we do when we looked at Yampolsky's *Elva*? From your interpretation it looks like you focused on the image and the title, whereas I focused on the image and my memories. Neither of us considered the many factors you mentioned. Does that mean that our interpretations are illegitimate? Perhaps yours is more faithful than mine to what Yampolsky intended with it. But that is questionable insofar as you, like me, have only the image and the title to go by. Unless, of course, you had access to Yampolsky and talked with her about this image, which I don't think you did from what you said earlier. But there is something more basic that your last remarks suggest: the tension between a free-for-all view of the validity of interpretations and one that is tightly reined in.

IS: You mentioned having access to Yampolsky. It wouldn't be possible because she died in 2002. But I am in touch with Arjen van der Sluis, in charge of her estate. He told me Elva's full name: Elva Ávila Pastrana. She was born in Huejotzingo, Mexico, the youngest in a large Mestizo-

Indian family. He father was an elementary schoolteacher, her mother a merchant at a local food market. Huejotzingo has a carnival tradition that features a popular reenactment of the famous Battle of Puebla, of May 5, 1862, in which the French occupation army was defeated by Mexican troops. Through her photography, Yampolsky was interested in documenting this traditional fiesta and for several years visited Huejotzingo at carnival time. She knew Elva's parents through Eliuth, or Eli, a sister who was ten or fifteen years older than Elva. At that time, this sister had started to work as a full-time servant with Yampolsky's mother, Hedwig Yampolsky, then running a *pensión*, an inn in Mexico City, for visiting foreigners as well as Mexicans. After finishing elementary school in her hometown, Elva went to Mexico City to continue her secondary schooling. She then enrolled at the Universidad Nacional Autónoma de México, known by the acronym UNAM, where she studied medicine. According to van der Sluis, all this time Elva was receiving orientation and financial support both from Yampolsky's mother and from Yampolsky herself, and probably also from her siblings. Yampolsky and van der Sluis once visited Elva in Jamiltepec, a small town in the state of Oaxaca, where she had been assigned as a young MD in the local state hospital. After having practiced for several years there, she went to Mexico City again, where she specialized in anaesthesia and worked there for various state hospitals until her retirement. During the nineties, the two sisters, Eliuth and Elva Ávila, built small brick houses in the same compound and next to each other. Each lived with her respective family, Elva with her daughter Xóchitl and some of her grandchildren. Soon after her retirement, Elva contracted bone cancer. She suffered tremendously in her last months of life. She died at home at the end of 2004 and was buried in Huejotzingo. According to van der Sluis, Elva was a kind-hearted person who suffered through life, first with her husband Xavier, then with her daughter Xóchitl. She became deeply religious and successively joined various Protestant and mystical groups.

Does all this matter to us? Perhaps only tangentially, helping to humanize the person in the photograph. But average viewers don't have access to this information, so the process of humanization takes place in other ways. More significant to our conversation is the fact that Yampolsky was an American born in 1925 who went to Mexico to study and never left.

In 1958 she became a Mexican citizen. Does her Americanness raise the question of whether she should be part of our gallery of Latino art? Not in my view. Look at both of us, Jorge. One born in Cuba, the other in Mexico. The two of us are Americans now. I became a citizen in 1994. Am I Mexican or American? The question is needless: I'm both. I was a Mexican by accident (I've written about this in my memoir *On Borrowed Words*, as well as in *Lengua fresca*) and an American by choice. Likewise with Yampolsky. The fact that you and I are communicating in English now (when we write e-mails to each other, sometimes we do it in Spanish) is proof of our journey. Does English falsify what we say? Not really. Or maybe only partially. Reading a book in translation might not be the same as accessing it in the original. Yet the book is read and the experience is had.

Anyway, about access. Yampolsky is dead. But even if she were alive, I'm of the opinion that the artist has no more control over the work of art than the viewer. Let me put it in a slightly different way. The artist controls the work of art as it is being created. Insofar as there's artistic freedom (I'm not thinking now of art produced under compulsive circumstances), it is his and his alone. However, the moment that work of art leaves his realm and reaches its audience, its interpretation is an open game. Yes, we might want to consider what the artist had in mind, what his inspirations were in order to shape it. But those are only a source and should not be considered implacable. As I suggested earlier, the work of art belongs to everyone and no one. It has no owner, not even its author.

Returning to the tension between a free-for-all view of the validity of interpretations, as you put it, and one that is tightly reined in, yes, that tension is crucial. I'm not a conservative by nature. By this I mean that I don't discard interpretations that are unexpected, innovative, and provocative. These generally come from a youthful perspective that attempts to break with tradition. A clash in art and literature bases its continuity on precisely those radical interpretations. Every generation approaches the world differently. It seeks to present a new vision of things. That newness is transitory. Sooner or later, the reigning interpretation, the once accepted in the present, will be debunked, giving way to an alternative one.

Needless to say, there's a difference between realistic and abstract art. That difference defines the field of interpretation. Don't you think that interpretation has stricter rules when it comes to realistic art, and within

that category, realistic photography? Yampolsky's *Elva* is about innocence. It might inspire the viewer to imagine who the girl is and what relationship she has to Yampolsky. Still, the facts in front of us are sharp and incontestable. What else is there? The aesthetic quality of the image is what makes it durable: its composition, the way it freezes the human condition.

JG: But what is there in the photograph that tells us it is about innocence? What is the image of innocence? The image tells us we have a girl. We also see an image that is in black and white, or perhaps more accurately shades of black and white. We see that she has black hair, that she is in a certain pose. We see a background of a certain sort, and so on. But do we see innocence? Do we see loneliness? We see a single image, a photograph of her alone. But that does not tell us that she is lonely. All of this requires a context. And the context can vary widely. There is the context in which the photograph was taken, the context of the photograph today, wherever it is, the context of the photograph in this book, the context of it in my life or memories. The contexts of the photograph are infinite. There is not one context, but an infinite number of possibilities, and all of them affect the way the photograph may be understood. The picture talks to us differently depending on where it is physically and otherwise.

This is not different than what happens when we hear a sound, say, the word *fire*. If we hear it shouted in a crowded theater and we also smell smoke, we interpret that there is a fire in the place and we need to leave as quickly as possible. If I am a soldier and I am standing next to a canon, I understand it as an order to fire the canon. If I hear the word in the theater in a falsetto voice, I take it as a joke. The possibilities are many.

You suggested that perhaps there are more stringent rules of interpretation for realistic art than for art that is less realistic. But I think the case of the photograph we have in front of us, which by all counts must be considered strongly realistic, is not very different from that of the word *fire*, which is certainly something not realistic at all, but an abstract sign. Indeed, even the realistic character of the picture may be questionable for reasons I mentioned earlier.

Obviously there is something wrong with the way we have been going about deciding the legitimacy of interpretations, because we have ended in a muddle that seems not to have any resolution. But where is the mistake? Where have we gone wrong?

I suspect it is the fact that we have been trying to solve the issue by considering the object of interpretation, whether it is realistic or not, whether it does or does not faithfully reveal what the artist intended, and so on. Instead, we should have begun by considering interpretation, rather than the object of interpretation. Because interpretations have aims, and their legitimacy should in all fairness have to do with those aims. Does it make sense to judge the legitimacy of what I do apart from the goal that I seek? The end is certainly the key to it, a point that Aristotle made well by identifying the end of any change with what he called the final cause, that for which anything happens or is done. The end of a journey is to get to a place, and the means that are used to do so are judged legitimate or effective to the degree that they lead to that end. If I want to get from Toronto to Paris, a horse would be useless and therefore ineffective or even illegitimate. But a plane would be both effective and legitimate.

Adding the many details about Yampolsky's life you did above have interpretive significance only if the aim of the interpretation of *Elva* is somehow authorial. But does it make sense if one's aim is not authorial? In fact, you have given a very strong interpretation of *Elva* as a picture of innocence, but where is the connection between all the data about Yampolsky you have provided and that conclusion? The legitimacy of your interpretation depends on whether it fits the aim you were pursuing.

IS: By looking at interpretation through the lens of an end, that end will surely vary from interpreter to interpreter. And "the end" approach gives a sense of practicality to the effort of interpreting. In my own case, I ask: Why do I interpret a work of art? Not because I'm attempting to reach a particular conclusion. In fact, reaching that conclusion will make the interpretation needless because interpretation is about discovery, about starting from a position of not knowing and ending in a position of knowing. Knowing what? Knowing what this particular piece of art means. Means to whom? To me. Why do I want to know what it means? Therein is the key to our discussion. Let's think of dreams. Like most people, I have scores of dreams every night. Most of those dreams—in fact, the majority of them—I won't be able to remember when I wake up the next day. In other words, metaphorically, most of my dreams end up in a wastebasket, what I would call "the infinite wastebasket of human dreams." Zillions of dreams end up there every night. How many dreams does the

wastebasket have? None, because the moment they make it there (and the "there" is an abstraction), they vanish into oblivion. However, every so often one of the dreams I have will be remembered by me. Which one? I wouldn't know how to typify it, since I've never done a taxonomy of my dreams. Maybe it will be the one whose emotions lasted longer in me, enough or me to remember the dream. I find the connection between dreams and emotions fascinating. I don't believe we dream of a ferocious monster and then feel afraid of the creature; I believe the feeling of fear is in us when we go to sleep and it creates a ferocious monster. Anyway, as soon as I wake up I'll think of the dream. Or, put in another way, the dream won't leave me alone. It will implant itself in my mind, begging to be considered. Considered for what? To be thought of, to be interpreted. And why would I want to interpret my dream? To try to make sense of it, to see how it relates to me. I wholeheartedly dislike Freudian analysis because it offers a cookie-cutter formula to interpret dreams. It does it through the prism of impulse and sexuality. I also don't feel any interest in the Jungian theory of dreams as a collective reservoir of symbols. My dream will have a personal message because it will be connected with my daily life. Understanding it will give me a sense of comfort. That's my end, my purpose: to understand what the dream says. If I fail to do so—and I often do—it isn't a big dig. I will have another dream the next night. But I will try. And here's my point, which is intricately connected with your concept of the end of interpretation: for me the act of interpretation is an end in itself. That is, not the conclusion I reach but the search I embark on, the journey of attempting to explain the dream. Or in our case the work of art is what matters to me. I don't care if my conclusion is provisional or if it is unfinished. What I care about is that I went along with the tide, that the dream was the starting point of an exploration. Just the starting point!

I see that in this volume, Jorge. Are we reaching strict, measurable conclusions about the works of art we're analyzing? Maybe so, maybe not. Nevertheless, the reason this encounter with you is exciting, why I look forward to your next response, why the debates we've been having linger in my mind, is that I'm enthralled by the journey itself. Some people, those who are the most practical, might think that in these dialogues we circumnavigate our destination, that we're not interested in conclusions

but in allusions and delusions. And I say yes to all this: I'm interested in the thinking process itself. I'm interested in thinking critically. I'm interested in surprising myself.

JG: Well, from what you tell me the end of your interpretation is a kind of free-wheeling game, a kind of Russian roulette, an enjoyment perhaps. But none of that really matters. The fact is that you do have an aim even if you say the aim is the interpretation itself. This is significant because other people have other aims in mind. For example, many literary critics have for an aim in their criticisms to determine what an author meant by the work they area interpreting. A Freudian will have something else in mind, having to do with sex and the libido. Thomas Aquinas had in mind a Christian reading of Aristotle. And so on, ad infinitum. Some of these might be intentional and others might not. Some might be conscious and others might not. But it seems to me incontestable that different interpreters often differ in what they are trying to do. Human action is often intentional and always directed, and interpretation appears to be particularly so.

And, mind you, the end is not a conclusion, as you seem to suggest. If interpretations were a matter of reaching preestablished conclusions, then they would enjoy very little leeway. A goal or aim is not a conclusion but a target and does not necessarily imply a determinate content or understanding, although reaching a conclusion can certainly be a target. As I said of the trip, if I want to get to Europe, I need a mode of transportation, but this does not entail the use of a horse or a ship. Likewise, when we are engaged in interpreting we are seeking something, a particular kind of understanding, but that interpretations have ends has nothing to do with them having preestablished understandings or conclusions. Those that do are obviously interpretations, but interpretations of a very particular kind.

If we consider the end of interpretation, we see that there is not one end that can be identified for all interpretations. In some cases the aim is to understand what the author of the *interpretandum* had in mind, in other cases it is what a particular audience understands or understood by it, in still others the aim is what the interpretandum means apart from whatever anyone understands by it, and still in others it is to relate that object

or its meaning to something we are interested in as interpreters. Take the case we have been dealing with, Yampolsky's *Elva*. My aim could be to understand what Yampolsky meant by this photograph; or how Mexicans understood the photograph when it was first made public; or what the photograph means apart from what Yampolsky, Mexicans, or anyone else understands the photograph to mean; or what the photograph says when we consider it in relation to Latin American poverty; or to understand the relation of the photograph to Yampolsky. Each of these aims imposes on the interpretations certain requirements, some of which are very stringent, whereas others are quite loose. Certainly the intention of the author involves very tight criteria of a historical nature. And if this is what we want to understand in our interpretation, we must work hard to find clues, both within the photograph and outside of it, outside of Yampolsky's intention. But if what I want of my interpretation is to relate this photograph to the current economic situation of Latin America, then the requirements are quite different and may have little to do with what Yampolsky had in mind. And if what one wants is to understand the relation of the photograph to Yampolsky, then the biographical paraphernalia that you brought up earlier about Yampolsky would be quite essential.

I have given names to these various kinds of interpretations in *A Theory of Textuality* (1995): authorial, audiencial, meaning, and relational. But that is not important for us here. What is important is the claim that you may want to dispute, that once we understand that interpretations have varied ends, the only way to judge their legitimacy and value is to identify those aims, for the aims give us different criteria for the interpretations. What is the moral of the story? That even though our two interpretations of Yampolsky's work are quite different, this does not imply that one of them is illegitimate whereas the other is legitimate. Indeed, their legitimacy will have to be measured not by how faithful they are to social or cultural criteria, and whether they contradict each other, as you seem to have suggested earlier, but by whether they satisfy the criteria appropriate to the aim pursued, that is, whether they lead to it. This means that there is no reason legitimate interpretations cannot contradict each other. Yampolsky's *Elva* can be both about innocence and not about innocence. You see, it would be terribly unfair and quite inappropriate to apply to our interpretations criteria of legitimacy that we did not intend to satisfy. Just

as it would be completely unfair and inappropriate, indeed, I would say stupid, to criticize my choice of a ship as a mode of transportation to get to Europe because it would take several days to get there without considering that my goal was not speed, but a pleasant, leisurely vacation at sea. What do you think of this proposal?

IS: By all means, more than one legitimate interpretation is acceptable of a work of art. And the criteria of interpretation are many, as you rightly say. But what interests me, in the end, is how your mind and mine have looked at Yampolsky's *Elva* and been driven in diverse, at times contrasting directions. I think I've finally realized what my end in the art of interpretation is: not to understand the work of art at hand but to understand the mind looking at that work of art.

JG: And that is certainly an appropriate and legitimate end, even though it is different from other aims, such as one that seeks to understand an *interpretandum* independently of the mind that created it. This is not a bad way to end our discussion of *Elva*.

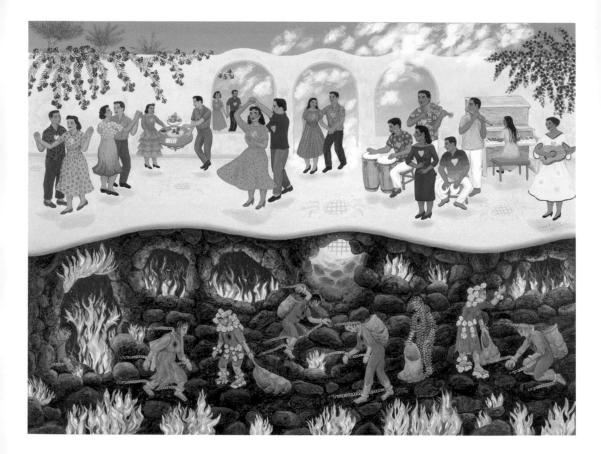

Carmen Lomas Garza, *Heaven and Hell* (1991),
48″ × 36″, oil, alkyd, and gold leaf on canvas, © 1991
Carmen Lomas Garza. Used by permission of the artist.

THE THEREAFTER

CARMEN LOMAS GARZA *Heaven and Hell*

Jorge Gracia: When I think about heaven and hell, the first things that come to mind are Dante's *Divine Comedy* (1308–21), Milton's *Paradise Lost* (1667), and Sartre's *No Exit* (1944). Each of these offers a different perspective on the allegory of heaven and hell. For Dante it is a vision based on the medieval philosophical theology of Thomas Aquinas, a beatific vision of God and an inhospitable, freezing world in the last circle of hell. In Milton's conception, informed by the Reformation, hell becomes the kingdom of the rebel angel Lucifer, who would rather reign in it than serve in heaven. And in the existentialist philosophy of Sartre, hell becomes other people. All three have taken aspects of the allegory and framed them in an imagery that works for their own purposes. Like these, countless other examples are found in churches, books, and museums. The Middle Ages in particular were especially rich in interpretations of the allegory of heaven and hell. The art in Christian churches was from the very beginning intended to initiate the faithful in the mysteries of Christianity and to teach the doctrines of the faith, among which heaven and hell figured prominently. These images were used to warn believers against sin and to entice them to follow the straight path of virtue with the happiness of heaven.

Ilan Stavans: You're using literature—even if infused by religion—to depict these two entities, heaven and earth. I want to approach them in a geographic and perhaps architectural way. When people talk about heaven, they point upward. They do the opposite when they talk about hell. The sky is heavenly. The underground is hellish. That is, heaven means an ascent whereas hell means a descent. This dichotomy in coordinates is crucial: we associate blissfulness with what happens above us and fear and bestiality with what happens below. Why couldn't heaven be in the east and hell in the west? When I look at the maps done of Dante's universe—my wife gave me the Dorothy L. Sayers translation when we first met and I always go back to its maps—the up-and-down distinction is presented, just as it has been almost since the *Divine Comedy* began to be studied by scholars. However, this map is emphatically Christian. Other religions don't have the same vision of heaven and hell. Some of them, like Judaism, aren't even sure if such places exist.

JG: Lomas Garza's *Heaven and Hell* fits right into this literary and religious tradition, but its interpretation is far from the standard versions related to the Christian doctrine. This work is far from being a work of spirituality or religious faith. The artist has used the imagery of heaven and hell to communicate to us something else, something more immediately relevant to our present lives than a future of pleasure or pain. The painting is not about rewards and punishments, but about our present condition.

The painting is divided into upper and lower parts, following the iconography frequently employed by artists depicting heaven and hell, at least in the West. At the top we see a party, a dance, taking place on a lovely patio. An architectural background in the form of a wall with three Spanish arches serves to frame the event. The central arch is the door that marks the entrance to the patio, the other two are windows. Climbing bushes full of flowers cover parts of the wall. Behind it we see three palm trees, a light blue sky, and cumulus clouds, most of which are behind the wall, but some in front of it. Inside, on the right, seven musicians, of whom three are women and four men, play a catchy tune, judging by the reaction of the audience. A guitar, a violin, two sets of different bongo drums, and a piano. On the left, a table is served with fruits, slices of melon, and sweets. Next to it a couple is engaged in conversation. He

leans on the table, relaxed, adopting a natural, comfortable posture, while she listens. Another couple is just entering the patio, he holds her waist and hand, while she looks at the musicians. Still another couple is on its way in.

The scene appears to be one of joy, happiness, and fun, but surprisingly no one is smiling. Their faces seem frozen and expressionless. On their chests, gold hearts mark them. Are these good people whose gold hearts deserve the fruits they are enjoying? Lomas Garza has a primitive, folk style that simplifies the vision she presents. She speaks to the people. Colors are simple, direct, and the strong yellows are sprinkled with other soft, but vivid, colors that serve to lighten the mood and contribute to an atmosphere of relaxation and pleasure. This is heaven.

But this is above. Below, in the lower half of the painting, we have an entirely different scene. Here we are introduced into an underground world, a cave, lighted only by flames that surge at every turn, including a small orifice on the bare rock covered by a grill. Escape is impossible. There is no way out, and the laborers in it, both men and women, are chained. This is a mine of sorts where the workers are picking green stones from the ground and walls of the cave. They are burdened with large sacks, which, when full, they carry somewhere, although we do not know the destination. The workers appear exhausted, sweating profusely, and staring at the ground and walls. The heat must be debilitating. Their clothes are simple—light brown frocks, with pants for the men and skirts for the women. One man is covered with what appears to be a coat of mail and two others have strange objects placed around their heads, circling their legs, below their feet, and tied around their middle. Their hearts are black, as if charred by fire or consumed by evil. This is hell.

So what is the meaning of this depiction of heaven and hell? I see many ways of interpreting this visual allegory. On the one hand, we can adopt a traditional religious interpretation in which heaven is a place where one is rewarded for having a good heart, a heart of gold, for living a good life, and hell is the place where one is punished for having a bad heart, a black heart, for having lived a bad life. This accords with the folk style of Lomas Garza. It is a simple way of conveying the Christian message, where justice demands that good be rewarded and evil be punished. But if we forget for a moment this traditional message, there are at least two other ways

of understanding this work. One is to go back in history and see it as a commentary on the history of Mexico in particular and of Latin America as a whole: the Spanish conquerors and wealthy *criollos* at the top enjoying a life of fun and leisure at the expense of the toil of the Amerindian. Or we can take a similar step but in a different direction, and understand it as a criticism of contemporary society and the dehumanizing effects of capitalism. At the top, the ruling classes, with plenty of leisure, enjoying the fruits of the labor of the lower classes, whose dehumanizing labor supports their extravagant lifestyle at the cost of pain and suffering.

IS: Your interpretation reminds me of the conversation we had on *La reconquista*. Garza's painting divided the world in hemispheres: up and down, the powerful and powerless, the haves and have-nots. As I said before, we're overwhelmed with this allegorical interpretation. Yet I wonder: Is the allegory still valid?

For me allegory is a form of representation that infuses a certain image with a religious symbolism it doesn't contain but that is insinuated by the creator of the image. To be understood, that insinuation needs to be appreciated by the viewer, who must understand what the creator is tangentially suggesting. But not all viewers are the same. I don't believe in either heaven or hell. Not only that, I was not raised thinking about these categories. As a result, they arouse little interest in me. What I mean to tell you is that I can see in Garza's piece the allegory you've been describing but I don't have any feeling toward it: it doesn't say anything to me. Actually, that's not true. The feeling that I have is that Garza's image offers an allegorical vision of the world to which I'm an outsider.

Let me connect this to Dante. In the Renaissance, the *Divine Comedy* was read as a Christian allegory. To readers today raised without any Christian values, it is like science fiction, or maybe like Tolkien's *The Lord of the Rings* (1937–49): a delicious fantasy about a world different from ours. Yes, to me Dante's world and Middle Earth are the same: alternative universes. I would even go further and suggest that even to Christian readers today this epic poem offers little by way of religious solace. Why? Because Dante's journey is less about any sinner than about this particular sinner, Dante Alighieri. It's universal in its odyssey and in its poetic style. That's why I love it—and teach it frequently. That's also why it isn't

read by Christian believers nowadays: because Dante wasn't a genuine Christian, he was simply a poet.

JG: Your comments bring to my mind the very difficult question of the recovery of the past, the distant past in particular, not our personal, immediate past. Our personal, recent past is still part of our contemporary context and much easier to recover through personal memories. Besides, we are still functioning within its parameters. I can understand and relate to the values of Cubans because I was born in Cuba and lived in Cuba until I was eighteen. I can understand the taste for a certain music, I feel it, and when I hear it I can't stop my body from wanting to dance to it. And I can understand contemporary American society and contemporary literature because it is about people among whom I live, indeed it is also in part about me. But what can I really understand about Dante's age? How can we recover a whole *Weltanschauung* that is foreign to us, that was part of a different culture and belonged to different peoples? Many argue that this is impossible and that we delude ourselves when we think we do. We never recover the past, we merely think we do. What we do is create something different. Others, however, argue just the reverse. They point to human natures and society and argue that because of this similar foundation we can understand what is universal in each culture and distinguish between what is universal and what is not. But even those who talk in the last way have difficulty explaining how we can go back to what is so distant from us.

I have struggled with this question for years because I was trained as a historian and at some point in my career I asked myself: What have I been doing as a historian? The answer was that I had been trying to understand the past. But is this possible at all? After much thought I came upon a suggestion: the past is understood only through traditions, which I conceive as ways of behaving, of doing things. These "forms of life," as Wittgenstein called them, are essential to the recovery of the past; they are what tie us to it, although they by no means ensure certain understanding. But they should help if we think that in fact this is how we understand each other. When we talk, we utter sounds with meanings, but the meanings are hidden from each other, because we only hear sounds. How do we know that what you said means what I understand? How can I know that

when you say *good morning* you mean good morning and not *go to hell?* We know because of the context and traditions. These are the words that are used in certain circumstances, and have been used in similar circumstances going long into the past. It is this behavior in context that creates expectations of certain understandings, even if absolute certainty eludes us. This is also why we can relate to Dante and the paraphernalia he mentions in the *Divine Comedy.* The devil, heaven, angels, and the like mean something to us, which is related to, although not exactly like, what Dante and his contemporaries understood, and may be why the whole system of heaven and hell mean very little to you—it does not speak to you because you were not raised in a tradition in which it has meaning.

IS: The devil interests me in particular, not for his religious power but for the creation he represents: a personification of evil. Years ago I collaborated with the Arizona artist Teresa Villegas in a book on the children's game of *Lotería.* Villegas sent me a number of paintings she had done based on Lotería cards. One of them, *El diablo* (The devil), kept on coming to me in dreams, although I was never afraid of it. On the contrary, in my dreams I sat down with the devil and talked. Gently, cordially. Who cares about the devil? Only fanatics.

JG: The devil, like most religious concepts, has its origin in the need of human beings to understand something about ourselves. We need this figure of evil to see and judge ourselves better. We cannot do this unless we objectify our selves, vices, habits, actions, and feelings. The devil, like God, represents something very human. Think of the story of Lucifer, the finest of God's creations, and of his pride in his perfection, beauty, and power. Think of how inferior he felt to God and how jealousy crept into his thinking to the extent that he defied the very one who had created him. What an ingrate! What a traitor! If the devil did not exist, certainly it had to be invented, because we need it to understand our own ingratitude and our treachery to those to whom we owe much. And our jealousy and envy. We need to see in the devil all that is evil in us, our faults and sins, so that we can perceive our perfidy and ugliness and undergo a sort of catharsis and purification. Yes, even though I do not believe in the devil, I do.

IS: Along these lines, one of the myths of religious history, I feel, is Judas Iscariot. You might be surprised to hear this but I feel closer to him than to Jesus Christ or any other benign religious figure. Judas represents evil. He's a traitor. As such, he betrays Jesus. But Jesus wouldn't be who he is without Judas. And Judas is a far more complex creature. He is poorly represented in Christianity. Yes, as a Jew I can't but feel empathy for him, among other reasons because Judas is a representation of the devil and we Jews have often been described along the same lines. It's easy to talk about evil in all of us. It's harder to reflect on oneself as the personification of evil. That's why the devil is such an attractive figure to me.

JG: Judas is to Christ as the devil is to God. That they require each other was noticed as early as that ancient religion of Persian origin, known as Manichaeism, that saw good and evil as intrinsically and inextricable interdependent. Good requires evil, and evil requires good. Everyone, I believe, understands that talk about good makes no sense without a notion of evil. How can you understand good when there is nothing that opposes it? We understand hot because we understand cold, and we understand wet because we understand dry. But Christians generally have thought that, although the concepts are interdependent and we need them for understanding either of the extremes, it is not necessary to posit that they both have existence. Christians hold that we need not hold that something evil exists because something good exists; evil can be merely the negation or privation of good. This is a standard doctrine of the Christian Church going back to the fathers of the Church. But adherents of Manichaeism believed that conceiving of evil as a mere lack of good made no sense, for how would that lack come to be if all there is is good? So they argued that the world did not have just one fundamental principle, whether that be good or evil, but two, good and evil. These two fundamental principles, beings, or forces, are in constant struggle with each other, and their relative successes and failures explain the presence of both good and evil in the universe. This is one of the most powerful arguments against the existence of God. If God is all knowing, all powerful, and all good, how come he allows evil to happen? He must not be all knowing, or all powerful, or all good, in which case he is not as he is supposed to be in Christian theology.

The great opponent of Manichaeism in the ancient world was Augustine, who adhered to this doctrine for a time, until he converted to Christianity. But, of course, if there is only one fundamental principle and this is good, how come so many bad things happen in the world? Where does evil come from? For Augustine and others, the explanation is that evil is ultimately rooted in the willful rejection of good. Thus Lucifer was good, but turned away from it and embraced evil. And so did Judas and, more important for us, Adam and Eve, because they are responsible for our present misery. But this view has not received acceptance in circles other than those of believers. No philosopher has been able to find an answer to the problem of evil that has received wide acceptance.

IS: As of late, I've been interested in representations of hell. Of course there is a vast Christian iconography, running from Dante to Milton to T. S. Eliot. There is also Borges, whose meditations on hell are more subtle. Borges often talks about hell as "an eternal minute." Or else as "the incapacity to understand ourselves." Hell, as it turns out, is portable. We carry it with ourselves wherever we go. Hell is fear. Hell is misunderstanding. Hell is loss. Hell is an extension of whatever we dislike.

JG: I share your fascination with the devil and hell. Indeed, I find that he, just as Judas, is more fascinating than the good guys. My interest goes back to college, when I was first confronted with Milton's *Paradise Lost* and his powerful portrait of Satan. I remember vividly when I first read the famous line from this epic poem: "Better to reign in Hell, than to serve in Heaven." It seemed to me that it encapsulated more effectively than anything else the character of Satan, and his enormous pride. But precisely because of it, because of the passion that inspired him, his character was all the more fascinating. Christ by contrast tastes like pabulum, whereas Satan is like aged wine, even if poisonous. One is simple, clear, and straightforward; the other is complex, confusing, and devious. Indeed, if heaven is going to be fun, I hope Satan has a place in it, for he would make life everlasting more interesting than one devoid of challenges. This is one reason I do not interpret Lomas Garza's portrayal of heaven and hell as referring to the other world, but rather to our world, one where slavery and inequity are rampant.

I find most depictions of heaven uninteresting. Humans have a great difficulty portraying heaven, but they have a much easier time with hell. Hell is more like our world, I imagine, and that is why it is easier to picture. But what is heaven like? The Greeks also had difficulty with heaven, even though they were not so puritanical or otherworldly as ourselves. Their solution was to make their gods liable to human passions and allow their intercourse, in more ways than one, between them and humans. This gave the Greeks the opportunity to portray their deities as living lives that are closer to ours, with all the virtues and vices that we have. And, of course, it was entertaining in the theater and made for interesting situations. But think about the Christian ideas of heaven, those endless days of listening to soft music, played by harps, and of perfect harmony. How can this be pleasurable? It sounds very boring, indeed. Do you want to go to that kind of heaven?

IS: I wouldn't go to heaven, no matter how attractive a depiction of it I might come across. I'm interested in human failings, not in human qualities. The difference between an optimist and a pessimist is that an optimist hopes ours is the best possible world and a pessimist knows that it is. I look at the world as a theater of accidents.

JG: Your reference to optimism brings to my mind two images. The first is that of Pangloss in Voltaire's famous novel *Candide* (1759), the other is that of Voltaire himself on his deathbed. Pangloss is forever the optimist, no matter what happens to defeat his belief that this is the best of all possible worlds. He will accept no evidence that contradicts his strong belief. Voltaire had a great time making fun of Pangloss and the Augustinian doctrine that God created the best of all possible worlds and that whatever is evil in the world is the result of the creature he created in his image and likeness. The rub, as Voltaire among others have pointed out, is that it is difficult to believe such a creature could be the source of so much evil as there is in the world. Great evil requires a great source, and humans do not fit the bill. But when Voltaire was on his deathbed, he is reputed to have called a priest and confessed his sins, presumably not because he believed in heaven and hell, but just in case that the heaven and hell he had ridiculed all his life actually existed and the faith he had spurned was true.

IS: Borges followed in Voltaire's path. He spent his entire life suggesting that heaven and hell were literary places, not religious places. That is, he argued that human fantasy had created these sites in order to establish a system of reward and punishment. Borges was enthralled with God. He writes about God more often than he does about Shakespeare or Cervantes, which are the two names most frequently mentioned in his oeuvre. When asked in interviews, he said he was a nonbeliever, maybe even an agnostic. Yet just before he died, in Geneva, a priest was called in order to give him last rites. I've never been able to find out if Borges, already quite sick, requested the priest's presence, just in case he had been wrong all along about the afterlife, or if someone else near him made the request. In any case, a priest visited Borges on his death bed. What actually happens in those moments?

JG: It is really difficult for a thinking person to believe in heaven and hell as described in holy books. Just as it is difficult to believe in God as an old man with a beard. And yet, it is difficult to believe that there is no afterlife. Our craving for immortality is very strong. We have difficulty conceiving that all we think and do, that our living, with its satisfactions, emotions, and failures, will come to an end. That one day our consciousness will cease to be, and there will be nothing left to us but whatever we managed to create. And yet, we go to sleep every night and we lose a sense of our selves. So why can we not think of death as a prolongation of sleep? If in sleep we are not conscious of ourselves, why is it difficult for us to imagine that our lives will cease at some point, that one might not wake up?

Some religions have discarded the notion of personal immortality and therefore of a heaven and a hell. Buddhism is one of them. Nirvana is not a place for the individual, but a state in which we lose ourselves in the whole. But Christianity and Islam have strong doctrines of personal immortality. And philosophers have not been left behind, and not just those who have a religious faith like Augustine and Aquinas. Plato argued strongly for personal immortality, although Aristotle left the question open. Why do we believe in immortality? Perhaps the best answer is to be found in Kant, who argued that the notion of a supreme being who was also supremely good and therefore just, was essential for morality.

We need to believe that there is a just judge of human deeds so that those who commit crimes get punished and those who live virtuous lives are rewarded, because this life does not reward goodness or punish evil generally. Yes, there are situations in which it does, but they are not common. Most evil goes unpunished and most good goes unrewarded. And the notion that good deeds are a reward themselves for those who do them, and evil deeds are the punishment of those who do them, is a rather lame doctrine. It is very hard to convince anyone that enjoying the result of a great theft is punishment.

This is why it makes sense to look at heaven and hell as metaphors for something that has nothing to do with the afterlife. It makes sense to use these notions to talk about the here and now, as Lomas Garza's painting does. I particularly like her depiction because it speaks to the people. Mexican art has traditionally inspired itself in the people, in popular themes that speak to them, and so this piece effectively contextualizes the Christian doctrine in such a way that it speaks to the ordinary person, which reminds me of Averroës. He lived in an Islamic society in which a literal interpretation of the Koran was favored, and any departure from it was regarded as suspect and even punished. Averroës himself had to suffer the consequences of his philosophical views that appeared to contradict a literal interpretation of the Koran. He spent time in jail.

After he got out, he gave some thought to this matter and concluded that there was no point in telling some people what he thought. For him, people were divided into three kinds: Those who lacked education or philosophical training and intellectual talent, a reason they understood the scriptures literally — these people were the proper target of preaching. Those who were trained in philosophy but accepted certain assumptions derived from faith. These people understood the scriptures theologically rather than literally. That is, they understood them within the framework of religious doctrines and thus were the proper target of theology. And those who were trained in philosophy and accepted only what philosophy is able to demonstrate. These people understood the scriptures philosophically, setting aside both literal meanings and any doctrines taken on faith. From this he concluded that it is a great mistake to speak to those in the first two groups in the language of philosophy. This language is appropriate for philosophers only, just as the technical language of medicine

is not appropriate to the sick who are not themselves physicians, in spite of what our heads tell us.

Averroës's advice solves one problem: it allows the philosopher to avoid punishment in a society in which power is held by nonphilosophers. We do not have to worry about being burned at the stake, stoned for sacrilege, or put in jail. However, it does not solve another problem: the craving for immortality and justice we have. This is a reason the notions of heaven and hell are needed, as Kant would say. But that does not make them true. For what we want seldom corresponds with what there is. Indeed, the reason we want it is precisely that we know we do not have it. So although we know heaven and hell must not exist, we want them and need them, and therefore believe in them.

IS: Your disquisition on Averroës, a philosopher I admire deeply, makes me think of another great thinker of the twelfth century, that is, of one of Averroës's contemporaries, although in another Abrahamic religion: Maimonides, who as you know was a Jew, maybe the most important rabbinical mind of all time as well as one of the most important philosophers in Jewish history. Maimonides also had a strong interest in hermeneutics. He was fascinated by the three groups Averroës established: those who were ignorant and didn't have the capacity to engage in philosophical discussions; those committed to a religious interpretation of the scriptures; and those engaged in philosophical inquiry, in his case, the followers of Aristotle. Maimonides spent his entire life interpreting scripture for the ignoramus and the believers. A result of this effort are his monumental works, the *Mishna Torah* (circa 1170–80) and the *Commentary on the Mishna* (circa 1145–68). Yet Maimonides is also known for one of the most incisive and perplexing works in philosophy, the *Guide for the Perplexed* (written in Arabic, first Hebrew translation, 1190). Written as a form of letter—or perhaps a manual—for one of his most distinguished pupils, in it Maimonides suggests that only philosophical inquiry is worth our intellectual effort but that such an inquiry isn't for everyone. It is only for the selected few, a cadre of initiated thinkers capable of understanding the most crucial (and dangerous) truths in the universe. In the *Mishna Torah* Maimonides reflects on the biblical chapters on the creation of the world. In the *Guide for the Perplexed* he attempts to synchronize—to resolve the

differences—between the existence of God and God's decision to create with Aristotle's ideas of a prime mover and an eternal world vis-à-vis a created world.

I'm telling you all this because it is hard to reconcile Maimonides's skepticism about creation, about the immortality of the soul, and about the resurrection of the dead, which he expounded in his hermeneutical works of religious texts, and the Maimonides who saw himself as a philosopher. The philosopher doesn't quite make himself believe in the resurrection of the dead, for instance, since this goes against the rules of nature. The challenge for him in writing the *Guide for the Perplexed* was to figure out a code in which to deliver the book so that it wouldn't be considered anathema. For that reason, reading it is one of the most peculiar experiences, since it cannot say what it wants to say. Ever since I discovered the book, in my early years in New York City in the late eighties, I've been a devotee. I've been part of reading groups whose mission is to unearth—if that is ever possible—Maimonides's message, a message that, once again, he only wanted to be understood by a minuscule group of initiated followers. In 1941, Leo Strauss, the German-Jewish émigré philosopher at the University of Chicago and an essential thinker for neoconservatives, wrote an essay on Maimonides called "The Literary Character of the *Guide for the Perplexed*," which is part of his book *Persecution and the Art of Writing* (1952). Strauss was also interested in Spinoza, Yehuda Ha-Levi, and Al-Farabi.

Anyway, throughout the years my central question regarding Maimonides is how he could have been two people in one, the religious interpreter and the philosophical thinker. As you said, the conundrum enabled him to escape persecution, although only to a certain degree. The *Guide for the Perplexed* was burned in different places immediately after it appeared and in subsequent decades. Yet Maimonides remains one of the most influential Jewish rabbinical minds. It is said that Judaism has had three Moseses: the biblical leader, Maimonides (whose Hebrew name was Moshe, that is, Moses, ben Maimon), and the Enlightenment philosopher Moses Mendelssohn.

Coming back to Lomas Garza's *Heaven and Hell*. The imagery she offers, to me, is allegorical, not religious. Heaven and hell aren't actual places, neither here nor anywhere. They are figments of the human imagination.

The work has a childish quality to it. The two hemispheres it depicts show the way Catholicism lurks in the background in Mexico, particularly in small-town life. People enjoy dancing, they smile, they eat, and they play piano and drums in heaven. Over there the sky is clear, the air is fresh, and life is plentiful. Yet underneath all that there's a conception of the end that is connected with fire and hard labor. You'll notice a hole at the center of Lomas Garza's piece: it appears to connect one realm and the next. Or maybe there's more than one hole: there's a sewer system (I count three mouths on the ground) that on the surface look innocent yet they are the link between the here and there. What does it all mean? Is it a cautionary tale, asking us never to be too happy, too mindless of what will come after? Is Lomas Garza announcing that for every joy there's a payment to be made in the world to come? Is this a piece about guilt? Maybe it's the Jew who is concluding that. More suitably, Lomas Garza says that life is divided between the upper ground and the underground and that both are intricately connected.

I said that there's a childish element at play here. Funny how the views of religion look to enlightened, secular people as infantile, immature, undeveloped.

THE STREET AS ART

BEAR_TCK *Chicano Graffiti*

Ilan Stavans: I find it intriguing, perhaps even bewildering, that graffiti artifacts are now housed at major museums such as the Los Angeles Museum of Contemporary Art, among other major institutions, for the idea behind graffiti was a rejection of art as a commodity. And museums are built on the premise that commodities should be displayed in a safe, public space in a way that is reverent and contextual.

Jorge Gracia: The spirit of graffiti art is rebellion and protest. Some of it is against the view of art as a commodity, as you say, Ilan. But political and artistic rebellion is also involved. The art world, like most worlds in which we live and function, is based on authority. The authority is that of the directors and curators of museums, art critics, and art historians. They set the pace. They tell us what is art and what is not art. They exclude some artists for the simple reason that they do not approve of what they do. Sometimes because what they do is new, sometimes because it is old, sometimes because of personal likes and dislikes, and sometimes because they belong to the wrong people or the wrong culture. And there are

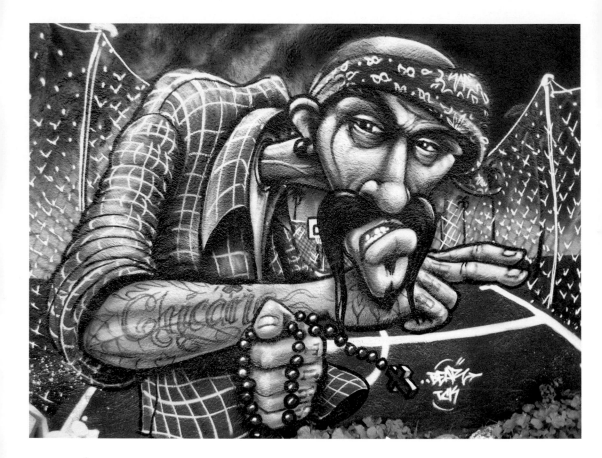

BEAR_TCK, *Chicano Graffiti* (2010), mural on wall.
Used by permission of the artist.

also some that make their judgments on the basis of financial interests. The art world, just like the world of literature, philosophy, or religion, is based on power relations and those who have the power are considered the authorities, whether they are authorities because they have the power or they have the power because they are authorities. Foucault was right on many counts. The number of artists who have been marginalized by the art establishment is countless. Indeed, the case of Martín Ramírez, whose work we discuss elsewhere in these conversations, is quite clear. His works were shunned by the art establishment, and even after it had attracted considerable attention, it was not in the MOMA that it was displayed, but in the Museum of Folk Art.

The art establishment wants to control art. It wants to direct where art is to go, and what is and what is not art. Museum curators and directors as well as gallerists have power because they manipulate the public's taste in art. Because art has become big business, it is essential for investors to control what happens. They cannot allow just any artist to sell; the market needs supervision.

Another institution that aims to control art is the government. Totalitarian regimes in particular control artistic expression in order to preserve their power. An interesting case is that of Cuba, where at the beginning of Castro's revolution there was a flowering of artistic expression. Indeed, even later periods of extraordinary artistic production and creativity continued sporadically. But eventually, the government felt the need to crack down on dissent of all kinds, resulting in the rebellion and exodus of many artists.

Religious hierarchies and authorities also have often tried to control art. Michelangelo's nude figures in the fresco of *The Final Judgment* in the Sistine Chapel were given loin cloths to cover their private parts, which the artist had shamelessly left uncovered for everyone to see. More recently, Serrano's *Piss Christ*, about which we talked earlier, caused a great stir, resulting in the curtailment of much public funding for the arts in the United States. And when it comes to Islamic countries, any depiction that is thought to criticize some Islamic religious belief, or parody Mohammed, is met with threats and violence.

Street art is a rebellion and protest against all these modes of oppression. It is a manifesto in favor of artistic freedom and creativity. For this,

artists have been incarcerated, beaten, persecuted, fired from their jobs, subjected to ridicule, and even killed. And yet, there is too much at stake for them to give up. They keep doing art and provoking the complacent community around them. When they cannot exhibit their work in galleries and museums, they turn to the street, the public forum where the control of self-proclaimed authorities is less strong and their vision and protest is more accessible. The street is the place where there are no constraints, where the public can see the art and judge for itself.

IS: I like your reflection on art and control. The more control one tries to exert on art, the less controllable it becomes. For the artistic spirit is always about freedom: total freedom. What attracts me is the idea of the street as a canvas. Isn't the street itself art? Graffiti proposes something along those lines, although not exactly that. It presents the street as a canvas. But the canvas has no meaning until and unless artists, in this case graffiti, adds its touch to it.

JG: Context is all important for art, just as it is for communication, and as your remarks suggest, it is part of the art, just as it is part of a text. Shouting *fire* in a crowded theater and in the field of battle means something very different, as I said before. Likewise, the place where a piece of art is located influences the art, and in some cases it is part of the art itself. Most street art is perishable, existing only on a sidewalk or a wall. On a sidewalk it perishes as soon as the rain comes and washes it out. On a wall, it might last longer, depending on the durability of the materials. The surface on which art rests is certainly part of the art, if there are undulations on it, if the sun hits it in a certain way during certain hours, if it is next to other street art. Frescoes depend on the surfaces on which they are painted. But this is not the only reason that a wall or sidewalk might be part of street art; it is also because the street itself is a concept that alters what the artist does. Street art is not the same as "high art" or "church art." Street art is an art for the street, for the place, for the people. And this is different from art for a living room, for a palace, or for a museum.

This brings me back to a remark you made earlier, suggesting that something happens to street art when it is taken out of the street and

put in a museum. Surely art taken out of the street is no longer street art since it ceases to be rebellious, to be a protest, becoming instead part of established art. In short, it becomes something else. But then we may ask, what makes a piece of art what it is, have the identity it has? This is a fundamental question for anyone interested in art, and perhaps we can talk about it here.

IS: Let me try to answer it, or to begin to answer it, by complicating the issue even more. Loci are crucial in any perception. The art left behind by our remote ancestors in the Chauvet Cave, in southern France, has meaning because of its location. Were we to take it out of the cave and place it in the middle of a park in New York City, its meaning would change instantly and dramatically. Something similar would take place if he took Diego Velázquez's *Las meninas* out of Museo del Prado, in Madrid, and placed it in a garbage dump. Even though art is easily movable these days, with exhibits transporting works from one site to another, the concept of an artistic space is very much with us, no matter how loose our definition of it is.

As for the street as a place to display art, graffiti is only one of the many features that might be present in it. For the street—the world—is an incredibly busy place. I say this because graffiti competes for our attention with plenty of other things. One of those things is advertisement. That's what I want us to focus on for a bit. Ads are generally not considered a form of art. Yet we regularly refer to them as original, insightful, even artistic. Yes, there's a sharp contradiction here because advertisement is like prostitution: it is pleasure manufactured for mercantile purposes. Incredibly talented people go into it. They are constantly coming up with new ways to make us do what the companies that hired them want us to do: buy something. Art doesn't have that function. It doesn't often want to persuade us. But it uses images strikingly similar to those employed in advertisement to generate the aesthetic experience in us. And, in doing so, these items are also capable of pleasing the senses.

It seems to me important to relate graffiti to advertisement because they both share the same space, both use artistic devices, and both generate pleasure. Yet they are also incompatible in that graffiti is about rebellion whereas ads are about conformism. Or are they? A strong current in

advertisement is intimately linked to rebellion. Buy this pair of jeans, an ad might say, and you'll be perceived as a rebel. Particularly among adolescents, advertisement has much to do with the opposite of conformism: with antagonism. And in order to make certain items look attractive, advertisers might use graffiti elements. Indeed, I've seen plenty of recent ads in which graffiti font, graffiti images, and the overall graffiti aesthetics are used to persuade the consumer to buy a product. Think about it, Jorge. Just as museums appropriate graffiti, putting it out of its own natural context, so does advertisement use the subversive qualities of graffiti to do exactly what it didn't intend to do: be part of society.

JG: Since you are enjoying complicating matters, let me complicate them even further. I could never shy away from complicating. Complicating means that one is not satisfied with the easy answer, the easy analysis, the items that have been considered. Complicating is an answer to an oversimplification of something that is more complex than one thought, a response to a feeling that something is missing. It is a sign that we need to look at the questions we are considering more carefully.

One complication that may be brought into our conversation has to do with what makes graffiti what it is, what its distinctive character is. The term *graffiti* itself is derived from *graph*, which is an abstract drawing representing numbers and relations. But today graffiti extends beyond drawings and includes designs and paintings made in public places where such items are not allowed. Whence comes the sense of something forbidden, something that violates social rules, and the idea that graffiti has as a purpose a protest against the status quo. Graffiti challenges social rules by breaking them. Any kind of drawing, design, or painting that does not follow this pattern is not graffiti. Take the subway. Cities profit by allowing advertisements on subway cars, both inside and outside. But this is not graffiti, because this is allowed. The same happens with public murals and mosaics sponsored or allowed by the government. It is not anything particular about the medium, the context, or the design that makes graffiti what it is. It is not even the fact that it may defile the surface on which it is found. It is rather that it is against the law.

If this is so, then whether graffiti is art or not has nothing to do with it being graffiti. Some graffiti is art and some is not. Is BEAR_TCK's *Chicano*

Graffiti art or not? Whether it is art or not depends on something else. So we are back to the question I raised a while back. What makes art what it is and different from things we do not consider art? This topic is one of the most controversial that anyone has ever taken up, so I doubt we can make any headway on this here, but do you want to tackle it?

IS: The way you put it, I'm prone to think of censorship and its benefits. Yes, its benefits and not its limitations. Censorship depends on prohibition. But prohibition can have a benign effect on society because it forces society to recognize its parameters. What is censored is often alluring, even more so than what is endorsed. Likewise with graffiti. You're right that not every doodle painted on a street wall is graffiti. But in my view the graffiti that is most attractive, although not always the most artistic, is the one that emerges out of prohibition, the graffiti that needed to be painted with stolen aerosol cans in the middle of the night. Other graffiti-like pieces might be more sophisticated, but they fail to emerge from a restrictive environment.

Clearly I'm not delving into your question of what is art because it is an impossible one. But I'm inviting you to think of artistic manifestations produced in a prohibitive situation. Doesn't that attitude inspire the mind? Doesn't it make the creative juices flow in a more distilled fashion?

JG: I can understand your hesitation to get into the question of what art is but I am sorry you did not take the bait. After all, we are discussing art works and it would seem to be strange that while doing that we do not touch on the very fundamental issue, at least a bit. But have it your way for the moment. I think at some point before we end these conversations we will get back to this fundamental issue.

IS: No, wait: don't let me out of this so easily. I do want to answer your question of what art is. And I want to do it in connection to graffiti. For I found a sentence of yours intriguing: some graffiti is art and some is not. To be honest, I had started the discussion in this chapter under the premise that graffiti is a response to conventional art and that such response might look chaotic, and indeed it is, but in its chaos it is art. It's a false premise, no doubt because graffiti in itself offers a wide range of possibilities: from

scribbles to sophisticated depictions of human emotion, such as the ones BEAR_TCK has given us. Where is the line separating the two? In *Chicano Graffiti*, the artist depicts a *vato*, a Mexican American man, through an unquestionably stereotypical lens. He is bald, has large lips, uses a bandana, wears earrings, his arm tattooed with the word *Chicano*, and he is holding lucky beads. His mustache is a caricature of the Pancho Villa look. Behind him is a fence, he is on a basketball court, and on top of him are the words *Puro Estilo* (sheer style), written in a baroque font. The index and middle finger of his right hand are a sign of swagger. The message is, perhaps, that alienation is power. Graffiti uses a particular geometrical look that has come to be seen as urban: the geometrical edges of letters are emphasized and splashy colors abound all over the design. Is *Chicano Graffiti* art? I have no doubt about it. This piece has clearly done with enormous care. The content has been meticulously crafted. It might look transient because it is made on a wall but the aesthetic value—a value, if I might say, that seeks to transcend time—is obvious. Art, as we understand it in Western civilization, is the product of individual talent. It is often signed. Some graffiti artists defied that tradition while others did insert their signature. On the vato's right side there's a sign forbidding the use of aerosol. It is not only a reminder of the tool used to produce the piece (spray paint) but also of the conditions under which it was done: not in an artist's studio, that is, in isolation, the artist away in his Ivory Tower, but in the middle of the city, with people around him. I wouldn't describe as art the hieroglyphics of a lesser graffiti artist. Any rebellious adolescent can produce such chaos, but BEAR_TCK is a master.

JG: OK, you have and have not taken the bait. But I will go along with you and move to censorship and prohibition.

At the outset, I think we need to recognize that censorship is different from prohibition. Censorship is a kind of condemnation, and it is usually related to what is considered to be a violation of an established belief or practiced value. Pornography is censored, for example, because it is considered to go contrary to the beliefs of a society or its practices, inspired by values it accepts. Prohibition is something different. I am prohibited from parking in certain places but this does not entail that I, or what I am doing when I do park in those places, is censored. Censorship carries a

certain moral and social authority. Moreover, censorship is often understood as censure, and in this case it is generally done after the fact. I can be censured for my conduct or a certain act in which I engaged. Prohibition is before the fact. I am prohibited from parking at such and such a place, and if I do I will probably be given a fine. So we are talking about two different things, and this raises the question of whether their beneficial or nefarious effects are the same, as well as of their relation to graffiti. Let me first speak to the relation to graffiti.

Obviously both graffiti and its author can be censored. Suppose that the graffiti contains pornographic materials and it appears in a public place where children play, or on the walls of a place regarded with reverence, such as a tomb of a hero or the wall of a church. This would seem a case that calls for censorship of both the graffiti and its author. But suppose that the graffiti has nothing objectionable in it, except that it is placed on a wall of a private home, or on a subway car. In this case we would not speak of censorship, but rather of violating a prohibition, the prohibition against using what is not yours for your own purposes without the permission of the owner, or the prohibition against defiling public property.

Now, the question that you raised concerns whether censorship or prohibition are in some sense good, even though we tend to think of censorship as bad and of prohibitions as somewhat confining. The answer seems to me to be that it all depends on the circumstances. Censorship can be good if the aim is good and bad if it is bad. The censorship of pornographic graffiti in a public square seems to be good, for its aim is to condemn an act, and prevent future acts, that go contrary to the good of society. But the censorship of dissenting opinions in a dictatorial regime is clearly bad, for the aim is the preservation of the dictatorship, rather than, for example, the good of the people. So your suggestion that censorship and prohibition have a good side to them is perfectly understandable, although your point is slightly different, namely, that both of these can be beneficial in that they provoke a reaction against the censorship or prohibition. This is right, although it has to be qualified: it is good only as long as the censorship or prohibition is just or constrains us in ways that are beneficial. Results cannot be the sole measure of whether an action is morally good or bad—what philosophers call consequentialism or utilitarianism, when exclusive, does not work. This takes us back to the ques-

tions we explored concerning Serrano's *Piss Christ*, although in the case of graffiti the matter is more serious insofar as the piece is out of the museum or art gallery and into the street.

IS: I agree with the distinction you make between censorship and prohibition. In the birth of graffiti, prohibition was an incentive. There were also cases in which a particular piece was censored because of its content. In 2011, as the Arab Spring was sweeping countries like Egypt, Tunisia, Libya, Syria, and others, I remember reading that in Beirut, Lebanon, graffiti painted on walls exhorting people in the country and elsewhere to march was erased because of the ideology it posed. However, the age of Facebook has pushed graffiti to a corner. Or maybe one could say that as a result of the social network, the kind of urban rebellion graffiti was known for in the eighties has made it possible to see graffiti in more aesthetic terms and perhaps that is why it now has a place in museums. While its political use has diminished (notwithstanding the example in Beirut), its artistic qualities are more appreciated. Let me also say that, as is clear from what I've just said, there are at least four different types of graffiti: bathroom graffiti, political graffiti, historical graffiti, and urban or street graffiti. All of them can be artistic although they are not necessarily.

Now I want to be the one pushing you. The title of this chapter isn't "Street Art," meaning that we're looking at the last category I listed in my previous answer. The title is "The Street as Art." Earlier on you asked me what constitutes art. Now I want to ask you: can an entire sign not specifically created by an artist be, well, artistic? Think not only of the wall where BEAR_TCK painted *Chicano Art* but of the entire neighborhood. With the artistic piece in it and without it, does the street, the neighborhood, the city itself have artistic qualities? Or think of a gorgeous Swiss landscape, a prairie where everything is bright and shiny and lean and in its perfect place. If one sees it, is it art? Does a photographer—the maker of a postcard—need to come to turn the sight into an artistic piece?

JG: Before I address your last point, let me go back to the kinds of graffiti you mention. What interests me in your list is that the various kinds of graffiti it contains can be grouped into different categories, depending on the basis of the categorization. Some of them might be gathered under the

category of, say, place graffiti, that is, graffiti that is classified according to the place in which it occurs. This is the case of bathroom and street graffiti, but others could be added, such as church graffiti, graffiti in a sports arena, school graffiti, and so on. Other kinds of graffiti, however, might be classified in terms of their content or the intention of their authors. This is so with historical or political graffiti, to which can be added erotic graffiti, religious graffiti, and commemorative graffiti.

In principle, it would appear that these categories are completely independent of each other and therefore that they can be mixed in various ways. One can have erotic graffiti in a school or a church and religious graffiti in a bathroom. But there are expectations. The overwhelming majority of graffiti in men's bathrooms in my experience is related to sex. Some are intended to arouse and others to communicate and so on, but the function is sexual or erotic. I have found very few instances of religious graffiti in men's bathrooms, although I have found plenty of cases of political graffiti in them. Does this tell us anything of significance? I think it emphasizes the social character of graffiti and its activist dimension. A museum seems rather an incongruous place for graffiti. The place of graffiti is public, a place where its message fits. So I tend to think that even when displayed in a museum, we look at it not as art, but as historical art that had a social intention and function. This does not mean that I disagree with you. Actually I agree with what I think is your first point. I am only unpacking it further.

Now as to your second point, concerning the artistic qualities of graffiti and their location, I think we need to make a distinction between aesthetic and artistic qualities. One major difference between the two is that anything whatever can have an aesthetic quality insofar as it causes an aesthetic experience in someone. Natural phenomena, such as sunsets or lakes, can be considered aesthetic because their contemplation causes in us an aesthetic experience, and so can objects that are the product of human design and production, such as a painting or a photograph. But natural phenomena cannot have artistic qualities. In order for something to be artistic it has to be the product of human intention and design. It has to be an artifact.

If I am right about this, then we have the answer to your question. The Swiss landscape has aesthetic qualities, but it becomes artistic only if it

is appropriated by someone. Say that an observer concentrates on some aspect of it, cutting that part of the landscape from other parts in order to admire it. And the city where the graffiti occurs can also be artistic insofar as it has the graffiti and is the object of artistic contemplation. But even without the graffiti, it can be artistic to the degree that it is an artifact and arouses an aesthetic experience in an observer. Art is always art for humans and by humans. It is the product of human design and intention and has a place in history. The world of objects independent of human design and intention may have aesthetic qualities insofar as it can be the object of an aesthetic experience, but it cannot be artistic.

But now that we are talking about the qualities of graffiti, maybe we should take up the issue of what makes graffiti, or any art for that matter, belong to a particular ethnic group, culture, race, or nationality. Does it make sense to talk this way, even though we do it all the time? The BEAR_TCK piece has for its title *Chicano Graffiti*. In what sense is it Chicano or can it be Chicano?

IS: I welcome the question, for it has been with me, in one way or another, for a long time and, in fact, goes to the essence of everything I do. Imagine for a second a traditional suburban living room. It can be in Long Island, although the location doesn't matter now. What matters is that, for purposes of this discussion, the living room is empty now. It has a sofa, a TV set, a series of chairs, a handsome carpet, square windows covered with soft curtains, a lamp, a piece of furniture in which photographs are displayed as well as other memorabilia. Let's place the living room in the year 1970. At first sight, one would get the impression that the place is owned by an average American family. Average for this time and place means white and middle class: the Smiths. The looks of the living room tell me they are average; that is, nothing in this site inspires disquiet, inconformity, rebellion. The father, John Smith, grew up a few blocks away. He's a lawyer in his fifties. His office is in Manhattan. His wife, Jenny Smith, is forty-eight. She takes care of the two kids, Jimmy, age twelve, and Susie, age nine. She plays tennis, goes shopping, etc. Yes, I've taken an easy approach, embracing a stereotypical view, yet that is my point. However, what if, after being allowed into the house, we discovered another façade. This isn't the Smith family but the Figueroas. Pedro Figueroa grew up in

East Los Angeles. He's a Chicano lawyer. His wife is Jenny and his kids are Jimmy and Susie, all same age as above. The difference, as you might suspect, is dramatic. In 1970, there were few Chicano lawyers. The most activists among them were involved in the civil rights upheaval we have come to know as the Chicano Movement. In my eyes, Pedro Figueroa is a rebel, although an atypical one. With a lifestyle like this, he's rebelling against rebellion, saying no to the agitation Mexican Americans and other minorities are engaged in. Once you know that information about him, the living room no longer feels a quiet, conformist place. Or, rather, it is a refutation of what Chicano culture is.

The question you asked—in what way is *Chicano Graffiti* a Chicano work of art?—brings us back to the issue of authorship, although it allows us to approach it from a different slant. How much does the viewer, we in this case, need to know about the artist in order to understand the work? How much should I find out about Dostoyevsky before reading *Crime and Punishment*? The answer is it depends what I'm looking to find in the novel. If what I want is to get lost in a page-turner about Christian guilt in nineteenth-century Russia, to lose myself in a fictional world without regard to its creator, then I shouldn't read anything about Dostoyevsky before delving into the book. But if the novel is for me a literary exercise only Dostoyevsky could have written and my interest is not only what he wrote but what there is of him in the work, then the author's identity is crucial. I might read the novel without finding out too much about it and then get a biography of Dostoyevsky, or vice versa, read the biography first and the novel second. One way or another, *Crime and Punishment* offers infinite clues about who wrote it, what the author does think of the time, place, and society in which he lived, and the kind of moral views he holds.

If I didn't know the title of BEAR_TCK's piece, I would still get substantial information from the graffiti piece. The protagonist dresses as a Chicano. The paraphernalia on display is inspired by Chicanismo. Of course, a non-Chicano could have painted it as well. Would it have been an act of imposture as a result? Does the artist need to come from the ethnic experience to represent it? Here we enter the muddy terrain of essentialism. I for one don't believe in culture as a ticket to authenticity. If I lived thirty years in Russia, I think I would know the country well enough to write a Russian novel. Would it be unlike anything written by a native

Russian novelist? Then again, precisely because I came from the outside I can offer a view of life that is unique. Which one of the two novels, the one written by a native author or the one I write, are more Russian? The question is meaningless.

Going back to my hypothetical living room, over the years I've sought to inform myself about BEAR_TCK. Who is he? Where does he come from? What kind of life has he led? I don't know much about him, in part because he shades himself from the "bourgeois" artistic world in which the artist is the star, the principal source of attention. What I know is that he called his piece *Chicano Graffiti*. Not just graffiti, but *Chicano Graffiti*. To me that represents a nationalistic, ethnocentric stand. He doesn't want us to see his work as unrelated to the particular ethnic culture he is seeking to emphasize. By emphasizing it he is injecting politics into his creation. He wants us to see it as defiant. Look, he says, this Chicano dude is different; he's original, he's not an American middle-class conformist.

Curiously—maybe the adverb I ought to use is *fascinatingly*—BEAR_TCK (he spells it with lowercase *e*) isn't a Chicano by birth; that is, he isn't Mexican American in origin. Does that matter? How is a Chicano made? And do you have to be a Chicano to produce Chicano art? The artist was born in Uruguay but has lived in Madrid since his early childhood. He was inspired to paint hip-hop and Chicano culture. I ask these questions because I myself have been involved in such efforts to understand my own art, intellectual endeavors, and identity as a Jew, a Mexican, and an American. What makes me a Jew? I was born in Mexico to a Jewish family. What makes me a Mexican? The same answer: being born in Mexico to a Jewish family. And why am I an American? Because America is both a continent and the name we often (and mistakenly) use to refer—in English—to the United States, where I immigrated in 1985. My Jewish identity is a particular field of ambiguity: Marcel Proust was of Jewish descent but didn't care about it; Franz Kafka thought himself a Jew but never used the word Jew in his literature (although he did quite often in his diaries and correspondence); Borges wasn't of Jewish descent but dreamed of wanting to be Jewish. So who is a Jew?

Likewise, who is a Chicano? Of course, the two aren't the same. Maybe what we're talking about here is the difference between Chicano and Chicanesco art. A similar difference can be made between Gaucho

and Gauchesco literature: the first is poetry done by gauchos, the second is poetry about gauchos by city people interested in rural life. In this typology, BEAR_TCK's is Chicanesco art. Should we care? Can a Jew write Mexican literature, create Mexican art, be considered authentically Mexican?

JG: You rightly brought the author to bear on our question, a move that is in line with your interest in the mind behind the object of interpretation, whether that mind belongs to the author or the interpreter. But here I want to introduce a wrinkle, a complication, which was first effectively raised by Foucault. It can be best put in terms of a question: Who is the author? There is a naive answer: BEAR_TCK is the author of *Chicano Graffiti*.

But this is too simple, in that it does not tell us exactly who BEAR_TCK is. Indeed, even though we have a name, what is the identity behind it? I, for one, know nothing about BEAR_TCK, whereas you tell me that you know more because you have taken pains to find out about him, although your investigations have not yielded much. Clearly, the BEAR_TCK I think about is different from the BEAR_TCK you think about, and this gives us different grounds for interpreting the work. These BEAR_TCKs we think about are what I called the "pseudohistorical author" in *Texts* (1996). These are the personae we think the author of the work is, although they are in fact our ideas of who that author is. I describe them as "pseudo," because they are creations of the interpreters based on selective information, inferences, and interests.

Even this clarification is insufficient to bring light into the situation, for in addition to what you and I may think, there is also the person who actually created the work, which I call the historical author, the historical person BEAR_TCK, in the case we are considering. Foucault thought this person was a myth insofar as it always amounts to what I called the pseudohistorical author, that is, a creation of the interpreter. But I think that, although we might have limited access to this person, and perhaps in some cases none, we can still conjecture his or her existence. Surely there is someone who created *Chicano Graffiti*, an actual person, whether he or she is who we think he or she is or is not. To the historical and the pseudohistorical authors, I like to add the *interpretive author*. This is no

other than the interpreter of the work, for an interpreter to a great extent reconstructs the object of interpretation, and if that is not to be an author, then what is?

So, after all, even if you are interested in the mind behind a work, you do not have a simple task ahead of you, for you will have to negotiate on the identity of the mind that you will pick to explore the mysterious BEAR_TCK. Indeed, whatever you find out about the historical BEAR_TCK will tell us very little about the mind behind the work, for the mind is really not observable by anyone other than BEAR_TCK. You might conjecture all kinds of things about what BEAR_TCK thinks based on the facts of his life, but you could be completely mistaken about who he is. It is altogether possible that his art and much of his life is a purposeful deception, and how could we decide that it is a deception or it is not?

Rather than the mind, I would approach the question of Chicano art, and of ethnic art in general, from a perspective I brought up before, the history of the person. A person is a historical reality that has many observable dimensions, although it also has some that are not observable. And these observable dimensions might be sufficient to give us clues as to whether the person is Chicano or not. Take me, for example. Am I Chicano? Surely not. Why? Because to be Chicano requires certain historical positioning in a group of people, and I have no historical connection to them. And it is this historical context that explains some of the characteristics I share with some Cubans but that separates me from Chicanos. Is BEAR_TCK Chicano? There is no easy answer. And what about his art? Perhaps it is even more difficult to find a convincing answer.

Unfortunately, we must bring this discussion to a close, but I think we are ending it on a high note, a Socratic one, namely, with a question. This ensures that we will have something to discuss when we meet again.

DESPERATE ESCAPE

JOSÉ BEDIA *Siguiendo su instinto*

Jorge Gracia: There are not many Cubans who are blond, and those who are often tend to turn their backs on things associated with the African component of Cuban society. This component is so pervasive that some people identify African ancestry with being Cuban. Even though I am not blond, many Americans, Anglo and otherwise, when they meet me for the first time and learn that I am Cuban, say something like, "But you do not look Cuban," assuming that because I do not look black I am not Cuban, or not supposed to be Cuban. Cubans should look black, and perhaps be black.

The history of Cuba from the moment that Columbus landed on its shores has been closely tied to Africa. At the very beginning of colonization, black slaves were already being brought into Cuba to take the place of the Amerindians who inhabited the island and had been decimated by forced labor and the diseases the Spaniards had brought with them. So many Africans were brought as slaves to the island that at the dawn of independence there were three persons of black or mixed ancestry in Cuba for each white, and the mixing of blacks and whites has continued to the present. The extent of it can be gauged from the question Cubans often

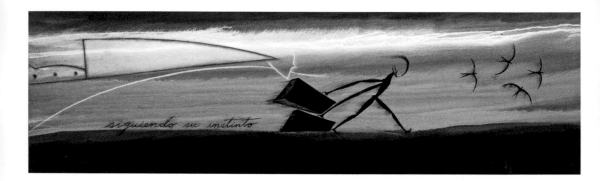

siguiendo su instinto

José Bedia, *Siguiendo su instinto* (2001), 18″ × 61″,
acrylic on canvas. Used by permission of the
Galeria Ramis Barquet and the artist.

ask in jest of each other: "Where is your grandmother?" We think that many families who try to pass for white, keep a grandmother hidden in a closet because she is obviously black.

Most people who are white or appear to be white in Cuba tend to favor European ways and to identify with either European or American culture. The higher the social status, the more identification takes place. But there are many exceptions, and one of them is José Bedia. He is a true blond, although with age his hair has turned darker and now it is streaked with occasional gray highlights. Instead of rejecting the African component of Cuban culture in favor of Europe, he has embraced it in extraordinary ways, most evidently in his art, where religion plays an essential role. African rites and symbols permeate his work, but he is no mere dilettante. Bedia has delved deeply into the African religious traditions that blacks brought with them, studying and practicing their rites. He is convinced that these original religions hold something important that has been lost in the modern world. And he has not stopped there. His desire to know about these foundational ideas have led him to Africa, and also to the indigenous religions of America and other parts of the world.

Bedia has traveled widely, searching for the wisdom of still-practiced, ancient faiths, for knowledge of a spiritual world on which the modern world has turned its back. This is no mere curiosity of the specialist; Bedia truly believes in the forces that move those who practice these religions. It is part of reality, the reality in which he lives every day. And since reality is what art is all about, Bedia has incorporated his understanding of the spiritual world into his work, meshing it with other concerns that also attract his attention, creating an ambiguity of meaning that is part of the depth he brings to his art. This syncretism is very far from the various trends that have characterized twentieth-century art. It has nothing to do with abstraction, formalism, expressionism, portraiture, and the rest.

Among the many pieces that illustrate this approach to art, *Siguiendo su instinto* (Following his instinct) is one of my favorites. The piece is divided into four strata, as if we were looking at the layers of sedimentary rocks accumulated throughout the ages, the layers we see on the highway when the road has cut through the rock to make way for it. The bottom and top layers are dark, although with different tints, more brown at the bottom and grayer at the top, and with the bottom layer being thicker, giving

weight to the piece. Between these two layers two others complete the picture. The two top layers narrow as they go from left to right, making room for the two lower layers, which thicken in the same direction. The bottom layer is divided from the next layer by an imprecise reddish divider, and ranges from a very light ochre to a most prevalent version of yellow streaked with ochre. This is the wider layer and the one where the main action of the painting occurs. Above this we see another layer in various whites, with subtle allusions to pinks and grays.

Three main images and a set of four birds huddled together make up the composition. Almost at the center we have a figure Bedia often uses in his work, the man-deer. This is a symbol of the continuity between humanity and the animal world, the world of nature. It is a symbol of a spirit related to the Afrocuban deity Ochosi, who plays a role in both Yoruba and Konga religions. Ochosi is the god of the hunt and has been identified in Catholicism with Saint Norbert. Here, as in many of Bedia's other works, Ochosi represents himself, humanity, and the artist. He is running fast, as if he were escaping from something ominous, and he holds tight the two suitcases he carries. His breadth shows the exertion of his effort. Ahead of him is the flock of four birds, leading the way and helped forward by a heavy wind that originates in the outline of a human profile blowing hard in their direction. This, again, is a common motif in Bedia's art, and stands for the spirit that moves humans to act.

Within this spirit is another common motif Bedia uses, a knife, very large in this work, symbolizing the danger from which the man-deer is fleeing, but also the sacrifice entailed by the flight. To flee means the separation of oneself from much of what one is about. The man-deer carries only two suitcases. He appears naked, despoiled of every possession. It's a flight in a hurry, instinctive, desperate, as the title suggests, perhaps at dawn or at dusk, just before disaster strikes. The knife is depicted in the third layer of the painting and blends into the landscape almost like hills on the horizon. Its handle has three dark spots marking the places the wood of the handle is tied to the metal blade. Why three? Elsewhere in these conversations we have discussed the symbolism of this number and how it has religious connotations of great importance, which surely are present here as well.

Obviously, although in fact nothing is obvious in art, this work is about

a trip, a flight, an escape, the abandonment of a place for another that is still uncertain. Where is the pilgrim going, where is he escaping, where is the safe haven? And will it be in fact safe and comfortable? The instinct of flight when threatened is common and for Cubans who have left our native island is a reality that has been lived and continues to be lived every day. And the three top layers of the painting suggest a flight to the sea. At the top, a dark sky, below which there is rough sea crashing on a sandy beach on which the man-deer is running. But there is also another side to the work, and that is the spiritual flight that we can take if we are willing to cut our ties to a life of drudgery and move into the spiritual realm or the realm of art. Here we receive help from the world of spirits, from nature, or from the freedom of art. Many questions come up depending on the interpretive road we take.

Ilan Stavans: You started this conversation by calling attention to the issue of race in Cuban society. Since you aren't black, people often tell you that you don't look Cuban. That is because in peoples' minds there is an archetype (as well as a stereotype) of what a Cuban should look like, even though a portion of the Cuban population isn't black. I'm defined by the same dilemma and have written about it in *On Borrowed Words* and elsewhere. I'm the descendant of Polish and Ukrainian immigrants to Mexico, all of them Jewish, all of them Yiddish speakers from what was called "the Pale of Settlement," the only section in Eastern Europe where Jews were allowed to settle. I didn't come to the United States because of political reasons, as you did. I came motivated by the desire to become a writer in a free, open society. I don't look Mexican. Yet a few weeks ago, while on a trip to northern China, close to Mongolia, while participating in a writer's festival, I was told I was probably the first Mexican ever to visit the city of Yinchuan. I don't know if this is true. I was told that Yinchuan, in the Ningxia Province, has a population of a million people. Could I really have been the first Mexican in this remote place? People approached me as if I indeed was. They asked me questions about Mexican food, about Mexican customs. They photographed themselves with me as if I was a creature from another planet. And suddenly it dawned on me: the people of Yinchuan probably thought all Mexicans look like me. So was I supposed to tell them that, yes, I'm Mexican, but I'm also a strange kind of Mexican, a

non-Mexican-looking Mexican? What would they have done hearing this convoluted explanation? Wasn't it better to leave it alone, to let them—however many would eventually do it—discover that for themselves? I've also thought that perhaps they knew the conundrum my presence posed to them and that's why they took so many pictures with me: because they had seen Mexicans on television and in the movies and I didn't look like one. Was I then the one upon whom the joke was being played?

I now want to tell you a story about the spiritual realm. A couple of years ago, during a trip to Bogotá, Colombia, to visit a shaman who has been a friend of mine for some time, I was invited to participate in a religious ceremony that included ingesting *ayaguaje*, a hallucinogenic. I was part of a group and thus not alone in the ceremony. Somehow I was responsible for the well-being of the group, so at first I resisted the idea of actively participating in the ceremony. But my friend persuaded me and I finally did. The experience I had was beyond anything I had ever gone through.

The ceremony started late one night. We were in an apartment. There were twelve of us. I was the leader, not only because of my age (I was approximately forty-six) but because I was a teacher and a writer and had been instrumental in organizing the trip to Colombia. A large mestiza woman with long, dark hair, and who was a *curandera* (a woman healer among the native population), sat next to a previously set table with all sorts of artifacts: candles, incense, a bottle of water, two guitars, a couple of buckets, tissues, some alcoholic beverage. People were asked to confirm they were ready to participate in the ceremony. The woman's two grown-up sons were near her. They took the guitars and started playing. It must have been around ten-thirty or eleven P.M. The music they played all night was deliberately repetitive: the same set of notes, time and again. The purpose was to induce us into a hypnotic state. One by one, we drank a sour potion made of a thick, dark substance. The curandera asked us to swallow it straight without tasting it, because the flavor was disgusting. The two sons began singing. Soon people started to fall into a trance. They appeared to be gone, in another universe. A few vomited, others shat themselves. For hours the only thing I could see were my friends in a state of shock. The hallucinogenic took longer with me than it did with the others. Every so often, the curandera would ask, in the third person, is

el profe ready? Up until then I simply observed my surroundings, patiently, scrupulously. Suddenly I felt the urge to vomit. I bent on my knees and puked in one of the buckets, which at that point was already full. Then I felt a bizarre, unexplained sensation: I stopped being myself. I ceased to be Ilan. In fact, I was no longer human. Instead, I had become a jaguar. I felt like a jaguar. I saw the world as a jaguar. My ears were those of a wolf. I had sharp teeth. I howled. I meandered around. I smelled people as if I was an animal. Yet I was conscious that I was a jaguar. That is, my capacity to reflect, to think, and to think that I was thinking, was fully with me. I had left the human realm yet I could see everything around me through the consciousness of a human being.

I'm telling you my story of initiation because it is the first image that came to my mind when I saw Bedia's beautiful painting about a journey, an escape. A deer is a deer is a deer, but when I first saw *Siguiendo su instinto*, the image I had in my mind was that of a jaguar. The curandera told me the following day, hours after the ceremony had concluded and hours after many of us had fallen into a deep sleep, a sleep in which we had managed to somewhat recover from the earth-shaking experience, as if we had jumped into an abyss and then suddenly—magically—bounded back, that she hadn't been surprised at all that I had transmuted into a jaguar. She said that my personality has strong affinities with the jaguar. That jaguars play an essential role in various indigenous mythologies. And that one day I might want to let myself go more freely, allow my attachments to civilization loosen up, and I will find my empathies with jaguars. She said I would become an even stronger person, a person more aware of my instincts, my awareness, less controlled by the tyranny of my intellect.

JG: The use of hallucinogenic drugs is a common denominator in certain religions to help those participating in their rituals to get into the appropriate mood, or see images, and perhaps more importantly to help them transcend a daily reality that might interfere. Considering that I came to the United States at a time when drugs were becoming very popular, particularly among those of us who were opposed to the Vietnam War, you will be surprised to learn that I have never used any. One can find many reasons for this, I imagine, but the main reason is that I grew up in a

family in which naturism was a strong influence. We were taught to avoid anything that would induce artificial states of any kind in our bodies, anything that tampers with nature. I grew up suspicious of drugs and did not even smoke in spite of the pressure to do so by my peers in the country of tobacco. Indeed, even when the need to take an aspirin to lower a fever was obvious, the dose we used was a quarter of a pill!

This did not mean, however, that there was no interest in spirituality in the family. Indeed, reading religious texts from India, the practice of yoga and the purification of the body through meditation were practices in which we all engaged at some point or another, and which I practice to some extent to this day. So I have never felt the need for induced states of consciousness. I can get high without any help from any quarter. Perhaps it is not the same high induced by drugs, but it certainly carries with it most of the signs of drug-induced highs, except that reason is never surrendered.

I do not criticize those who use drugs in religious ceremonies and practices, because I do not know what it is all about and as long as I do not see any ill effects from those experiments, I cannot find myself condemning anyone for engaging in them. Moreover, I see the need to understand that we live in different realities. One is the world of nature, in which we are immersed when we join the unspoiled land, mountains, and oceans. Another is the world of culture, a creation of humans who build structures, create art, and engage in science and philosophy. And the third is the world that transcends both of these. This is a world beyond both culture and nature, a world that religions and philosophers try to explore and make available to us. All three seem to me to be important insofar as humans encounter all three in one way or another, in part because these worlds are not completely separate from each other and may be dimensions of one another or of the same reality.

One way to read Bedia's painting is to think about it not as a metaphor for his emigration from Cuba, but as desire to escape the world of culture, aided by nature, into the world beyond. The man that we see in the painting has the head of a deer, so he is part of nature, and he blends into the landscape, moving toward a goal, aided by the birds that seem to guide him. Nature signals the way for him to follow. Perhaps the knife delineated in the mountains suggests the abuse of nature by humanity, a place

from which Bedia wishes desperately to escape by following his instinct as an animal. Yet, even in his flight, he carries culture with him, the two suitcases he holds in his hands, because humans are both part of nature and culture. Yet, his ultimate purpose is to transcend culture through nature. What is beyond? That we do not see, because it is perhaps not possible to see it. The transcendent world becomes an unspecified end the shape of which he cannot know, but hope. And hope is a spiritual virtue that both transforms and leads us in spite of its delicacy, "a thing with feathers," as Emily Dickinson would say.

IS: I'm in agreement with that interpretation. I can see the Cuban journey you've described, but since I'm not Cuban, that dimension doesn't speak to me loudly. The journey symbolizing the escape from culture is precisely what my first reaction was about and the connection between the deer and the jaguar emphasized that connection. The question is, why do we dream of escaping the world of culture (that is, Western civilization) when the impression we have living in it, or the impression we want to give, to ourselves and to others, is that it's superior to other forms of culture, to the point that we see those other forms as primitive, awkward, archaic? We're talking here of the myth of escape, about which Freud wrote in *Civilization and Its Discontents*. But again, Freud, while touching on crucial philosophical points that define us as a culture, strikes me as rigid and formulaic. That myth of escape is patent in Defoe's *Robinson Crusoe*, in More's *Utopia*, in Voltaire's *Candide*, Swift's *Gulliver's Travels*, in H. G. Wells's *The Time Machine*, in Kipling's *Kim* and *The Jungle Book*, in Golding's *The Lord of the Flies*, and in so many other stories that are part of our literary canon. We simultaneously dream of other realities with envy and condescension. Escape, escape—what is it about our culture that suffocates us? And isn't art, like Bedia's painting, a way to express that longing for a more primitive side in us and to therapeutically overcome that longing?

JG: Yes, and we should add Thoreau's *Walden* to the list because it emphasizes a dimension of the escape that is not as clear in other sources: the aim of escaping civilization altogether and going back to nature and the natural man. The spirit of Rousseau is alive and well everywhere. I re-

member in the late sixties how hippies, disgusted at the Vietnam War, which they took to be the epitome of American culture and imperialism, emigrated to Canada, where they settled in farms and raised chickens in quasicommunal societies. Who among us has not once sat by the sea and longed to leave behind all that humans have created and that suffocates us, turning back to a time when we lived away from cars, houses, institutions, and regulations? Who has not dreamed of shedding the clothes we wear, figuratively and really, and running naked through a prairie? Remember the fashion of streaking years back? When I was in college, during one summer I worked with other college kids in Buildings and Grounds. After finishing our duties at one in the morning, we walked home. But some nights, when it was raining, we would take off our clothes and run naked through the campus with a feeling of exhilaration and freedom. We justified this with the thought that we did not want to get our clothes wet. But the fact was that our action had nothing to do with this. The reason behind it had more to do with a desire for freedom, getting rid of impedimenta, and going back in history to join our ancestors who painted the Lascaux caves and ran naked on the fields of France hunting game.

What was it that we were trying to escape? The tyranny of culture. In many ways I think of my life as a series of repeated attempts at escaping the shackles of cultural insularity. Having been born on an island, I longed to flee this circumscribed environment and join the rest of the world, to be liberated from the parochial social conventions that tied me down and particularly the too common narrow conception of spirituality peddled by many organized religions.

It is unfortunate that religion is one of the great oppressors of humanity. Not that it should be. Indeed, most of the great founders of religious faiths, particularly Christ, Buddha, and Moses, sought freedom. In the case of Buddha, it was freedom from suffering, in the case of Christ from what he considered meaningless regulations, and in the case of Moses from the tyranny of oppressive masters. We might disagree with their views, and we might or might not see them as divinities, but I think they express, more than any others perhaps, the longing for freedom.

IS: It is ironic, indeed, because religion—or, better, institutionalized religion—while trying to be the resource, the tool for social betterment, ends

up becoming a tyrannical force, establishing a moral code that instead of allowing people to be free, constraints them to a set pattern of behavior. Jesus Christ is the perfect example. One of the segments I like the most in *The Brothers Karamazov* is the one about "The Grand Inquisitor." What would happen if Jesus returned to earth? What would he see? How would he be greeted? In Dostoyevsky's view, it is the very Catholic Church that wouldn't know what to do with him. Why? Because his revolutionary ideas have been institutionalized. Jesus Christ's vision of salvation has been channeled through a hierarchical structure. In so doing, the principles he propounded have been turned into slogans. By definition, a slogan is a buzz sentence, an empty message. What I'm saying, Jorge, is that the search for freedom is innate to our being human, yet there are constant obstacles created by us as well that put that search at a peril. Alison and I like doing Yoga. Every so often, we find ourselves in a session in a city we just arrived in. The session enables us to escape the frantic rhythm we have, either because of work or as a result of family obligations. It is funny to me to enter a Yoga studio as I leave a traffic jam and return to that traffic jam as soon as the class is over. Escape, a moment of solace and silence. These are forms of escape, although they are transitory, momentary palliatives.

JG: How else to escape? Surely art is one of these escapes, but art, like religion, can also be tyrannical and have an effect contrary to liberation. For there is an art establishment, of which we talked before, and this establishment often rules tyrannically. It tells us what is good or bad, what is permitted or not, and who should and should not be an artist. The artists that fit its mold have enormous success, but those who, like Van Gogh, do not abide by its rules, are marginalized. It is curious that precisely the most obvious avenues of escape can become the most stifling!

But there is more in that the very escape presupposes the tools given to us by the culture from which we wish to escape. This is clear in Bedia's painting. He is escaping, but he carries his bags, and the bags are no doubt filled with things from which he is trying to escape. Indeed, the bags themselves are cultural objects prescribed for travel by our own culture. Can we ever begin with a tabula rasa? Can we wipe out the past and begin a new? Every attempt at doing it seems to end in failure and frustration. Think of Descartes's famous intention to begin philosophy anew,

forgetting everything that went on before him, and particularly every-thing that had to do with scholastic philosophy! What a failure and cant that was! Because the very formulae he uses to break through had already been used, almost verbatim, by Augustine, and the very argument that is the basis of all his philosophical thought—that there is some truth that we cannot doubt, the *cogito, ergo sum*—is again a move Augustine had made. So, yes, as you say, this supposed escape is a myth, a bait we hang in front of us to hope for something different and make us do certain things that at the end do not result in freedom but in a new form of slavery.

IS: I don't want to ignore the message in Bedia's painting *Siguiendo su in-stinto*. The title itself pinpoints the force that often pushes us to search for escape: our instinct. Our daily life is a balancing act that oscillates be-tween wanting to conform and wanting to rebel. To conform is to accept the social rules we live by, to rebel is to defy those rules, to either run away from them or to rearrange them in order to make us feel more comfort-able, less constrained. Escape comes in many forms. It can be a voyage such as the one Bedia presents. That voyage can be external, the actual movement from one location to another, as in going on vacation, or taking a break from routine. It can also be an internal voyage, which means we could stay in the same place yet be moving our inner world. That inner change is sometimes connected with hallucinogens, as in the religious ceremony I described to you at the beginning of this conversation. Or it can be an existential voyage of enlightenment.

I want to return to a point you made before: art as escape. I myself have talked about it in a number of places. What kind of escape does art offer? You said that art can be tyrannical as well. It surely can. Art as a form of escape certainly applies to the artist. Through the work, the artist seeks alternative universes. Or at least alternative ways of looking at things. My question is, is it true that art is an escape for the rest of us? Yes, when I go see a play, I escape my world and enter another. The same thing with a movie, a dance performance, a novel. This, however, is a cliché. Having a dream at night is also an escape. Sharing dinner with a friend. If you take this train of thought to an extreme, you'll realize everything is an escape: we're always looking for windows to see outside of ourselves. But are all these truly escapes? When one escapes, one flees, one interrupts a se-

quence. Too many escapes aren't an interruption; they are simply another pattern. A person who spends his life traveling doesn't see a journey in the same way a person who travels irregularly does. Indeed, for a person who travels regularly escape might be the desire to engage in some form of routine. This makes me think of the use of the word *crisis* in Mexico. We Mexicans always say we're in crisis: psychological crisis, financial crisis, political crisis. However, crisis by definition is occasional, not frequent. Too many crises in a row negate the idea of a crisis.

In any case, I hesitate to look at art as escape. It is reductive. Art is often routine. Art is conformism.

JG: Well, yes and no, I'd say. We cannot generalize about this. For the artist, art is work, a way of life, and thus perhaps a kind of routine as you suggest. Many artists get up in the morning, go to their studios and work for a number of hours every day, just as you and I might do—certainly what I do, not as an artist, but as a writer of philosophy. I would not call this a routine, however. I would call it a habit, something we regularly do and are used to doing. Even in this sense one can conceive that art can be an escape. Many artists of various kinds say explicitly that art for them is therapeutic. It allows them to concentrate on something that takes their minds away from worries and preoccupations. This is something I've found to be true in my own life. In times of trouble, getting back to the habit of thinking and writing has been a lifesaver. In many ways it's like meditation; it focuses the mind on something that has nothing to do with the trouble you are experiencing. In this sense, art can be described as an escape. It's going away from something and finding refuge in something else.

Now, when it comes to nonartists, I'd say that for them art is neither a routine nor even a habit, except perhaps with few exceptions of people whose jobs have to do with art, such as museum curators, gallerists, and so on. For them, art is a new experience, even when they look at it frequently, because what they see is new and prompts novel experiences. You see, most art has the quality of novelty and creativity, something new that attracts our attention, and its contemplation makes us shift our focus to something different than the object of our previous concentration. It provides an outlet, a distraction, and in a way an escape.

So perhaps we can look at the Bedia in a different way. Perhaps the painting is about the escape that art provides both for the artist and the nonartist. In this sense the man-deer represents the artist escaping from the mundane, everyday routine in which we are inexorably immersed, or it represents the art observer, who through art enters a world of wonder, again different from the everyday. This seems to me quite in line with Bedia's own ethos, his search for something other and deeper than customary existence. Thus Bedia's painting, as its title suggests, becomes a flight of someone who follows his instinct, leaving behind the concerns of everyday life.

IS: José Bedia's art shares an approach with an artist whose art we're scheduled to have a conversation on: Martín Ramírez. Bedia is Cuban and Ramírez Mexican. Bedia is engaged with the world whereas Ramírez's odyssey, as we shall state, is about alienation. He literally escaped from a world that was too dangerous, too frightening to him. He didn't escape through art but through mental illness. Or maybe the right way of putting it is that his mental illness was a protective mechanism. Ramírez mesmerizes me in a unique way. I've written about him in *The Hispanic Condition* (1995), among other places. His work is stunning but his tragic life is what intrigues me: the artist's life as a statement. He seems to me a character in a case study by Oliver Sacks, the author of *The Man Who Mistook His Wife for a Hat*. Except that Sacks has a reductivist view of the mind. I used to admire him but every time I reread him I find it wanting. In any case, what links Bedia to Martínez is the bluntness in their *Weltanschauung*, the methodical way they depict reality. There's something a bit childish in them, and in Ramírez's case that something might even be the quality we come across in a person with autism.

In any event, I want to say one more thing about art and escape that relates to my last point. We tend to think of art as a window to the imagination. But a mathematician, a plumber, a housewife might be as imaginative as a painter, a writer, a dancer. Art is another tool, another route to enter the realm of the imagination. And what is that realm? The dimension where the items we're surrounded by aren't *only* what they seem. A rose is a rose is a rose. But it is also something more, more, more. To be imaginative is to have the capacity to bend things, to have a creative drive,

to reconfigure the environment that surrounds us. Artists do that but so do politicians, teachers, physicians.

I don't mean to say that you or I should actually be writing a book called *Thirteen Ways of Looking at a Bathroom Sink*. A sink is rather pedestrian. A plumber fixing in an imaginative was a sink that is broken doesn't turn that sink into a medium through which others will see life differently. Art does exactly that! But that doesn't mean that the imagination is a realm exclusive to artists. There are several forms of imagination and such forms are applied differently. To be imaginative often means to be able to escape a particular circumstance. But again, the word *escape* makes me uncomfortable. By writing stories, by crafting poems, I don't see myself escaping anything. On the contrary, a plot I develop often becomes a prison from which I feel I can't escape.

Luis Cruz Azaceta, *Slaughter* (2010), 84″ × 156″,
acrylic on canvas. Courtesy of the artist and Arthur
Roger Gallery, New Orleans. Used by permission.

THE HORRORS OF WAR

LUIS CRUZ AZACETA *Slaughter*

Ilan Stavans: What is horror? I recently typed the word into Wikipedia. To my surprise, I came out empty-handed. There are entries for horror films and novels. There's also a music genre called horror punk. But the word *horror* doesn't get its own entry. Why? Horror is the fear awakened in us by a site that shakes our very essence.

Jorge Gracia: Azaceta's *Slaughter* is indeed a horrific piece of art that shakes you up when you look at it. If the aim of art is to shock you out of complacency and stir your emotions, this is without a doubt art par excellence. This piece brings to the fore the horrors of war and human conflict. Humans have, from time immemorial, glorified war. War is a means to glory. It is about victory over our foes and their defeat. It is about discipline and cunning, about who is smarter and stronger. It is essentially the culmination of all that is masculine, macho. And it is about superiority, about triumphing against all odds. Where is the young man who is not filled with passion when reading of Achilles's deeds in the *Iliad*? What male does not long for the glory of battle in which he has the privilege of dying heroically rather than living a long and ordinary life? Think about Borges's story

"The South," in which the protagonist romanticizes his ordinary death resulting from an illness as that of a gaucho in a fight.

Our cities are full of war memorials that depict heroes. Arches of triumph grace our most important avenues and parks. They celebrate our struggles and victories. Only occasionally, by comparison, do they mourn the dead, and even more rarely do they dwell on the misery and pain that war causes. And understandably so, because if they did, we might think twice about fighting another war. The cost might be considered too great, and the glory too little. After all, what good is glory to the dead? And what good is victory at the cost of life? Is the young soldier whose remains are buried under a monument to his valor any better for the monument than the skunk whose body decomposes in the forest? In order to keep the machinery of war going we must ignore the miseries of war.

Azaceta's work brutally illustrates what societies do not want to see, dwelling on the slaughter, the dismembering, the butchery. It makes us wonder, for what? Ah, and here comes a dangerous possible answer: political gain. Certainly not for the glory of those who fight the war, because generals and political leaders seldom have to pay any price for war, and they are the ones who profit from it. They make the decisions; they send young fighters to their deaths; they articulate the rationales and justifications for war; they arouse the passions of society through their demagoguery; and they get the credit for victories. But they do not fight. Yes, they shed tears for the lost, but what good are tears to the wounded, the sick, and the dead? It is much easier, indeed it is wonderful in many ways, to be the commander than to be the soldier.

Azaceta has painted a landscape composed of layers, piled up on top of each other, strata that suggest perhaps stairs, a climb from horror to horror. Or perhaps even more grim and shocking, a kind of sandwich, with various layers of meat and fillings. A closer look reveals that the strata turn out to be human limbs or pieces of human limbs. In some cases they are compressed human bodies, faces, parts of human remains, still fresh from the cutting. Some are still alive. You can see the bones in the middle of the limbs, as you can see them in hams when you cut them. In a couple of instances, a face has completely disappeared into a mass of flesh except for a small ear that sticks out, in an effort to hear, to record something that happened. More often we see mouths or remnants of mouths,

open, screaming in a desperate attempt to communicate, teeth, tongues, throats, crying for attention, letting us know what we choose to ignore. In various places we see what look like Red Cross flags. Are they asking for a truce, a respite to take care of the wounded, in a field of devastation, before the slaughter goes on? At the top fly black flags, symbols of death, of armies and peoples gone mad, or are they a kind of joke, a bit of black humor? A succulent sandwich, indeed!

In one of the layers, three trucks on a road transport more limbs away, taking them on a climb, toward an unknown destination and coming from a dark, ominous structure, with stone walls, a dark hole, illuminated by a light. A slaughter house? This seems one key to the painting and to the theme it explores. Another is the layers that are interrupted at one point by greenery. This suggests that what we have here is a landscape, but it is a landscape of death, a field of battle after the fight is over.

IS: A succulent sandwich is an extreme image. There is a dreamlike element in the painting. Yes, madness, destruction. I also see the insinuation of black humor. Is there black humor in war? Should the fact that we send our children to it—to the slaughterhouse—be considered a joke? I have never been able to understand the rationale behind the enlistment of young people to fight a war for a country, whatever the cause might be, even if that cause is the struggle to overcome the spread of evil, as was the case of the involvement of the United States with the Allied Forces during World War II. How do you make a case for people to sacrifice their lives in favor of a higher cause? I know this statement denotes skepticism toward the idea of patriotism. This position of mine is an expression of the disconnection I feel toward any national paraphernalia: a flag, an anthem, the concept of "sacred soil," etc. To me these ideas are impossible to justify. We're all selfish brats, aren't we? Our only purpose is to defend our individual turf. In all honesty, I can't reconcile the individualism I see expressed in people all the time with the possibility that any one of them would at some point decide to leave behind everything he has in order to fight for a higher purpose. Higher purpose? What does that truly mean?

Azaceta's painting reminds me of a famous nineteenth-century story, "El matadero" (The slaughterhouse), by a romantic Argentine writer, Esteban Echeverría. It is an indictment of dictator Juan Manuel de Rosas's re-

pressive techniques against the liberal establishment. (His most famous opponent is Domingo Faustino Sarmiento.) The plot takes place during lent. Meat is scarce in Buenos Aires. At one point, a liberal wanders near a slaughterhouse. Its butchers bully him. They end up capturing the liberal and killing him in a horrible, violent outburst. All this is to say that the slaughterhouse is an invaluable metaphor for tyrannical regimes. The meat-processing company, the meat grinder, are symbols of the way right-wing politicians don't look at people as individuals but as numbers. These numbers serve to catalogue the meat those individuals are made of. Martin Scorsese has a lucid movie called *Gangs of New York* (2002), with Daniel Day-Lewis, that takes place in, among other sites, a slaughterhouse of the nineteenth century. Closer to us, the slaughterhouse is an allegory for the annihilation camps the Nazis built to systematically erase the Jews from the face of Europe. In short, the slaughterhouse is bestial, an expression of instinctual desire, a reference to what is animalistic in us.

JG: An interesting element of this work that should not be missed is that Azaceta has represented what military people refer to as the theater of war, the place of battle. A theater is a place where an enactment takes place, a performance by actors engaged in playing scripted parts. It is ironic that a place of battle should be referred to by this name, and it is suggestive that it is this place that Azaceta uses to represent the horrors of war. The irony is intended, for his rendition has a comic-book quality characteristic of his work that serves to make the point explicit, though indirectly. Dark humor is common in the work of Azaceta and a trait of Cuban art. The exaggerated flesh, bodies, and bones contribute to the irony and the absurdity of this so-called theater. A hole stands for a mass grave and a lamp perhaps for hope, a motif frequent in Azaceta's work. The image of minced meat and ground beef, connoted by the title, points to the destruction of the individual. The result of war is annulment, annihilation.

IS: I want to go back to something you said in your opening statement to this conversation: Azaceta paints what we don't want to see. Is that what art is supposed to do, articulate the thoughts, the fears, the ugliness we are but refuse to acknowledge as our own creation? When I was young, I was

fascinated with the concept, developed by the French theorist Antonin Artaud, of what he called "the theater of cruelty." Artaud believed that if you show on a theatrical stage all the violence we humans are capable of and often engage in, audiences would become somewhat immune to it. Immune and even allergic. Once outside the theater, that reaction would make us all less violent. It's the same logic applied to the title character of Anthony Burgess's *A Clockwork Orange* (1962): take a vicious gang member and expose him to an endless deluge of images of violence. That exposure would be therapeutic. Once the therapy is over, he'll become a flaccid, "normal" citizen. This behavioral approach, modeled after B. F. Skinner's book *Walden II* (1948), is a sham.

JG: Art has many purposes, as I think I suggested elsewhere in these conversations. Most great artists have dealt with ugliness, horrors, cruelty, and the like. Much of Azaceta's work explores these topics, which puts him in a great tradition of Spanish art. Think of some of Goya's *Caprichos*, but even more to the point of Goya's *Executions of the Third of May, 1808* (1814–15), and Picasso's *Guernica* (1937), whose theme is, like that of Azaceta's *Slaughter*, the horrors of war. Of course, *Guernica* refers to an actual and particular event, the bombardment of the town of Guernica by the Germans during the Spanish Civil War, and *Executions of the Third of May, 1808* purports to record the execution of members of the Spanish resistance against Napoleon's invading armies. In the case of the Azaceta, the reference does not seem to be to a particular place, historical event, or war, although its date suggests he had in mind recent wars fought by the United States.

Much art, however, isn't about the ugly and the horrific. Indeed, there have been times in the history of art in which art was thought to be about the beautiful. And sure, there is much that is, both in painting and other forms of art. Think about Balanchine's dance masterpiece *Serenade for Strings* (1934), Beethoven's *Moonlight Sonata* (1801), Monet's *Water Lilies* (1914–26), and Myron's *Discobolus* (circa 460–50 BC). There is nothing horrific about these, and yet they are great art. So let's say that we agree that art can be about the ugly and horrific, although it need not be. Still, one question that is challenging is the degree to which art can be horrific. Are there any limits?

I recently went to see a movie that had received excellent reviews by some critics, Gareth Evans's *The Raid* (2011). It is the story of a group of police that raid a building where a criminal gang resides. There is practically no instant in the film in which some limb is not being cut, some person is not being battered, and blood is not freely flowing, all in a most graphic way. This is an enactment of horror, of uninterrupted violence, the filming of an event as dreadful as the one depicted by Azaceta's *Slaughter*. Another notorious example is Mel Gibson's *Passion of the Christ*, which so concerned me that I edited a book on it entitled, *Mel Gibson's Passion and Philosophy* (2004). Do these extraordinary depictions of gore and violence contribute to, or detract from, the artistic value of the works?

IS: A horrific scene is one that has the power to horrify. Horror is the experience of intense pain, fear, or dismay. This comes when we look at a scene that involves blood, gore, violence, or dismemberment. Why do we have these reactions? Spinoza said that all things want to be preserved in their being. That preservation, in living creatures, involves an instinct. We protect ourselves from danger because we don't want to die, we don't want to cease to be who we are. And we protect those we love from danger because our being is defined by a sense of communion with those who are connected to us and to whom we feel a similar connection. The fear of death is the strongest possible fear. War is an open field where that fear is likely to be experienced. We support war when we believe that is necessary for the preservation of who we are as individuals. We reject it when we feel is unjustified.

Depictions of violence can have multiple purposes. Among them is the fact that they might memorialize an act of self-preservation. They could also attempt to make us aware, perhaps even immune, to the excesses of violence that surround us, not only during war but on a regular basis in the towns in which we live. I now come to your question: can a work of art glorifying violence be beautiful? It can. What about depictions of violence that aren't about glorification? The answer is yes, again. I'm thinking of some of the examples you listed, especially Goya's depiction of the Napoleonic war. The carnage is there in an unavoidable fashion. The viewer is confronted by it. Yet the images are masterful.

Truth is, violence has beauty. In 1927, Thomas DeQuincy published an

essay in *Blackwood's Magazine* called "Of Murder Considered as One of the Fine Arts." It was based on a satirical paper about some factual crimes committed in London. His argument is that murder has an aesthetic quality. Some years later, DeQuincy followed the essay with a sequel as well as a postscript. A number of readers have been influenced by his opinion, including G. K. Chesterton, George Orwell, and Borges. Since the standpoint is satirical, one might be cautioned to believe DeQuincy endorses the idea that violence is beautiful. Others have been categorically blunt. In her book-long essay *Regarding the Pain of Others* (2004), Susan Sontag discusses looking at photographs of other people dying, or at least suffering. In various places of his oeuvre, Slavoj Žižek also delves into the topic. He wonders, for instance, if Adolf Hitler went far enough and if our daily diet of violence is actually insignificant.

I want to approach the idea from a less political, more artistic approach. Scenes of sexual ecstasy are immensely appealing because we see humans on the verge, reaching a climax we dream of but are afraid to reach. The Japanese film *In the Realm of the Senses* (1978) is an example. These scenes can be vulgar but, as in the case of the movie, they might be extraordinarily beautiful. What makes them beautiful? The delicate, aesthetically refined touch with which they are presented. Images of violence can be equally inspiring. Will they make us less violent? No. Will they teach is about good and evil? Not necessarily. Will they satisfy our spiritual thirst? Sure.

JG: It was Plato who first argued that being, goodness, and beauty are coextensive, meaning that whatever is a being is, to the degree that it is a being, also good and beautiful; whatever is good is, to the degree that it is good, also beautiful and a being; and whatever is beautiful is, to the degree that it is beautiful, also good and a being. This famous doctrine was picked up by Plato's followers, including Aristotle and through him the scholastics. The scholastics dubbed it the doctrine of the transcendentals, because it concerned certain properties (goodness and beauty—there was also unity, and later others were added) that applied to every being, and thus transcended particular kinds of beings (say, cats and dogs).

There is some truth to this view, as there is to most views that are widely accepted by philosophers, although one can never be sure, for

there is also quite a bit of truth in Cicero's saying that "there is no doctrine so absurd that a philosopher will not hold it." Generally, a view is not accepted by philosophers just because someone holds it, but because they see some point in it. And it makes sense to argue that for something to be beautiful it has to be something, even if only in someone's mind. Nothing could not be beautiful, could it? It also makes sense that the beautiful must be good, for surely that which delights us—let's assume the aim of the beautiful is to delight—is also a good, precisely because it delights us.

In spite of what appears to be its prima facie sense, we run into difficulties when we look at works of art that do not appear to be beautiful and yet are considered to be aesthetically and artistically significant, as is Azaceta's stark representation of the consequences of war. Some authors who think that art concerns the beautiful insist that such representations are in fact beautiful. But are they? I rather think they are not. And if this is so, then much art cannot be considered to deal with beauty. Art must be about something else.

Accepting this conclusion leads us to the view that violence and ugliness can be part of art, even if they are far from being beautiful. Further, it leads us to the conclusion that the degree of ugliness, if you will, of an art piece has nothing to do with the value of the art. In short, there are no limits to the ugliness in art that comes from its opposition to beauty. If there is to be some limits to the inclusion of ugliness in art, they must come from a source other than beauty.

The value of the Goya's *Executions of the Third of May*, Picasso's *Guernica*, or Azaceta's *Slaughter*, then, should have nothing to do with whether they are ugly or beautiful. But this leaves us in a quandary, for I think that if we were going to ask ten people why they thought these pieces were great art, we would get ten different answers. Why? I do not think we can give an answer to this question unless we do it in terms of a theory of art, although we could try by saying that judgments of value concerning works of art are necessarily based on interpretations, and as I pointed out in another of our conversations here, the legitimacy of an interpretation depends on how it satisfies the aim for which it is given. So we could argue that the value of art would depend on the aim sought by the interpreter, the judge of the value. In the case of the three works mentioned, one could claim that they are great works of art because they successfully

describe the horrors of war, and that is the aim that our understanding of the works involves: the successful portrayal of the absurdity and violence of war, which is that about which we think the works are or should be.

This sounds pretty good, doesn't it? But frankly, I am not convinced. I like the view because it coheres well with my theory of interpretation, but does it explain the artistic value of the works? Well, yes and no, and this is not enough to satisfy me. In short, I am not sure this answer works, insofar as it does not explain why the works are great works of art as such, that is, qua art, for the explanation I gave might apply to works that have nothing to do with art. So what is missing? How can we justify a positive value judgment of these works?

IS: My way to respond to the question is by exploring the meaning of *beautiful*. Not the semantic meaning, which is the way we define the word. I'm talking about the cultural meaning of *beautiful*. Here we enter a Platonic realm defined by universals and particulars. Is there a concept of beauty that transcends time? Sure: the statue of David by Michelangelo was crafted centuries ago. It was considered beautiful then and it is considered beautiful now. In other words, beauty is capable of superseding a particular time and a particular space. On the other hand, ideas of beauty are always in flux. In Rubens's age, an obese woman was perceived to be beautiful. And not only women. His portrayal of men is also defined by big bodies. Rubens's massive bodies are different from Fernando Botero's massive bodies: the former lets the skin unfold in excessive ways; the latter also stresses size but is more cartoonish, less realistic. In any case, a century after Rubens, the concept of female beauty changed. The ideal was now a small, slim, and svelte woman. And the obese woman became unattractive, that is, ugly.

Violence might be seen through the same lens. Although it might be difficult to assess how violence was viewed in aesthetic terms in biblical times, the Bible as a text abounds in scenes of carnage. These scenes are connected, for instance, with the kingdom of David and his imperial successors. They are also present in the books devoted to various prophets. In *Revelations*, blood, destruction, and death are the sine qua non. Some of these sections are presented as cautionary tales. Beware of what idol you follow, we're told, for destruction is imminent. Yet some of the writing in

these parts is inarguably beautiful. And, more important still, the depictions made in the Middle Ages and Renaissance of these biblical portions by Tiziano, for instance, have unquestionable beauty. Why? One reason is the way the scribe and the artist use words. But there's another explanation: violence might be morally wrong but aesthetically pleasing. The answer is precisely in this conundrum: How can you describe as beautiful what is morally repugnant? Because what's repugnant is the action and not the depiction itself.

I said before that beauty might be both universal and constrained by the coordinates of time and space. War has been with us since the outset of humankind. There's a gorgeous sonnet by Francisco de Quevedo in which he sings to the moon as a witness of past, present, and future battles. Yes, the same moon—*la misma luna*—witnessed the crusades, the battle of Lepanto, the war of 1812, the invasion of Normandy, and so on. What has changed is the setting. The motifs behind war are always the same and so is the outcome. I remember watching the first twenty minutes of Steven Spielberg's *Saving Private Ryan* and being mesmerized by the beauty he achieved in depicting the arrival of American soldiers at Normandy. I also remember thinking the actual battle couldn't have been beautiful but this depiction is. Why? Because Spielberg uses color and sound masterfully. Because the audience is as frightened as the soldiers probably were during that fateful day. And because the overall rhythm of the piece is sublime. So he managed to extract beauty out of devastation. In so doing, he moved me. While looking at the sequence, I also thought this war is like all wars. All wars are one single war, the same war. But the beauty is different because the artist makes it relative, placing the disaster in one particular moment.

Might it come a time when *Saving Private Ryan* (1998) will be considered obscene? By obscene, I mean excessive. In other words, might the idea of beauty change as our culture gives place to another, to the extent that viewers of the future will think that Spielberg indulged in ugliness? Sure, it is likely to happen, just as a Rubens woman is now considered ugly. He will still be considered a master, although his views, his appreciations will no longer be current. This is as it should be. Still, violence will still be a compelling canvas to the artist, no matter what take the artist endorses.

JG: Well, then, it seems that you agree with the explanation I gave, but which I found unconvincing, to this extent: that the key to the value of art is in the interpreter and the interpretation. Interpreters and interpretations are immersed in their milieu, their cultures and concerns, their presuppositions and prejudices, and it is they that determine whether a piece of art is beautiful or not—I would prefer a term other than *beautiful* since I do not want, as I mentioned, to think of art as necessarily beautiful—or valuable in the artistic sense. Accordingly, to the degree that a work of art fits what interpreters want of it in their interpretations, the work is good art.

But let me add something here that complicates matters and reveals a source of my difficulty with this view, namely, that apart from the fact that judges and critics of art do not always agree on the value and significance of a work of art, even when they belong to the same cultures and times, one frequently finds that individual persons disagree with whatever the art establishment says about art. Don't you know people who say that Picasso's cubism is terrible? How many people can appreciate *Les demoiselles d'Avignon*? If you ask me, and considering that, as I say somewhere in these conversations, Michelangelo is one of my two favorite artists, I do not find his David as beautiful as you would think. For one, the hands are quite disproportionate to the rest of the body. And I recently heard the architects of the new home of the Barnes Collection, in Philadelphia, say that they had not seen as many bad pieces of art in a collection as they saw in that collection—they were referring in particular to the Renoirs. So, does not this get us into the slippery slope of relativism? Does not the emphasis on culture and the interpreter lead us to cultural relativism? You said that we were looking for something universal, but it appears that we are ultimately locked into the particular. Can we transcend it and reach a judgment about the value of Azaceta's *Slaughter* that goes beyond our cultural and personal parameters and perspectives?

IS: Let me answer as you often do: yes and no. Is the piece admirable? Yes, it is. The artist offers a powerful, emblematic depiction of human carnage. But can we transcend our relativism and judge Azaceta's slaughter in a universal way? No, we can't. Each of us is defined by subjectivity and the reaction to this or to anything else will be shaped by that subjectivity.

In my view, relativism isn't a slippery slope. Instead, it is an enviable

characteristic defining human interaction. There is Spanish saying *en gustos se rompen generos*. In English, there are at least two variant translations, or versions of the same epithet. One is "to each his own," meaning that individuals are inevitably defined by their own subjective coordinates. The other is "there's no accounting for taste." That is, no matter how ignorant or educated, how intuitive or calculating a person might be, their reaction to a work of art is, to a degree, unpredictable, even when that reaction is defined by peer pressure. George Bernard Shaw once said that we should never underestimate what the masses will like. He said it with a degree of content: the masses can be manipulated in such a way as to embrace what they don't like and to like what they don't embrace. This makes me think of Borges's disdain for Dostoyevsky, whose work he found appalling. He couldn't believe readers could cherish a novel like *Crime and Punishment*, in which a student is pushed to kill his landlord out of good will. (Of course, what Borges didn't say, and what's clear to me, is that self-righteous morality, in this case Christian morality, is what propels Dostoyevsky, whose entire oeuvre could be called "Crime and Punishment.")

What makes art appealing is precisely the tension between its universal quality—it can reach deep into the human soul while transcending its particular time and place—and the individual reaction it awakens in people. As much as I admire your thoughtfulness, I wouldn't want to have the same opinion about Azaceta's *Slaughter* that you do, Jorge, because I, like everyone else, want to be myself—not you or anyone else but me. And to be me is to have the distinctive qualities that define me as a person. Plus (and I return to a point I've raised a number of times before in our dialogues), I am often surprised *by myself.* That is, the reactions I have to what surrounds me aren't formulaic, which means that I don't know what I think until I let myself think it.

Relativism is constantly seen as dangerous because it presupposes anarchy. If everyone thinks differently, if there's no consensus, then no single tenet serves as glue to bring collectivities together. But this is a sophism. Relativism isn't chaotic by nature. There's order in relativism. That order has to do with dissent. To dissent is to have an opinion that is different from the consensus. The consensus is homogeneous. Dissent is about equilibrium. In saying no to a group that endorses the yes, you are creating an alternative. That alternative, even if neither you nor anyone

else took it, is implicit to the group. In other words, consensus contains within itself the potential of dissent. Relativism isn't the same as dissent, yet it is related to it. If everyone likes a popular novel, say *The Da Vinci Code* (2006), one assumes that its positive appreciation is universal. Yet if everyone really felt compelled to like the Dan Brown novel, people would actually not read it because people don't want to feel that their reaction to a work of art or literature is predictable. Instead, they want to find or themselves what they think, instead of being told.

With this I'm saying that relativism doesn't preclude a consensus and that even though Azaceta's *Slaughter*, because of its graphic nature, creates strong reactions, reactions are defined by the personal and cultural parameters that make each of us who we are. Still, by expressing our relative views, we can all reach a consensus. And that consensus might be nothing but a universal—and universalist—view on what this particular artist means. As you can see, I'm suspicious of any unified theory of art as well as of any unified view of what people's reaction to art ought to be. Yet this doesn't keep me from sometimes endorsing a majority opinion on a particular work.

As for *Les demoiselles d'Avignon*, I love the piece. Yes, Picasso is often infantile in his work. That, it seems to me, is what he's striving for: after centuries of sophistication, a return to the basic in European art. Could a child have painted his images? No doubt about it. I sometimes imagine Picasso, while having his compulsive love affairs, hiring a village fool to do some of his work. The same might be said of Jackson Pollock. Could you or I do the same type of art? We could but why? Pollock did it first. He made people fall in love with his revolutionary views. Replicating those views would be preposterous. This doesn't negate the fact that rather than art, Pollock's canvases are sheer splashes. What do they say? Nothing, in my mind. Actually, they do say something: that we've reached a point in which art isn't something specific but, instead, it is just anything. That anything doesn't require a specific talent to draw, to offer a depiction of what our perceptions process.

Maybe the saying should be "there's no accounting for bad taste"!

JG: Well, I'm delighted that you have answered the question I posed to you in the way that you rightly say I answer most questions, with a yes and a no! Does this mean that you are becoming a philosopher? That the philo-

sophical bug has bitten you? Those thoughts are delightful to me, but I am sure that you could easily explain to me why they are not accurate. Well, be that as it may, let me say a couple of things that will not be satisfactory but that will have to serve to end this conversation insofar as our space is up.

Relativism, whether individual or cultural, which are the two versions you seem to espouse with respect to taste, are rampant in contemporary society, and not just with reference to taste, but with reference to any kind of value, including moral value. The mantra is values are culturally relative or individually relative. What is good or bad, and certainly what is good or bad art, is dictated by the culture or the individual. This sounds good. It is the position that all freshmen take when they enter college, particularly in their sophomore year. It is commendable that they do, because at home they usually have been fed the worst kind of absolutism, one based on some kind of blind and dogmatic set of cultural beliefs.

But a little reflection shows that this relativism is a kind of absolutism; that is, it is the very position they are rejecting, in that it applies indiscriminately to all values. As such we have an inconsistent position. May I remind you of something I think you said before with respect to Mexico, that if we are in constant crisis, there is no crisis. This may be applied to our case by saying that if all value is relative, then no value is relative, and by extension, if everything is art, then there cannot be any art, and if every art is good, then there can be no good art. Art and good art are categories that are significant only if they are accompanied by the categories of non-art and bad art. In short, relativity in values makes sense only if there are cases in which they are not relative. And the interesting question is what makes them so. The challenge is to determine the difference between the two. In the present context this applies to the use of violence, gore, and ugliness in art. Do these contribute to making the work art and good art, or do they contribute to making it not art or bad art? Going back to Azaceta's *Slaughter*, why is it art and good art if indeed it is one, the other, or both? That is the question, and one for which both you and I gave answers that I find unsatisfactory. Perhaps readers will come up with something better!

THE AMBIGUITY OF MADNESS

MARTÍN RAMÍREZ *No. 111, Untitled (Train and Tunnel)*

Jorge Gracia: I'd like to begin our reflection on this work with an anecdote that I have narrated already somewhere else, but that seems to me appropriate here.

A few years back, on a trip to New York City to attend the opening of a Cuban-art exposition organized by Glexis Novoa, an artist and curator whose work my wife and I admire, we decided to take the opportunity to make a pilgrimage to the Museum of Modern Art. When we got there, we saw advertized an exposition of the work of Martín Ramírez in the Museum of Folk Art located next to the MOMA. We had seen pictures of Ramírez's work before and had been intrigued by them, so we decided to go in.

Ramírez was a Mexican laborer who came to the United States to work on the railroad. After years of struggles, he ended up in a mental institution, where he was diagnosed as catatonic schizophrenic. He did not talk, but he drew and painted pictures on any pieces of paper he could find. His work is a stream of trains, tunnels, cowboys, *campesinos*, city escapes, and virgins. The human figures are usually trapped in buildings and cells from which escape seems impossible. Visually the work is ap-

Martín Ramírez, *No. 111, Untitled (Train and Tunnel)* (c. 1960–63),
15″ × 31″, graphite, tempera, and crayon on paper.
© Copyright Estate of Martín Ramírez. Used by permission.

pealing to some audiences and disturbing to others; but it is difficult not to be moved by it.

Around ninety pieces were displayed in the exposition, roughly a fourth of the extant work from the artist. After two hours of marveling at the stunning character of the art, we were on our way to the elevators, when my wife, who, unlike me, frequently strikes up casual conversations with strangers, said to one of the guards: "Not bad for a nut, don't you think?" The guard responded with quite a bit of animation: "Nut? No, this guy was not crazy at all! He knew more about life than we do." This was unexpected and serious, so I told Norma, "Let's go back, we better take another look at these pictures."

The guard had struck a chord. He had told us that Ramírez's pictures were not just what they looked like; there was something deeper and perhaps disturbing in them. Until that point I had been looking at the work in formalist terms, as striking images devoid of a philosophical dimension, but the guard's comment awakened me to a different perspective, which also contrasted with the commentary on the works presented at the exhibition. The curators had done a fine job of assembling opinion about Ramírez. There was a psychologist who talked about Ramírez's mental condition, and whether he was in fact schizophrenic or not. A sociologist discussed the social factors that influenced the work. An art historian located the work in an art context. And the person who discovered Ramírez narrated the story of the discovery and how the art establishment had first turned its back on the work. All this was interesting and useful, but one thing was missing: the philosophy, which is what the comment from the guard suggested. He had given a brief, but nonetheless significant, interpretation of the philosophical relevance of the work: the work was about life and it showed a kind of knowledge and wisdom that we lack in contemporary society. Upon reflection it reveals the human condition, its loneliness, its angst. Indeed, one cannot but be led to think of the title of Jean-Paul Sartre's famous play *No Exit*.

I used this anecdote to pose the question of the relation between art and philosophy in my book *Images of Thought* (2009). Here, however, I would like to explore another angle that it suggests, the notion of artistic madness. The notion that artists are somehow crazy has been a constant theme in the history of art. And with reason. Why would anyone do what artists do? Most artists have to suffer depravation, alienation, and loneli-

ness. Van Gogh died having sold only a single work, one purchased by his brother. The image of the starving, misunderstood artist is common in the history of art, although it might not be accurate in many cases. One would have to be mad to sacrifice so much in order to work so hard.

Ilan Stavans: There's another approach, Jorge. We describe as madness whatever we're unable to understand through reason. But there are numerous things that fall into that category, thus emptying it of meaning. Notreason covers an enormous spectrum and art conveniently falls into that category: an expression of the irrational, of the sublime. I'm uncomfortable with this idea because reason is too simplistic a category as well. For the romantics, the artist was the conduit through whom the divine—or the muses—communicated. The image of the artist in that period is of the lonesome figure in tune with nature and the spiritual world. There is an intimate link between this view and the portrait of the biblical prophet. In the Bible, and, as a matter of fact, in all prophetic religions, most of which are part of Western civilization, the prophet possesses a special kind of knowledge. He (they were all men) receives that information from above. What distinguishes him? Not any human quality necessarily. Instead, the distinction comes from God. God chooses the prophet, often in spite of himself. Indeed, the biblical narrative is full of cases of reluctant prophets. The most distinguished is Moses, who is considered a prophet of prophets. Moses isn't really happy with God's choice of him as a messenger. He is a stutterer. Plus, he was raised in an Egyptian household. Several times in the story he looks for ways to escape his own fate. Yet God anoints him as his conduit. This act of anointment is important because in the biblical prophets have a higher status than kings. Yes, Moses is more important than King David, for instance. In the Middle Ages, the qualifications of a prophet were the subject of intense debate. In Maimonides's *The Guide for the Perplexed*, composed in the twelfth century, the argument is made that there are different types of human knowledge. The highest type is owned by prophets. Maimonides offers a scale in which he places prophets even above angels. At the other end of the spectrum are madmen.

I say all this because it strikes me that, as a legacy of the romantic period (think of Goethe, for instance, and of Emerson, too), our concep-

tion of artists in the modern age isn't that different. In our secular culture we no longer ascribe to God a special channel through which he establishes a dialogue with his creations. But our view of the artist is of a singularly sensitive individual, delicate in his qualities, who isn't too far from mental illness. Those qualities enable him or her to understand something about life that most other people are unable to appreciate. But unlike the biblical approach, in our case it has to do with strictly human qualities. Artists, in our view, might be nurtured by society, but they are born to be different. Their sensibility is both a sign of birth and a fate—or shall we say a burden?—they must carry. Their sensibility also connects them with the dark side of humanity. That dark side is madness.

JG: Yes, madness means many things. For example, it can mean great folly. If we put all our money in one stock and the stock crashes, we are accused of madness. We were mad, foolish, to take such a risk. It can mean being angry and furious, or acting under such passions. The jealous lover can kill the loved one in a fit of madness. It can mean an obsession with something that makes us forget everything else, that allows us to bracket the world, regarding anything that takes us away from the center of our attention, our focus, as an unwelcome distraction. In many ways these are related notions, but they are not necessarily tied or even consistent. Finally, there is the sense to which you are referring: someone might be considered mad because he or she is unusual, because his or her actions go against norms generally accepted in society, transcending what is rational or considered rational, or are even irrational.

Some of these senses carry with them a positive connotation, as in the case of art that transcends the ordinary, the commonplace, what is acceptable. But some carry with them a negative connotation. We talk about mad scientists both in negative and positive ways. In some ways we admire the obsession and the dedication they put into their efforts. But we do talk about Dr. Frankenstein as mad because in the pursuit of his experiment he forgot about everything human, about human decency, rights, and the possible consequences of his experiments. There is a fine line between the good and the bad in madness, and whether it is one or the other often deepens on the results. A play in the stock market becomes foolish or mad if the stock crashes, but if it happens to work,

then the player is regarded as brilliant. The frontier between madness and sanity is not always clear and it may also depend on who draws it. These various kinds of madness are not always tied, some can exist without the others, and they are not even consistent, although they are related. Their relation, as Wittgenstein would say, is similar to the relation of resemblance that characterizes families. Every member of a family relates in some way to some other member, but not necessarily to all other members of the family. My grandmother and I might have the same nose, and a certain taste for the artistic is shared by my mother and me, but I inherited my father's analytical mind.

This is the reason why you, Ilan, might find the discussion of madness puzzling and uncomfortable, but it need not be so. Nor do we need to infer that madness is empty of meaning. I would say just the opposite. Madness is full of, pregnant with, in the commonplace metaphor, meaning. It is a very rich notion that enlightens our understanding of the world. And it is its very richness that confounds us when we think about it. Precisely because of its variety, it should serve us to explore not only the work of Ramírez, but also the way all creative people—artists, writers, and scientists—go about their business.

IS: Ramírez is an astonishing example because he comes from a lower social stratum and from an ethnic and national group not perceived by the mainstream as having potential as an artist. Let me qualify this statement. Mexico is seen in Europe and the United States as a fiesta of color and sound. But not until the twentieth century was the country considered to be part of Western civilization. This means that the conception of the artist in the country didn't fit European standards. More than artists, it was believed that Mexicans produced artisans. Artisans are collectivists, not individualists. Their effort is done in community. Their signature doesn't define the artistic pieces because the artistic piece is generic, not tied to any particular person but to a group. In other words, Ramírez might be said to come out of the blue. He is unexpected because art isn't supposed to emerge from an individual like him.

JG: No doubt Ramirez is unique in many ways, but is this uniqueness what would justify our calling him mad? In many ways he is typical of what we

expect of artists. Artists work constantly in spite of the few who have tangible financial returns for their efforts. Yes, many artists today have made big money. We all know about Picasso, who not only enjoyed unprecedented fame, but also wealth. But the lives of most artists are very different from this. Very few can support themselves through their art. And many have to sell out in order to live, by which I mean that they have to produce work that has an audience even though it is not what they would like to do. This is a kind of necessary prostitution prompted by the need to eat. The one thing that true artists have in common is their obsession with their work and the hard labor in which they engage day in and day out. Long hours of toil, alone, locked up in their studios, and in most cases in places that do not deserve such a name, being merely cubicles where they hide, like rats, so they can be alone and satisfy their compulsion to work.

The case of Ramírez is an extraordinary example of someone whose only outlet, the only means of communication to the outside world, was his art, although it is doubtful that communication was his aim. He worked constantly, whenever he could find paper and pencils. It was an obsession. He never sold anything. He never received any help for doing it. And he never received any recognition during his lifetime. Yet, he kept at it, possessed, tirelessly. Nor did he talk about his art, or himself. Indeed, he did not talk at all. But he produced works that today astound us. I'd like for us to think about artistic madness in the context of the art Ramírez has left us. I want us to think about the relation between the art and the artistic obsession of this poor Chicano who spent most of his life in a mental institution. We can begin with *No. 111, Untitled (Train and Tunnel)*.

IS: The first reaction I have to the piece is its naiveté. I'm perfectly aware of the implications this concept has in art. *Naive* means "unaffected simplicity." Or, better, it means a resistance to artificiality. Children draw naive art because epistemologically their thought formulation remains unsophisticated. In art, however, naiveté is understood as a rejection of high-minded depictions of the human body. The naive artist has a special connection with childhood. And perhaps also a connection with primitive, uncivilized cultures. When André Breton, the priest of the surrealist movement, traveled to Mexico, he was hypnotized by the country's art. He

described it as being naive, in touch with ancestral, dreamlike elements, a type of connection that European art in the early decades of the twentieth century had all but lost. Ramírez's *No. 111, Untitled (Train and Tunnel)* is the kind of piece that makes you wonder if the artist was a child. It also pushes you to think: In what sense is this art? How can it be appreciated when it negates the whole tradition of artistic semblance in Western civilization? Yet that's precisely where it's genius is: in what it negates.

JG: The fact that his art is so different supports the view that this is the reason why it is not sufficiently appreciated, for in the Eurocentric conception, for something to be art it must fit the artistic trends that have developed in Europe. This does not mean that the artists have to imitate what has been done in European art, although this attitude has been prevalent at some points in the history of Western art. The matter is more subtle. One way to interpret this view is that for something to be art it must fit the dialectic of artistic production developed in the West. An artist can rebel against what was considered art before him or her, but the rebellion has to fit the kind of rebellion experienced in the West. To rebel against academic art, as the impressionists did, is fine, but of course, the art toward which the rebellion was organized was Western art, and the art that was produced by the rebels was part of European art. This brings up another condition: in order for something to be considered art in this perspective it must be somehow connected to Western art. The problem with Ramírez is that what he did has no connection to anything present in European art. Some other Mexicans and Latin Americans have been able to plug themselves into the tradition of Western art, even if they have modified it. Think of Diego Rivera, in Mexico, who in spite of Mexicanisms joined the Western tradition in many ways, and of Wilfredo Lam, the Cuban who incorporated Cubism in his depiction of Afrocuban heritage. This was sufficient for them to qualify as artists from the European and Anglo-American point of view. But what does one make of Ramírez?

The problem with him is that he does not seem to connect with anything in Western art. There is no artist in the history of Western art that has done anything similar to what he did. And then there is the fact that he was in a mental institution and classified as a catatonic schizophrenic. This kind of madness is not the traditional madness of the artist, judged by Western standards. An artist can starve for the sake of his art. He

might even cut off one of his ears. But the case of Ramírez is altogether different. His madness does not appear to be artistic. So how can we consider him an artist and how can we consider his work art? After all, art is a historical product and essentially tied to the life of the artist and the culture in which the artist lives.

IS: I want to make a confession. I've been a passionate admirer of Martín Ramírez ever since I discovered him in the early nineties. I've read everything I can put my eyes on about him. I've seen every exhibit of his art. One of the pleasures that I get in this passion is the feeling that I'm in front of a fraud. It isn't that he himself was a fraud, that is, an impostor, but that he's been packaged by a sophisticated cadre of art commentators (myself included) and collectors that see him as a genius. How different is he from an autistic child trapped in his own mind, one that doesn't have a clear way of reading the world, that isn't attuned to the grammar of emotions we live by? How many like Ramírez, capable of doing incredible—and naïf—art, have been trapped in a loony house? I suspect your answer is, Ilan, you're depreciating him with your comments. But that's precisely the point. I'm just not 100 percent sure he's that original.

JG: Before you settle on this view about the value of Ramírez's work, I'd like you to consider something to which I referred earlier: the art establishment ignored him completely for quite a while, and even to this day snubs him. His major exhibition in New York City was not in the MOMA, but in the National Museum of Folk Art. His work was relegated to the category of folk art. Yet, as you say, he has recently been a darling of art critics, perhaps an invention of their desire for novelty, power, and profit, as you suggest. My view is that his art, like all significant art, responds to a human experience. He has touched the human psyche in a way that had not been touched before, bringing to the fore the human predicament, our loneliness and desperation, our sense of being trapped, and our desire to escape. This is a reason his art has such an impact on those who look at it. It moves an audience. It enters the secret recesses of our minds. Yes, it is simple. Yes, it is repetitive. Yes, it is naive in more ways than one. But he moves us. I don't give a fig for what art critics say, or what the art establishment recognizes. I respond to Ramírez on my own. I saw his works for the first time on TV, and I was immediately drawn to them, without

knowing anything about the artist or what critics said. It was love at first sight. Perhaps we have something in common, although I do not think many people would think me catatonic in any sense. Schizophrenia or autism? You will have to ask my family and friends. The point is that Ramírez speaks to me.

The ability of certain artists and their work to speak to an audience is something to which we might want to return later. But at the moment I would like to move the conversation toward the metaphor of the face that we mentioned in the introduction to this book, because faces are so conspicuously absent from much of Ramírez's work, and perhaps this allows us to speak more about him as an artist.

In the particular work of Ramírez we are considering we do not have a face. Not that he always ignored faces. He occasionally drew virgins and country folks. But the mainstay of his work is all about trains and tunnels, and it is an example of this kind of work that we have chosen as point of departure for our discussion. So, how can we relate this work to the metaphor of the face? I propose that we try to imagine Ramírez's face. We know that he hardly ever uttered a word, but this did not mean that he did not function in an ordinary manner. Like other humans, he ate, slept, kept the usual hours at the sanitorium, and so on. He functioned. At the same time, he spent all the time he could spare doing his art work, which, by the way, he might not have considered art—this is another issue that we could discuss. But let's leave that aside and return to his face.

I think two points are probably important: the consideration of the face when he was working and the consideration of it when he was not working. I imagine that when he was working the face revealed enormous concentration. His work requires precision, all these lines carefully calibrated to converge at certain points to create images of trains and tunnels, the symmetry and the careful planning. The face must have been intent, devoid of any emotion that could detract from the attention required by the work. The world outside the piece of paper on which he was working must have disappeared for him. Except for the work of his hands, he was oblivious to everything. But at the same time, there was light on the face, the light of discovery, of creation, of originality. He did not draw what he already had in his mind, but what he discovered in the process, the images that slowly revealed themselves through his concentrated effort.

And when he was not creating, how was his face? I imagine it very different, impassive, with an expression that set him apart from the world, but different from the one that marked his moments of creativity, a kind of blank slate. This separateness had no object and no product. The light that illuminated his face while he worked went out of it the moment he stopped.

IS: I like your proposition. Yes, Ramírez's face when he worked must have been an emblem of concentration. His ghosts were struggling to emerge and that concentration was a way of channeling them out. Is that face different from yours or mine when we're writing? Writing for us is thinking. I don't know what you'll say to this but I don't know how I'll react to one of your statements until I begin writing my response. That is, your statement prompts a reaction from me. That reaction is the desire to write back, to offer my viewpoint. My reaction isn't my response per se. The response comes only when I start writing. How does my face look when I'm intent on shaping my sentences on the screen, when my fingers are dancing freely on the keyboard? (I type very fast but I only use four fingers, so I need to look at what these fingers are doing.) I assume my face has an expression of concentration. I don't laugh, I don't genuflect. Instead, I look frighteningly serious. All this, by the way, is how I imagine my face because I don't have any glass or mirror in my office, nor is there anyone in my office to tell me how I look. When I'm not writing, and when Ramírez wasn't painting, my face and his must have been "normal," by which I mean the average face of a man going about his duties.

JG: Your comments suggest to me an interesting point. Not only are you explicitly referring to Ramírez's face, yours and mine, and comparing them, but you are also describing them. So let us focus on what you say about yourself: that your face has an expression of concentration, that you are not laughing, etc. In doing this you are in fact imagining how you look because, as you point out, you do not have a mirror in which you are seeing your face. In short, you are providing me and the readers of this book with a self-portrait. Creative people very frequently do this. If they are painters they paint themselves; if they are writers, they write about themselves; and if they are philosophers they tell us about their encounter with philo-

sophical problems and their views about them. Are we being narcissistic? Undoubtedly so. And the danger is that, like Narcissus, we should die because we cannot move away from the contemplation of our self-image. This is an interesting point that we could explore, but it is not the one I want to emphasize.

My concern is rather with what portraying ourselves entails. In a recent art exhibition I organized and which originated in Buenos Aires but is now traveling in the United States, entitled *Painting Borges: Art Interpreting Literature* (2010), one of the pieces of art is an interpretation of Borges's story "The Other," painted by Laura Delgado. Following Borges's lead, Delgado paints herself, but she does it as a girl drawing herself. So we have a double portrait of Delgado: Delgado as a young girl and Delgado as the girl drawn by Delgado as a young girl. We have two different portraits of Delgado. One is of her in a dark room, covering her eyes, and facing the picture of herself she is creating, and the other is the picture of a girl in a pleasant and happy landscape, with flowers, perhaps enjoying her surroundings. These pictures give us a double revelation of Delgado. The first is a gloomy image, afraid perhaps of what she has created, and the second is the creation of that girl, happy and unconcerned. Both are objectifications of what Delgado thinks she is or was. They are, in the title of the painting, *La otra* (The female other).

So, Ilan, in describing yourself, you are, like Delgado, imagining yourself; you are creating something that does not exist, but that you either want or do not want to be, which, precisely because of it, reveals much about you. Now, the extraordinary thing is that, as far as I know, we do not have self-portraits of Ramírez. Why? One would expect that, as other artists, he would have created some, even be obsessed with himself as some artists are. But no. We only have those trains, and occasionally other people, almost caricatures, but never himself. Is it because there was nothing to be described, because his catatonic state left nothing for him to depict, because he was catatonic? Is it because he found too much of a horror in his condition and did not want to make it an object of reflection, to know it explicitly? Why did he not draw himself?

IS: Perhaps because he was autistic. I'm not a psychologist so I don't know if people with autism have the capacity to self-reflect. I believe they can.

And if they can, I assume they can imagine themselves in the act of imagining themselves. The question is whether they can see themselves in the reflection that results from others seeing them. Autism is defined by a lack of tools to read social behavior. A person with autism frequently doesn't know what others are thinking about him. He knows that others are thinking something but it is difficult for him to know what this thinking is about. My impression is that Ramírez is trapped in himself, that he is an island, separated from the rest of us, that he can imagine scenes with trains and horses, and he might even imagine himself in them. But he can't imagine those scenes with him as seen by others. That's a handicap. Or an astonishing artistic trait.

JG: This reminds me of John Donne's famous verses:

> No man is an island,
> Entire of itself,
> Each is a piece of the continent,
> A part of the main.

It seems so true that we are part of humanity, social animals, as Aristotle argued. And yet, as you suggest, Ramírez is very much alone, trapped in himself, and separated from the rest of us. Is he just an anomaly? Should we dismiss his isolation and loneliness as a matter of mental illness? I'm not inclined to do it. Perhaps he is just an extreme case of what all of us experience in some measure. Indeed, is this not, at least in part, why his art and his plight resonate deeply with the rest of us? Because we are also alone. None of us can access what the other thinks or feels. We get clues—language, gestures, behavior. But do we really communicate, do we really establish direct contact with the other? Do our minds ever encounter each other?

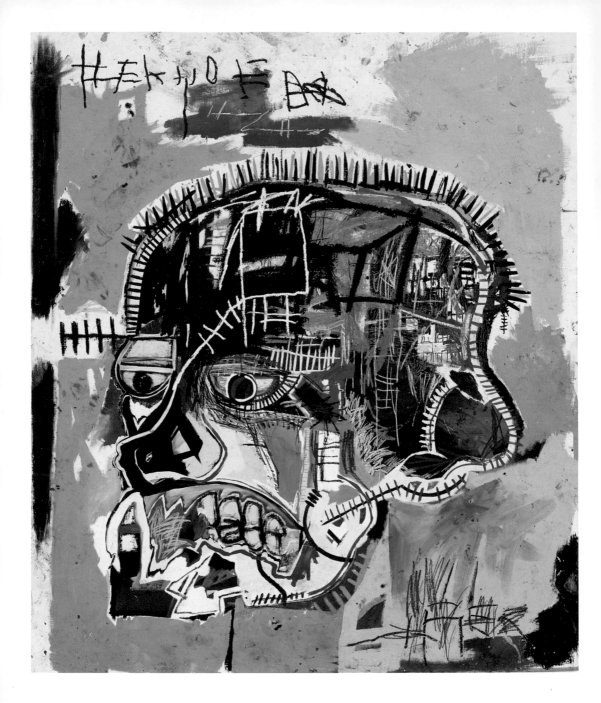

Jean-Michel Basquiat, *Untitled (Skull)* (1981), acrylic and
mixed media on canvas. © 2012 the Estate of Jean-Michel
Basquiat/ADAGP, Paris/ARS, New York. Used by permission.

I LAUGH IN YOUR RACE!

JEAN-MICHEL BASQUIAT *Untitled (Skull)*

Ilan Stavans: I want to start this conversation by talking about graffiti. In order to do it, it is important for us to distinguish between private and public spaces. I'm not only thinking of the difference between a person's realms: the home, the school, the street, the workplace, the temple, etc. There is a difference between those realms in which there is a sense of intimacy and those in which we are in touch with others. Navigating these realms is the daily affair of every average person. I'm also talking about the space we have to connect with material culture, in this case art. The way art is presented in society can either be in a private collection (the secluded realm of a wealthy person's home) or in a public space (a museum, a fair, a park). Either way, we make sure people know the art piece is easily recognizable for what it is: art. For instance, outside Bogotá's Museo de Arte Moderno there are several large statues by Fernando Botero. They are typical of his style: an obese man and a woman, fully naked, made of bronze, in a public plaza. Neither you nor I would walk naked in that place because such behavior is considered amoral. More than amoral, illegal. Yet these two statues are without clothes. Why don't passersby raise an eyebrow? Be-

cause Botero's pieces are art. The artist is granted permission to do what the rest of society can't do, in this case showing the private parts in public.

Jorge Gracia: True, art is given a certain leeway, but it is not completely free to do what the artist wants. Going back to an example of art we considered earlier, Serrano's *Piss Christ*, this work created a scandal when it was displayed, because it was considered to be insulting to a religious community. The case of nude statues is rather interesting. A few years back a foreigner bought a mansion in Hollywood and proceeded to decorate his garden with nude statues that were considered shocking to the neighbors, who tried to have them removed. It was not the nudity that was considered unacceptable, but that the statues were painted in natural colors, the skin, the hair, the genitals, and so on. This should not be shocking to a Western audience when one considers that Greek statuary, which is the source of Western statuary, was usually painted in naturalistic colors, and it is only because the colors of the marbles faded with time that we became used to thinking that artistic sculptures should have the color of the materials of which they are made, as do the ones from Botero, to which you refer.

Artists have a certain freedom, but it is a freedom limited by written and unwritten rules accepted by the community. In Italy, there is a famous painting in the bed chamber of the palace of the ruling prince that represents Jupiter ravishing Venus. He is half dressed, but has a full erection, ready to penetrate her. (The image cannot but remind us of Michelangelo's rendition of the creation of Adam on the ceiling of the Sistine Chapel.) Even at the time, the permissible Renaissance, this depiction was acceptable in a bedchamber, but not in a public square. On the other hand, it is not only artists who are permitted liberties. In ancient Greece, the Cynics were allowed to go around nude and even to relieve themselves in the square, presumably because they were philosophers. Masculine nudity in Greece was quite acceptable, and males exercised in the public square and competed in sports in the nude. Greeks thought the male human body was the epitome of beauty and therefore were not ashamed of exposing it. But we live in a different world, inherited from Judaism, Christianity, and Islam, all Semitic religions that have a very dim view of human nudity. I doubt very much that I would be permitted to show up

for class in western New York with no clothes on—even in permissive and "sinful" New York City this would not be allowed. In short, it appears that the rules that establish the parameters of artistic freedom are local. But are these rules different for graffiti than for other forms of art?

IS: Graffiti plays with the conundrum of the private and the public in yet another way. Octavio Paz once drew a difference between a revolt, a rebellion, and a revolution. The graffiti artist paints his art in a public space. He chooses a wall or a subway train. In most cases, the act of painting the piece is done at night, against the law, using utensils the artist might have stolen. That whole illegal aspect is crucial because graffiti is born somewhere between a revolt and a rebellion. The artist doesn't want to conform to conventional forms of artistry. He wants to subvert those forms, to offer an alternative route. His art is a rejection of the status quo, a negation of the values accepted by society.

JG: The rebellion can be about form but more often than not it is about content. Graffiti is art out of the mainstream, marginal, alternative; art that seeks to be present where it is not given a space or is not permitted. Its presence is denied because it is different and challenges the canons of art or because it has a message of rebellion not just against established art, but also against the society in which it takes place. Sometimes the rebellion has to do with the censorship of art, but more often than not it has to do with politics or morality. Basquiat's art fits the model of rebellion born out of alterity. Here is a man who was half Puerto Rican and half Haitian, black by the racial standards of this country, and who lived on the margins. His death, of an overdose of drugs at a relatively early age, informs and dramatizes the character of his work. What I see here is a cry for expression, a search for understanding and communication in a hostile environment, a violent context where survival is a daily affair. Like Ramírez, he was on the fringes of society. As a racial mixture of two marginalized social groups, Basquiat was looked at as an aberration and his art as something foreign, born from an alien experience. How could the art establishment pay attention to anything that came from his hand, faces made out of troubling lines, living skeletons, sharp and monstrous? His art comes out of an experience that has nothing in common with the

experience of art collectors from Park Avenue. Like Ramirez's art, it is an anomaly to the center. And yet, his works are posthumously fetching millions at auctions!

IS: When I talked about Martín Ramírez, I established the difference between art and *artesanía*, that is, between artist and artisan. I said that the artisan works in community. I also said that the artisan doesn't stamp his signature in the artesanía. Graffiti is done publicly. At times it is a collective effort. But individualism is at its core because the graffiti artist makes everything possible to sign his work. Sometimes that signature is a pseudonym, but that doesn't matter. In art and literature pseudonyms are always welcome. Think of Mark Twain as an example.

JG: Let me turn back to Basquiat's work of art and see what it tells us about all this that we have been discussing as well as some other things. I'd like to mention two points in particular that I find striking and significant. The first is that *Untitled (Skull)* fits well into the kind of work that Basquiat generally creates, what we might call his style. It is fundamentally a pastiche, composed of lines and patches of colors that overlap each other. One would have expected that these assemblages of images would create a confusing picture, but the contrary is true. An overall image is quite dominant and evident. We see a human skull, in all its stark appearance and many connotations. Although it is not quite a skull, since there are eyes that are looking intently at something. The piece contains no distractions outside itself, except for the fact that the image is suspended against a background that turns out to be a New York City subway map. There is only one image, but the details suggest many interpretive avenues. The subway map prompts us to think of travel, a road—but how different is this allusion from Bedia's! The skull, or head, makes us think of death, except that the eyes are very much alive, and what we see of the mouth are the teeth, perhaps smiling grimly, but at what? The assemblage of parts indicates a monster made up of inconsistent pieces, à la Frankenstein. This is obviously Basquiat, what he sees himself as being, an identity in transit, a Puerto Rican, a Haitian, a New Yorker, a black man, and what else? Someone homeless in more ways than one, a drifter, a drug addict, an artist? But it is not just himself. It is also humanity, you and I, in our

quest for unity and coherence in the multiplicity and contradictions that make us who we are. We talked earlier about our selves as pluralities in the context of Brito's *Conversations*, and here we have a depiction that makes the point eloquently and emphasizes the inconsistencies of our components.

Another thing worthy of note is that, in contrast with the frequent somber and sober renditions of skulls in art, this is a strange and garish image, after the fashion of horror comic books. The contrast with the drawing in charcoal that one would expect of a serious subject is strong, and inescapable. This poses a challenge for the observer who has to figure out how to interpret the image. This brings me to the second point I want to mention, the topic of the work. A human skull has always been a motif used as a point of departure for a meditation on death. Death has been an important topic of art. We need only think of the frequent depictions of it in the Spanish baroque. But in Latin America, particularly in Mexico, it is a topic dealt with in a folksy, popular way, as we discuss in another of our conversations. This is something in which Basquiat's work shares. His piece also adopts a popular approach to death. Like Mexican representations of death, which often include skulls in various forms and are rendered garishly and often humorously, Basquiat's skull speaks in a popular medium, a kind of graffiti.

This emphasizes the dilemma faced by observers, who have to ask themselves: Is this work making fun of death, or is it taking it seriously? Can we find common ground between humor and seriousness? Basquiat is Caribbean, a product of two cultures, the Puerto Rican and the Haitian, both of which have strong senses of humor and frequently laugh at serious subjects, but he is thrown into a culture with roots in humorless Puritanism.

IS: Jean-Michel Basquiat's *Untitled (Skull)* is a play with the motif of the face. There's a monstrous quality to it. The face depicted is full of scars and stitches. It is also quite colorful. I can see a skull in it or behind it. For some reason, I can also see Shakespeare in the profile, the curve in the back of the head, the expression. And, miraculously, Basquiat's painting reminds me of the famous map of the subway system in New York City. I don't think this is intentional; nevertheless, I see the resemblance neatly.

JG: Here is another topic that the case of Basquiat's art brings up and seems to me might be worth exploring. It has to do with the popularity and fame of artists and how these are related to the life of the artists and particularly to their tragic lives and deaths. That today Basquiat is considered a phenomenon in the art world is quite clear by the exorbitant prices that his works fetch. And we know that his life was miserable. For a time he was homeless and a drug addict, who eventually died at an early age of a drug overdose. Is his art appreciated to a great extent because of his tragic life?

IS: A sharp question. It makes me think of Anne Frank. Would *The Diary of Anne Frank* be the classic that it is had she not died a martyr? Philip Roth once imagined her to be alive and well as an old lady, quietly keeping the secret that she didn't perish in Auschwitz but, miraculously, she survived. She doesn't want others to find out for obvious reasons: our perception of the Holocaust as a whole would collapse instantaneously.

JG: That is a delicious supposition that probably only a brilliant Jewish writer like Roth could have made! I'd love to think about its implications, but let me not get derailed from the issue I had raised. Many recent artists who have become famous seem to have had a tragic existence and often a tragic death. Another example of this among the artists whose work we have been discussing is Ramírez, who spent most of his life in a mental institution, without speaking to anyone. Is his art appreciated in part because of his personal circumstances rather than the quality of the art? Earlier in the discussion of his work you suggested that his art might be overrated. If this is so, is it because of his strange, tragic life?

In some cases the tragedy of the artists' lives gets represented in their art. Not that the art itself they produced is sanitized from tragedy. Perhaps they have become famous precisely because in their art they represent lives that have been sad and tortuous, full of distress and pain. Consider the case of Frida Kahlo. I have often wondered whether she would have had the posthumous fame that she enjoys if she had lived a happy life, or at least one that was not so full of pain and suffering. In this connection I am reminded of the commission for a work she undertook in honor of a young woman who had committed suicide by throwing herself from a high floor of a building. The family had in mind a traditional portrait,

something to remember the dead daughter in the future, probably with a happy countenance and pleasant smile that they could look at repeatedly to remind themselves of the good times they had shared with her, and the times when she had been happy. Or perhaps just a portrait of the dead daughter, in the style of portraits of dead children we talk about in another of our conversations. Instead, Kahlo painted the actual suicide, the girl in mid air, after she had thrown herself into the abyss, although before she reached the ground. The painting is horrific, and as expected, the family rejected it. Clearly here is an artist who likes to dwell on pain. In her case, perhaps her work is valued not just because of a tragic life, but because her work expresses that tragedy in ways that we would not otherwise grasp.

But what do we make of Ramírez? And is the case of Basquiat like that of Ramírez or Kahlo? Do we value the work of these artists because of its formal characteristics? Because of the suffering they express? Because they are the authentic expressions of the artists' intimate experiences with pain? Or because they are the art of someone who lived a tortured life, but displays no evidence of the suffering of the artist?

IS: No, Ramírez is incapable of expressing pain in his art. At least I don't see it. Kahlo, on the other hand, makes a spectacle of her pain. I often get the impression, while seeing her paintings, that she suffered in order to paint. Yes, there's a performative quality to her art. One could say that Kahlo sublimates her suffering. My approach is different: I don't believe she transcends her suffering through her art. In fact, I think it's the other way around: she enjoys suffering because it enables her to paint.

I know I'm being blunt here, but not too much. I'm fascinated by Kahlo as well as repelled. She's become a martyr, a saint in Western art. For a woman to be as extroverted, as articulate about her inner life, is astonishing. But Kahlo is too much Kahlo: she's an actress, a clown.

Basquiat is more subdued. No doubt his tragic life injected value to his work. But his suffering is less public than Kahlo's, don't you think?

JG: Yes, very much so, both in Basquiat and Ramírez. In Ramírez in particular, one can see a mind looking for order and predictability, while it travels through dark tunnels that do not appear to have an end. An

emphasis on lines, repetition, and a certain symmetry. Some psychologists characterize the kind of mind that Ramírez reveals in his drawings as eminently masculine. And something similar applies to Basquiat. In extreme cases it is a sign of a form of autism, more common with male children than with females. There is a suggestion of profound loneliness, but not of self-centered suffering, as is the case with Kahlo's work. For Kahlo, the universe rotates around her and her plight, which is explicit. But neither Ramírez nor whatever suffering he might have experienced — and he obviously did — are explicit in his work. The case of Basquiat is more complicated.

IS: Let me ask you, as an aside: Have you ever painted yourself? At any moment of your life, have you had the temptation, and have you fulfilled that wish, to become an artist? And here's the crucial question: If you were an artist, what would you do with your pain? Would you turn it into art?

JG: If you mean whether I have ever painted, the answer is yes. But if you mean to ask whether I have ever done a self-portrait, the answer is no. While studying architecture in Cuba I also attended the Escuela de Artes Plásticas de San Alejandro for a year, when I was eighteen. This was the main art school in Havana. My strong suits in high school were the sciences, particularly physics, geometry, and algebra, but in my last year I discovered, and became fascinated with, painting. The choice of architecture as a career was an attempt to mesh my two loves at the time: science and art. But I wanted more art than architecture provided, so I went to art school as well, while I was attending the university in architecture.

To answer your other question, my interest in art had nothing to do with expressing pain. Not that I did not appreciate art that expresses pain. Of my two favorite painters, Michelangelo and Picasso, I appreciate works that express pain and also works that do not. One of my favorite Michelangelos is *The Last Judgment* (1536–41), which contains pictures of the condemned in all their suffering, fear, and anxiety. And my favorite Picasso is *The Old Guitarist* (1903), an unequaled rendition of melancholy and misery. My career in art was short lived as a result of my departure from Cuba, so I did not have an opportunity to delve deeply into art. At art school I was merely engaged in drawing exercises with charcoal and some

elemental sculpture, which involved the human body, torsos, hands, feet, and faces. The models were sometimes replicas of famous nude statues and at other times live models. I still have a few of these that I brought with me when I came from Cuba.

So what would I do if I were an artist? Would I make pain my primary subject, one of my subjects, or ignore it completely? Neither the first nor the last alternative, I think. The reason is that art has to do with who we are, what surrounds us, and our experiences. It can be, as I suggested in our last conversation, an escape. But it can also be many other things. It can be a celebration; it can be commemorative; it can serve to remember or to forget; and it can be an expression of joy or suffering. The impressionists were mostly interested in joy, whereas the expressionists were just the reverse. I would find it impossible to be either one of these to the exclusion of the other. My life is not uniform. At times it has been happy and at times sad—I have been visited by joy and tragedy. And for the artist, just as for the poet or the philosopher, both are subjects of interest, both involve something important. I could never be a Kahlo, nor could I be a Renoir. This is another reason why I like Michelangelo and Picasso; they speak to me in their broad range of expression.

IS: A few days ago, my sixteen-year-old son asked me if pain shapes character. I told him it does, but Alison, my wife, immediately announced that she disagreed. She said our suffering doesn't make us better people. I think Alison is both right and wrong. Suffering doesn't make us better people but suffering does make us people. Unlike animals, which, needless to say, do not suffer like us, we're aware—conscious—of our suffering. We think about it, we dream about it, we process it. Perhaps too much suffering ends up killing us. But the capacity to process the suffering we feel allows us to mature, to get a sense of perspective, to grow up. Don't you think?

JG: Yes, but as usual I'd like to add a qualification. Let's distinguish between pain and suffering. Yes, I know, these terms, as their Spanish counterparts, *dolor* and *sufrimiento*, are often interchanged without serious semantic consequences. But I like to think that pain captures better a physical dimension, whereas suffering captures better a psychological one. If

we draw this distinction, fuzzy as it is, then I would say that pain has no value but suffering may. In short, I agree both with Alison and you. With her, if what she had in mind was physical pain, and with you if what you had in mind was mental suffering.

With Alison, I do not see the value of physical pain. Why should women be cursed with pain at giving birth? The Bible is quite clear that this is a punishment, and indeed our word in English comes from the Latin *pena*, which means "punishment." Pain is not natural; it is not in our nature to feel pain. Pain is a sign of something gone wrong with our bodies. The only value of pain is to alert us to that fact. And the value of a strong pain is to make clear that we need to deal with its cause immediately, whereas a minor pain just gives us a warning, but does not exact immediate attention. In fact, I think pain dehumanizes people, it makes us wretched, and it gives rise to the worst instincts. Who will not betray his or her loved ones under torture? Pain is an evil, and evil cannot result in good in spite of all the religious chatter against this.

The case is different with suffering, however. Suffering is a result of human society. We suffer when we lose someone we love, or when someone we love does something that is hurtful to us. Suffering as a mental state can have both good and bad effects. It can cause a state of despondence and self-destruction, but it can also give us the opportunity to understand ourselves and the world more deeply. Suffering can humanize us because it is a human experience caused by human interaction or human expectations and frustrations. And causing this suffering in us, either directly or vicariously by consideration of the suffering of others, is one valuable function of art, whether from Basquiat, Ramírez, or Kahlo.

IS: I appreciate your distinction, but it strikes me as a philosopher's attempt to rationalize the etymological difference between two words. That is, it is more artificial than actual. When a parent looses a child, he is both at pain and suffering. Is one different than the other? Maybe there are nuances but the end is the same: internal agitation.

You're interested in the nuances. And they might indeed be important. The medical dictionary published by *Merriam-Webster* defines pain: "A state of physical, emotional, or mental lack of well-being or physical, emotional, or mental uneasiness that ranges from mild discomfort or dull

distress to acute often unbearable agony, may be generalized or localized, and is the consequence of being injured or hurt physically or mentally or of some derangement of or lack of equilibrium in the physical or mental functions (as through disease), and that usually produces a reaction of wanting to avoid, escape, or destroy the causative factor and its effects." Interestingly, it says the following about suffering: "Pain that is caused by injury, illness, loss, etc.; physical, mental, or emotional pain." In other words, suffering is the cause and pain the consequence.

This dichotomy—equally unsatisfying to me—reminds me of how difficult it was, when I first came to the United States (or, better, when I first came to the English language), to distinguish between being angry and being upset. At first I thought the two were one and the same. Actually, I thought, as in the case we're arguing, that one was the cause and the other the effect. In Spanish we don't make as clear a distinction between these two emotions: *estar enojado* and *estar molesto*. We use them both but few people see the semantic difference between them. Alison told me that anger is a result of an external force affecting us, whereas being upset is more of an internal reaction. Thirty years after my arrival, I still can't establish the difference: I'm angry at my friend for not using unnecessary words to express himself; and I'm upset with the way I performed during the test. Is this because I'm a foreigner? Or are we in front of another semantic conundrum linguists and philosophers like to reflect on? Basically, I wonder if, with the profusion of words our language has, distinguishing between them is a matter of collective advancement or if it is simply an intellectual game.

JG: Dictionaries record the way language is used by people, and people use language in whatever ways occur to them, often mixing meanings and categories without any regard for consistency. For example, the terms *race, ethnicity,* and *nationality* are constantly being mixed in the most confusing ways. They are even confused in the Census, and even by most academics. Why? Because not everyone has thought about the concepts behind them. For example, Latinos with a completely European ancestry are often classified as belonging to a race that is contrasted with the white, namely, European, race. The fact is that Latinos and Hispanics come in all kinds of races and racial mixtures. If they belong in a group, it must

be an ethnic, not a racial one. The case is similar with Jews. Jews come in all kinds of races, depending on their descent, but they have been often classified as one race. Now, if you look at dictionaries, you will find that some of them will appropriately mix the categories of race, ethnicity, and nationality. The reason is that they merely record how words have been and are used, not how they should be used to avoid conceptual confusions. The same applies to the terms *pain* and *suffering*, as I acknowledged above.

IS: As you know, I have a passion for dictionaries. This passion has brought me to collect dictionaries of all kinds. I've written a short book of interrelated essays called *Dictionary Days* (2005). There are many types of dictionaries, of course. In terms of their relationship to language as a whole and the assumptions they make about the role language and the dictionaries themselves should play, I like to divide them into two categories: the prescriptive and the descriptive. Prescriptive dictionaries prescribe; that is, they don't reflect how people speak but, instead, tell people how to speak. The *Diccionario de la lengua Española de la real academia* is prescriptive. The erudites of the Spanish Academy debate which words to include and which words to exclude. Can you believe it? They leave words out because they don't want people to use them. Descriptive dictionaries such as the Oxford English Dictionary attempt to record the parlance of the people and, at the same time, offer a historical record of what has come before.

I say all this because for a long time—most of my youth—I was under the impression that dictionaries were infallible. If they include a word, if they define it, it must be right. But dictionaries abound in mistakes, such as the ones you've mentioned. And others contain entries that are frankly absurd. For instance, until quite recently the *Diccionario de la lengua Española* defined a day as the time the sun takes to rotate around the earth. Can you believe it? It is as if Galileo hadn't existed, which, as far as the Catholic Church is concerned, would have been a welcome occurrence.

Yes, dictionaries reflect the confusion that exists in the popular imagination in regard to the dichotomy between race and ethnicity. But if that confusion exists, it isn't only out of ignorance, ours and the dictionaries, but as a result of the foggy space in which these two terms coexist. I

agree with you that philologists need to redefine them. But in my mind that won't be enough. Words exist in constant flux. They come in and out of fashion. They also change meaning because culture is never static. At no time in history have words ever been settled. You know this as a philosopher.

JG: Just a beginning thought: even what you call prescriptive dictionaries record usages, although they record only usages that they approve; their concern is with proper usages, not with conceptual precision. The latter is the job philosophers try to do. Philosophers are not interested in how people use words, except insofar as that allows them to understand different concepts and keep them separate in order to think clearly, with arguments that maintain as much precision and clarity as possible. We are not descriptive linguists or even prescriptive linguists; we are prescriptive conceptualists. Linguists are found in other departments in the university, not in philosophy departments. However, I should point out that there is a whole philosophical school, not popular any longer, named ordinary language philosophy, which believes that philosophers should become linguists. The job of philosophers is to solve, through a return to ordinary language, the problems that other philosophers create precisely by their misuse of language. The impetus behind this view was Ludwig Wittgenstein. But, although very popular in the fifties and sixties, this view has largely fallen out of favor. Today most philosophers believe that philosophical problems are not always problems created by the misuse of language, but can and often do reflect genuine conceptual puzzles, although the misuse of language contributes to them and understanding and using language appropriately can help to solve them. I am of this persuasion, although I have great respect for ordinary language. Indeed, ordinary language should be used as much as possible, and distinctions that go contrary to ordinary use should be introduced only when they explain why people misunderstand each other.

This is, in fact, what I tried to do with you and your wife. You contradicted each other, but I was not convinced that you were really engaged in a contradiction. It seemed to me that you were speaking of different things, and by introducing a distinction between physical pain and mental suffering, I tried to make you understand the sources of the confu-

sion. You see, a philosopher is a midwife of ideas or concepts, as Socrates claimed, or a linguistic therapist of sorts, as some Wittgensteinians would say, who through the analysis of language brings about conceptual clarity and hopefully agreement through the resolution of linguistic and conceptual confusions—to this extent Wittgenstein was right.

Of course, keep in mind that I am not arguing for rigidity in language, not even for taking language as having only one function. It is simply false that language is always used for one purpose, even if this is as common as communication. Languages are used in a multiplicity of ways that fit our needs, desires, and intentions. One can use language to vent anger, whether this is communicated to someone else or not, or to persuade, to excite, or whatever. This is why it makes no sense to think of rules that dictate proper usage for all times and places. But in certain cases, it is appropriate to think about, for example, the best way to use language for this or that purpose.

Is this a game or is there advancement? Well, I think it should have contributed to establish peace between your wife and yourself, and probably your son as well. Now all of you should, if you are not stubborn, come together in the understanding of your true differences, which might not exist after all, and your son will feel enlightened and satisfied. Ha! Ha! Ha! But there is more to it, for this is the essence not just of philosophy, but of law as well. Lawyers are really philosophers of sorts or, as Socrates would say, pseudophilosophers (sophists), that is, philosophers who do not care for the truth. This is far from a game. Our livelihood as human beings, our very survival, depends on how we communicate and use language and how well the terms we use express sound concepts. This is why we teach philosophy in the university. Without it we would be completely lost, since only philosophers have the task of conceptual clarification and criticism. The philosopher is the gadfly, the critic of his academic colleagues—the scientists, literati, and artists—and of society at large. But, mind you, unlike Plato, I do not think philosophers should be kings, for we are not practical enough, perhaps, and we have too much hubris, pride. We function more effectively as advisers. In fact, I am just waiting for a call from the White House any minute.

AMERICAN AMERICA

MARÍA MAGDALENA CAMPOS-PONS *Above All Things*

Jorge Gracia: Campos-Pons is Cuban, black, and a woman. In a society of WASPS, as the United States still is, she is in a perilous situation, insofar as the reins of power are in the hands of a white, Anglo-Saxon, Protestant, and male elite. As a Cuban outside Cuba, she is considered neither an American nor a Cuban. She is that rare animal, a Cuban American, something that is still evolving and lacks any permanent essence. There is no natural place for her. Maybe in Miami there is a place, and indeed, the art gallery that represents her is located in Miami, which is significant. But is there a place for her in Boston, where she lives? Not really. She is a foreigner. A stranger. An anomaly. And then she is black, but not an American black. American blacks and Cuban blacks share their race and some phenotypes, but they do not have the same culture. Again, she is an outsider, and as a woman, with her struggle in a still male-dominated world, she has another strike against her. Her game, both in life and in her art, has to be survival. How can she survive in this country, this society, this people, when she is an alien in more ways than one? Can she find a place in this community? What can her place be? Or is she condemned to be a stranger?

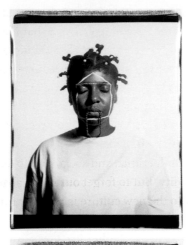

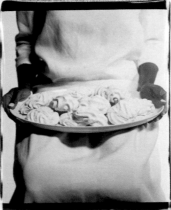

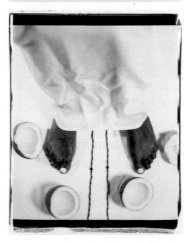

María Magdalena Campos-Pons,
Above All Things (1997) 3 of
24″ × 20″, large format Polaroid.
Used by permission of the artist.

Her predicament is not essentially different from that of all those of us who are also immigrants in this country. Or for that matter, the plight of all those who are immigrants anywhere. What should we do? Should we assimilate and lose whatever we associated with ourselves before we came here? Or should we reject the society in which we live and hang on to what we were before we arrived, hoping we could still be it?

This is the great dilemma that all immigrants encounter. Both paths appear to lead to destruction. To hang on to what we were, to stay in the past, to remain in a cultural, ethnic, and social ghetto leads to alienation, frustration, and marginality. But to forget our roots, abandon our former selves, and assimilate into the new culture is not only impossible, but destructive. In one sense we remain aliens in our land, and in another we become Frankenstein monsters. Neither is a happy alternative. What do we do? Where do we turn? Where do we find the place where we belong, where we fit, the place that is our *patria*?

Ilan Stavans: In my life as a translator, I often wonder what to do with the word *patria*. No easy equivalent exists in English because etymologically the word has a Latin root that makes it incompatible with Germanic languages. It could be translated as "homeland." Or else "fatherland" or "motherland." Make a choice.

JG: The choice is impossible, because the word comes from the Latin *pater*, "father," which is masculine, but the Spanish *patria* is feminine, like "mother." It is both, which means that it can be neither. We need a mother and we need a father, and our land has to count as both. We are in a pickle, and so is Campos-Pons. She needs a patria, but can she get it? Prima facie it would appear impossible. It cannot be the country where she finds herself because that country is alien to her and not accepting of what she was before. And it cannot be what she was before because now that she is here, she has already changed and she is no longer what she was. Indeed, she is also a foreigner to those who remained behind in her former land. She is in a no-man's-land, in a cultural and social limbo. Adding to the confusion is that she is black, but Cuban black, not American black, as I said, something that separates her from both the racial group to which she would appear to belong in the United States and from most other Cubans who live in this country. She is a minority within a minority.

IS: The relationship between minorities and patria is complex. It moves along the same lines of the relationship that exiles, refugees, maybe even slaves have to this concept.

JG: A patria can be adopted or natural. One can choose it, be born in it, or inherit it. You were born in Mexico but have become an American citizen, and as born of Jewish heritage you are allowed to have Israeli citizenship. I was born in Cuba but have become both an American and a Canadian citizen by choice, and as a grandchild of a Spaniard I could opt for Spanish citizenship. Both of us have multiple patrias. You have one by birth, one by genealogy, and one adopted. I have one by birth and two by adoption, and one by genealogy. To my knowledge, Campos-Pons has at least two, Cuban because of birth and American because of adoption. So we may ask, are all these our patrias, or, as the saying goes about Jesuits, are there patrias and patrias?

The law is one thing, but our feelings are another. Who are we? This is a crucial question for people like us, immigrants and children of immigrants. But how are we going to find a satisfactory answer to this question? What criteria are we going to use to determine who we are? One way to look at it is by considering what we do and how we approach the question. The case of Campos-Pons is quite telling, for she has found a way to deal with the dilemma that she and others like her encounter through her art.

IS: The word *patria*, to me, is blunt, injuring. I don't know if I have a patria. I was born in Mexico and feel gratitude to that country for being the state where I grew up. But do I love Mexico? Am I patriotic? The answer to these two questions is no. I don't hate Mexico. I'm not indifferent toward Mexico. But I don't love it either. I wouldn't become a soldier in order to fight for it, in part because I have a strong distaste for the army as an institution but also because I simply don't have enough passion for Mexico in order to fight for it. And do I feel that for the United States? No, here again I'm apathetic. I love the United States. I'm grateful to it. But I don't believe it is the greatest country in the world. I don't even feel it is my country. Instead, it is simply the place where I live, my place of residence. I admire Campos-Pons because she suggests that our family is our home. And our home is our patria.

JG: She has gone back to an earlier heritage that binds her to a family tree common between her and other blacks: Africa. By ignoring the elements in her history and makeup that separate her from both other Cubans and other Americans, she has discovered a foundation of her identity, a bridge to a community larger than those differences. She has done this by picking up the strains of her personal history, what she learned from her grandmother and other members of her family, traveling a trail of connections and memories that are similar to those of other blacks in this country; she has found them by going farther back than the ephemeral present, focusing on a transcendent and archetypal past.

The result is worked out in her art. This is what I see in her work in general and particularly in the work that we have before us, *Above All Things*. The very title of the piece is suggestive of this move. It opens a way to what is important, what is above everything else, a way of great significance: the past and, because of it, a way to other people. It is the bridge to the other who, until now, was deemed as foreign as she was herself. It is the basis of a dialogue founded on the memories of a shared past, the discovery of a familial bond. Races and ethne are familiar in important ways. Both are larger familial social groups, extended over generations, but nonetheless unifying their members in significant ways.

IS: I identify with this work because genealogy is important to me. In *On Borrowed Words*, I looked at my ancestry from the perspective of language and family. And in 2012, I published an illustrated volume titled *Return to Centro Histórico*. In it I use photographs to invent the past I'm no longer able to re-create based on history. Photographs, for me, are memory triggers as well as memory replacements. The moment we take a photograph, the moment we find one, that image competes with the memory we have and is capable of even replacing it.

JG: Two things stand out when I look at the work. The first is the represented image, a black woman. The second is that the image is broken into three panels. Both are important. The first, because above all things Campos-Pons is a black woman; the second, because also above all things she is broken. Being a black woman ties her to other black women, not just in her place of origin, but in her present place—with other black women she shares a history that goes from oppression to fulfillment. And a bro-

ken image suggests that she is not whole yet, that she has been broken by events and needs mending. Slavery severed the blacks who were brought to the Americas from their ancestral land, Africa; and the exodus from Cuba of Cubans who left the island severed them from their patria. The mending takes place through spiritual ritual. *Above All Things* depicts the act of making an offering to African divinities. Campos-Pons is preparing to communicate, in a trancelike fashion, with Orisha, one of the divinities in the Yoruba religion, who are manifestations of God and mediate between heaven and earth.

IS: I, too, empathize with the idea of the broken panels Campos-Pons plays with. The suggestion is that history and identity are always fractured and in need of arrangement by us in order to make sense. But making sense is a game: we are who we aren't through the arbitrary nature of this game, the reinvention of our past.

JG: And how are we going to arrange it? Is there a fixed formula, a logarithm, that we can use to do the arrangement for all, like in a cooking recipe: add a little of this and little of that, mix it well, and then add something else? Or is the mixing idiosyncratic to each one of us? Clearly the elements of the mix are different. Here you are: Jewish, Mexican, American, and White. And here I am: Spanish, French, Cuban, American, Canadian, and white. And Campos-Pons: African, Cuban, American, and black. How can we make something whole of these apparently disparate elements? How can we integrate all these elements into one personal identity? Do we do it in terms of feelings, and, if so, what kind of feelings? Are we talking about patriotic or nationalistic feelings, feelings of kinship, or something else? Do we reject some of these claims and accept others? And how do we proceed? It looks like there may be conflicts among these different claims on us.

IS: The answer to all these questions is one: randomness. Life is lived with a teleological sense. We move through it thinking that in the end everything will make sense, that the pieces of the puzzle that define us will ultimately come together. Truth is, they don't. Let me put it in another way: the puzzle can be put together in multiple ways, the results of which are

diametrically different. Am I a Jew who was accidentally born in Mexico? Or am I a Mexican who happened by chance to be Jewish? Whatever way you answer it, another me will emerge.

By the way, Jorge, a while back you told me that people often say to you that you don't look Cuban and that's because you aren't black. What if you were black? Can you imagine yourself as such?

JG: I can certainly imagine myself as having a different skin color and other phenotypical features, but I can't imagine myself as black. Why? Because in order to be black I would have to be someone else entirely. Race is more than the color of skin or the shape of one's nose. For me to be black, my ancestors and my history would have to be radically different. Being black in Cuba had deep consequences. It meant many things: at least some of your ancestors were slaves; your social standing was at the lowest level of Cuban society; your education was inadequate; your friends were members of the lower classes; you belonged, if at all, to social clubs that were open to blacks only and you could not belong to clubs that were the province of whites; the opportunities open to you were limited; you could not attend elite schools; you were de facto barred from enjoying the nightlife of Havana open to whites; your access to health services was restricted; you did not eat the same foods that many whites ate; you lived in generally poor neighborhoods; you were often insulted and suffered discrimination; and so on. These are just a few things that occur to me, and which I would have to be or have if I were black. For me to be black, meaning to be a Cuban black, not just a Cuban white with a darker skin and some features associated with blacks in Cuba, implies that I would be an entirely different person.

In short, it is not possible for me to be black, rather than white, without changing everything that is essential to me as a person. I could not be Jorge Gracia if I were black. You see, race is not just a matter of skin color; race is something that involves most of what one is both genetically and historically. If we change someone's genesis and history, then the person is not that person.

Now, let's change the question a bit and ask whether I could imagine myself as having a black ancestor. Suppose that all of a sudden I discovered that I had a black grandmother. Can I imagine that? Of course, I am

Cuban, am I not? And Cubans have that famous saying to which I referred before: "¿Y tu abuela, dónde está?" The question is a playful way of suggesting that most Cubans have a black grandmother that we keep in the closet because we want to pass as white. But what would it mean for me to have a black grandmother that I did not know about? Nothing much, as far as my past history, for nothing in that history, whether I knew it or not, would change. My perception of the history, however, would change because I would know something I did not know before, and my future history would likely also change because whether I took this information well or badly, my behavior would have to be adapted to the new circumstances. But I would still be Jorge Gracia now and I would still be Jorge Gracia in the future, although who Jorge Gracia would be in the future would be modified by the information about my ancestry. Whoever I am is the result of many factors, some out of my control and others under my control. So the new information would surely alter my future self. If I were to take the information badly, I would try to hide it and keep passing as having a lily-white ancestry. And if I took it well, I might try to search for the history of my black ancestors and identify with blacks more than I did before. But this is just the tip of iceberg, as the cliché says.

IS: As a writer, I love to imagine myself in others. What if I could live for a day with Shakespeare's mind? Could I have been a Nazi? (I wrote a story called "The Disappearance" that toys tangentially with the idea.) How different would my life be had my ancestors not immigrated from Poland and the Ukraine to Mexico but to Johannesburg or Shanghai? In what way would I change if I were my father and my father were me, or if I were my son and my son were me? What if I didn't have control of one arm, just like Cervantes? (Years ago, I wrote a story called "The One-Handed Pianist," about an accomplished pianist who suddenly cannot play with one of her hands.) Of all these possibilities, the one that keeps popping up is my envy of Shylock, the protagonist of *The Merchant of Venice* (1596–98). I wish I could have been Shylock. Likewise, I have an envy toward Judas. I find him a fascinating character.

Aren't these imaginings also a form of art? They are closer to what an immigrant goes through. You and I are immigrants, meaning that you and I know what inventing a new self is about. The immigrant might be

the most misunderstood figure in today's culture. Immigrants are often ridiculed, pitied, celebrated. In my mind, an immigrant is a person toying with freedom in a way seldom allowed to others, for the immigrant, like the snake, has the capacity of changing skins. Through assimilation, the immigrant becomes someone other than he was. Not that I can become Judas or Shylock. But having become an American Ilan that is different from my prior Mexican Ilan (although I'm still a Mexican Ilan), I can imagine what being Judas or Shylock might be like.

JG: We can all imagine all kinds of counterfactuals, that is, states of affairs contrary to what actually happened or is the case. This is a mine for artists and fiction writers especially, who exploit their imagination in doing it. Even ordinary people do it, and do it effectively. An immigrant might think, for example, what if I had not emigrated to the United States? Indeed, I often think about what my present would be like if I had gone to Canada or Switzerland to study when I was fifteen, as I almost did, rather than stay in Cuba. I had already registered in a school in Ontario and was ready to leave when my mother had a serious attack of regret and convinced me not to go. But all these counterfactuals are cases of possibilities. The question you asked was about race, and this is so fundamental in terms of ancestry and history that a change in it makes it impossible to maintain an identity. It is like imagining a square circle. Can we do that? We certainly can think of what a square circle is: It is a geometrical figure that has the properties of a square and a circle. But it is impossible to imagine that such a thing could exist. We cannot do it because the notion of a square circle is contradictory. Not that people, and particularly theologians, do not often speak as if contradictions did not matter. There was this crazy monk in the Middle Ages by the name of Peter Damian (who, by the way, was canonized by the Catholic Church), who thought that God was so powerful that he could bring it about that what had happened did not happen. Well, that is just not in the cards. If something has happened, not even an all powerful God can change it.

I'm afraid I'm boring you with my distinctions, but distinctions are the essence of philosophy. So the answer about imagining possibilities is that we live doing that. We imagine possibilities every day. That is how we plan the future. And we also imagine counterfactuals without any prob-

lem; we often conceive contrary states of affairs and their consequences. I could very well imagine that I was not born, or that instead of I being born, someone else, of a different race, was. But the point is that under those conditions I would not be who I am, but someone else.

I'd like to take the opportunity to get back to race, however, because Campos-Pons's work raises a question that has elicited much controversy and discussion recently. I am referring to whether race is a matter of genesis or culture. Her search for African roots brings culture and ethnicity into the matter of race. Do you have any strong views on this?

IS: When it comes to race, the dichotomy between nature and nurture is impossible to solve. I'm fond of a novella (given its length, perhaps it's a short story) by H. G. Wells titled *In the Country of the Blind*, although I recognize that its premise is far better than its execution. Wells published the piece in a magazine in 1904 and in a collection of stories in 1911. The premise is this: a person called Nuñez (or Nunez, given how poorly the British copyedited their literature at the dawn of the twentieth century), who is a mountaineer and whose sight is average (he sees what most people see), travels to Ecuador. Climbing a fictitious mountain called Parascotopetl, he has a fall through a steep precipice and suddenly finds himself in a valley, where he stumbles upon a people who are blind. Do you know the Spanish saying, "en el país de los ciegos, el tuerto es rey," in the country of the blind, the one-eyed man is king? This tale is a twist; or let me say it differently, it pushes the saying to its extreme. The mountaineer becomes a threat to the blind. As is usual in these types of stories, he falls in love, there's a quest for freedom and self-immolation, and so on. My point here is that Nuñez antagonizes the blind. As a result, they seek to make him "normal": to blind him. Only then will he be like everyone else.

Races from different regions of the globe have distinct physical characteristics, starting with skin pigmentation. But race is also a social and cultural construct. That is, as you're being raised in a particular group, one defined by race or ethnicity (for there is no group not *defined* by it), you become part of the architecture of race that surrounds you. It is the same with an accent. People seldom say they themselves have accents, yet they always refer to the accents other people have. Speaking is natural.

Everyone does it. But nobody has a neutral language. That is, nobody is free from having an accent. And where does the accent come from? From the way we learn to use language, the milieu in which we were raised. Are there accents that are better than others? That's a cultural judgment. A French accent in English will take you places. So will a German accent. These two accents mean very different things. The French accent in a woman might be seen as sexy, even voluptuous. The German accent is rougher. It carries intellectual weight. It also reminds people of the Nazi atrocities, although that connection is quickly fading. A Spanish accent is seen as more pedestrian, less cultivated. I'm talking of the English-language realm alone, and, within that realm, of American English.

Campos-Pons's work under discussion brings to my mind a view of race on which you'll probably have a position. Here's my pitch: Latino art, especially a piece like *Above All Things*, becomes a racialized version of Latin American art. That is, the way Latin Americans approach race is different from the way Americans do. As a result, Latinos, and Latino artists in the United States, define themselves through a prism that is unlike what they experience in Mexico, Cuba, Puerto Rico, etc. And what does it mean to be racialized? It means that in the context of a Caucasian society, Latinos, by definition, are "others." Their art emerges from this quality of difference. In Latin America, instead, artists most frequently come from the upper and upper-middle classes. While they might be black or white or anything else, class is a more decisive factor. Or at least it is the entry-way to understanding art in general, after which the issue of race might be approached.

Let me take another route: How different would Latino art in the United States be today if the majority of the country's population was either mestizo or black? My answer: very different.

JG: Ilan, you raise so many interesting questions that I'm lost as to how to respond, almost. But let me give it a try. First, about the relation between race and ethnicity. You seem to throw up your hand in despair—it is a problem without a solution. Well, in many ways it is, but I am interested in diagnosing why it is so difficult and why people are so confused when they think and talk about race and ethnicity. To cut through many complications, let me say that I think the reason is the asymmetry between

race and ethnicity. These are two phenomena that are closely related but that at their roots are very different. Race involves two very important assumptions: lineage or genesis on the one hand and physical features on the other. According to the first, to belong to a race one has to be related by descent to members of that race. According to the second, to belong to a race one has to share with other members of that race certain physical features, such as skin color or a certain type of nose. These are what philosophers like to call necessary conditions. If either one is not present with respect to a particular race, people do not think of the person as belonging to it.

The case with ethnicity is quite different, for different ethnic groups have established different requirements for belonging to the groups. For some populations in Mongolia, for example, descent is absolutely necessary. One cannot be a member of a certain population group unless one is a child of parents who belong to that group. This means that an adoption from birth will not make a person belong to the group of the adopting parents, even if the person has always lived with the group and the only culture it knows is that of the group. This is a strictly descent-oriented view of the ethnos. But other ethnic groups do not have the same requirement. For example, for Jews (at least for some), you belong to the group if your mother was a Jew, but you can also become a Jew if you convert to Judaism and adopt Jewish ways. This means that ethnicity in this case is not exclusively a matter of descent. Moreover, it is common that people will associate membership in ethnic groups with having certain phenotypical features. As I mentioned above, some people do not think I am Cuban because I do not look black.

You can see, then, how race and ethnicity can be easily confused with each other, because the requirements of ethnicity may include race, or be primarily established on the basis of racial criteria. So some ethnic groups can be racially differentiated, whereas others cannot. This makes it possible for people to justifiably think of certain ethnic groups as races and of others as not races. The next step is to think of all ethnic groups as races, that is, to think of the racialization of ethnic groups that are not racially distinct, such as Cubans, Latinos, and so on.

This affects how Latino art is perceived. For those who racialize Latinos, either thinking of them as black or as native Americans, the art must

have some connection to the race. For those who do not, the art need not have racial connotations and can instead have only cultural connotations. And, of course, if the situation in the United States were different than it is, and the majority of the population were mestizo or black, the way Latinos and Latino art would be regarded would be very different. If the perception of Latinos fit within the racial or ethnic profile of the population, any of their art that had a Latino flavor would be regarded as part of American art, but any art that did not, would not be so regarded.

This raises the question, even more difficult, of establishing what makes, or would make, Latino art to be such, and whether the presence of whatever that is would in fact contribute to the value of the art. Then we could ask ourselves whether the works of art we have considered here qualify as Latino art and whether they are good or bad art on these bases.

IS: I am glad you have made us return to our central tenet: What is Latino art? We have touched upon it in a number of places in these dialogues. As I look back at our debate, it seems to me we are ambivalent about the topic. But we obviously haven't exhausted it, at least not from my perspective. As we've said, using labels to define art—and, for that matter, to refer to anything—is a convenient epistemological approach for all of us. Yet the moment we become conscious of the use we give them, these labels suddenly appear dangerous, perhaps even empty. What makes Latino art Latino? I have a total of four answers, which I'll divide in two pairs.

My first answer doesn't point to the content of a particular artistic piece, in this case Campos-Pons's *Above All Things*, but to the artist behind it. If Campos-Pons is Latina, then everything she does is a product of that worldview. The second answer moves in the exact opposite direction: it actually doesn't matter who the artist is for a piece to be considered Latino art. If the piece itself displays a Latino theme, figuring out what a Latino theme is might be impossible, especially in a piece like this one.

Let me analyze these two answers by talking about Shakespeare and Kafka, two authors who never cease to amaze me. Is *Hamlet* (1603) an English play? Well, certainly, since the playwright who wrote this tragedy was born in Stratford-upon-Avon and for years lived and worked in London. Plus, it is written in the Queen's English. Yet the plot takes place in Denmark. Shouldn't it be considered a Danish play then? If so, then

Romeo and Juliet (circa 1591) is an Italian play and *The Tempest* (1610–11) a Caribbean play. Needless to say, a writer might set his play wherever he wants; his choice won't make his plays less native to his own milieu. In short, it is uncontestable that since Shakespeare was English, so is his work.

However, the argument gets complicated when one thinks of minority art. Let's ponder the case of Franz Kafka. He was Czech, all right. Reading *The Castle* (1922), we are able to understand the relationship between the protagonist, K., and the authorities in the castle by knowing the exact locus of the Prague castle, where the kings of Bohemia had their offices. But Kafka is a peculiar literary figure in that he was a Czech who was Jewish and wrote in a high-brow language, German. Does this novel have a Jewish theme? The word *Jewish* is nowhere to be found in the work. In fact, that word is absolutely absent from Kafka's literary oeuvre (although it is present in his diaries and letters). This brings me to ponder: Does a novel need to address a Jewish theme in order to be a Jewish novel? If you ask me, there are novels that aren't more intimately connected with Jewish identity than this one, as well as *The Metamorphosis* (1915) and *The Trial* (1925). They explore Jewish angst, Jewish theological motifs, in sublime fashion. And yet they never do it directly, never saying the word *Jewish*.

What makes Latino art Latino? I gave you two contradictory answers. Let me add two more. The third answer: the viewer. If the viewer (you, me, whomever) says it's Latino, then it is Latino. Yes, this is quite a capricious, subjective response. It is impossible to systematize it, since every person might chose another approach. Still, the viewer's response is ultimately what art is about and we must respect its chaotic characteristic.

Finally, the fourth answer is esoteric and maybe annoying; it is also a summation of the previous three. Latino art is Latino because of the mystery of what can be said and what must be kept silent about our essence as Latinos. That mystery is inexcusable, which is to say that Latino art is anything and everything we want to find in it.

Having said all of the above, my inclination is to go back to the beginning and state that art both stresses and transcends cultural qualities.

TWISTED TONGUE

ADÁL *La Spanglish Sandwich Bodega Bag* (2000)

Ilan Stavans: How do you explore language—by which I mean semantics—in a
work of art? Two artifacts come to mind. The first is Rembrandt's *Balta-
zaar's Feast* (circa 1635). I talked about this scene in a conversation about
the Bible as narrative I had with a Canadian journalist, Mordecai Dasche,
which became a book: *With All Thine Heart* (2008). The scene depicts
King Baltazaar of Babylon taking sacred objects made of gold and silver
from the temple in Jerusalem. There is a reference to the Book of Daniel
(5:1–31), specifically to an emblematic statement that is known as "the
writing on the wall," which reads in Hebrew: "Mene, Mene Tekel Up-
harsin." Rembrandt's painting seems to me driven by this quote, as if the
artist needed to re-create the biblical scene in order to be able to write
the four words, and not the other way around, to write the four words so
as to paint the biblical scene. Without the words, the image would be far
less attractive. What do the words mean? The debate is ongoing and I'm
not interested here in rehearsing a discussion I already had. Suffice to say
that words are the centerpiece of art in this example, words that in them-
selves are unclear.

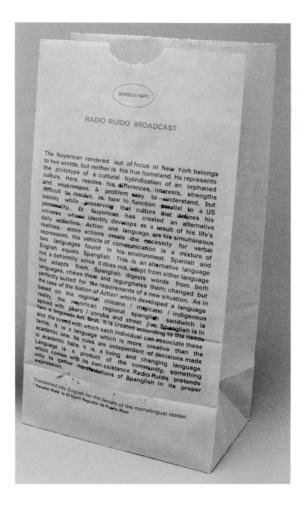

Adál, *La Spanglish Sandwich Bodega Bag* (2000), paper bag with printed text, 11″ × 6″ × 4″ (27.9 × 15.2 × 10.2 cm). Collection of El Museo del Barrio, New York, gift of the artist, 2001. 17.1 a-b. Photo by Eddie J. Bartolomei. Photo courtesy of El Museo del Barrio. Used by permission of the artist.

The second artifact is René Magritte's *La trahison des images* (The treachery of images) (1928–29). There is a tacit contradiction in this painting between what the viewer sees, a pipe, and the caption under the painting, which suggests that this isn't a pipe. The contradiction is both semantic and epistemological. Semantic because the viewer encounters two languages: the language of art and the language of words. In this case their respective meanings are oppositional and epistemological, because our understanding of what is a pipe is refuted by the assessment that what we see is not a pipe. Magritte's playful game in this piece is to emphasize the ambiguous, even incongruous messages the modern world, full of paradoxical meaning, often sends of our way.

Jorge Gracia: The problem that Magritte's work creates for observers is that we are confronted with a contradiction, and contradictions are intolerable. The image tells us that what we are looking at is a pipe, but the title tells us that what we see is not a pipe. It appears that what we have in front of us is both a pipe and not a pipe, and what is worse, it appears that both statements are true and both are false. We have a paradox in the line of the Liar's Paradox. If you remember, that is formulated as a statement that is both true and false, and therefore impossible: I am a liar. If I am a liar, this statement is true, and therefore it is also false. But if I am not a liar, then the statement is false, and therefore true. So what do we make of this? How can we resolve this puzzle?

Another example of this kind of puzzle is what are called complex questions, which are frequently used rhetorically. For example, if a prosecutor asks a man who is accused of beating his wife: "Have you stopped beating your wife?" there is no answer that the man can give that will exonerate him. If he says yes, he is doomed, because his answer entails that he has been beating his wife. And if he says no, his answer entails that he is still beating his wife. In both instances he acknowledges guilt. The reason both answers damn him is that the question assumes that the husband is beating his wife.

Bertrand Russell's solution to this puzzle was to argue that statements and questions such as these need analysis before they make any sense. A statement such as "The present king of France is bald," when in fact there is no present king of France, is confusing because it is complex in spite of its apparent simplicity. In order to make sense of such statements

we need to analyze them in their components before we can make sense of them. His idea was that analysis shows that the statement about the present king of France, contrary to what it appears to be prima facio, is composed of other statements. One is that there exists a king of France at present, and the other is that the king is bald. Now this can be applied to the case of Magritte's work. The problem with it is that the subject terms of the two propositions, "this is a pipe" and "this is not a pipe," refer to two different things. In one case, the reference is to "the image of a pipe in this work of art" and in the other it is to "the kind of thing represented by the image of a pipe in this work of art." The first is obviously not a pipe, since it is a drawing, and the other is a pipe insofar as it is the drawing of a pipe.

This dissolves the conflict to which I referred and that we find puzzling when we first approach the work. However, there is more to Magritte's piece, for it does raise, as you suggest, two other issues. One is the difficult and complex question of whether one can possibly translate a visual image into words, or words into a visual image and, related to this, of how linguistic items, such as words of natural languages, function in visual works of art that are composed of images not predominantly intended as sentences or expressions of natural languages. As you know, I have raised these issues in two recent books, *Images of Thought* (2009) and *Painting Borges* (2012), but I am still dissatisfied with the results.

IS: One of the first things that needs to be said about Adál Maldonado, better known as Adál, is quite simple: he uses a paper bag. This might sound ridiculously apparent, but it isn't. We've been focusing on the connection between words and art, and we'll return to this confluence shortly, but it's important to talk now about the artistic side of the piece. Why a paper bag? The item is part of our everyday life. We use paper bags for all sorts of things: packing lunch, handling items in the supermarket, and so on. The paper bag is a companion. As such, one could think that it's been with us forever. Evidently, it hasn't. It appeared in the early decades of the twentieth century as a manifestation of a fast-moving, mobile society driven by commerce. Paper was no longer used exclusively to write. Its uses became more diverse, and one of those uses was to carry along items from the domestic realm to the public and vice versa.

The paper bag is different from the plastic bag, which appeared on the scene much later, in the material it is made of. They can also be distin-

guished by what they hide and what they reveal. A paper bag hides its contents from view. When I was an adolescent, I remember being puzzled by the use of paper bags in newsstands when a customer bought a copy of *Playboy* or any other pornographic magazine. Part of the contractual agreement involved in the sale was the secrecy attached to the product: pornography is for private consumption; thus, the buyer should not be identified in front of others.

Adál, as an artist, is part of the Nuyorican aesthetic. That is, he belongs to a movement that sees Puerto Ricans as both subalterns and subversives. His use of the paper bag can be interpreted in several ways. One of them is the idea of mobility: Puerto Ricans travel from one place to another, that is, from the island to the mainland, from home to the workplace, from their ethnic ground to mainstream America. What do they carry with them? A paper bag. This is a sign of their humble background. It is also a comment on their lack of means. It isn't a fancy purse we're talking about but an average, nondescript paper bag.

JG: An interesting point about this piece is precisely that it consists of a paper bag. This is different from a work of art that consists of a picture of a paper bag. Alberto Rey, a Cuban American artist who was brought by his parents into the U.S. when he was three years old, has produced a wonderful painting of a paper bag. This is a rather large oil on plaster work (96″ × 48″ × 4″) entitled *Bag of Chicharrones* (chicharrones are pork rinds). Rey took great pains in the depiction of the bag, its grease-stained surface, the folds, the light brown color, with a result that is both traditional and innovative. Traditional in that the work is an oil painting using proven techniques of the medium, which Rey has mastered thoroughly; innovative in that I do not believe anyone had done this before him, his subject matter was entirely new.

Obviously, Adál's work is very different in both of these senses. But there is even a more important difference. Rey's work is part of a series of paintings he did on cultural objects from Cuba. The fact that Rey was brought to the United States when he was three created a vacuum in his past. He did not have memories of Cuba, although he was introduced to Cuban culture by his parents and relatives. When he became an artist, he tried to capture Cuban culture by appropriating memories. In one of his series, called precisely *Appropriated Memories* (1995–97), he depicts

Cuban landmarks, such as the fortress of El Morro and the Valley of Vi-
ñales. Another is a series of pop culture items, untitled *Icons* (1993–95),
including such items as a bar of guava paste and the bag of pork rind
to which I referred. For him, then, the bag is a symbol of Cuban popu-
lar culture, an iconic image of something very common and very Cuban.
The work is intended to capture what he missed and had to reconstruct.

In the case of Adál, the piece is part of a series that depicts paper bags,
but it is something very different. The bag is an object not foreign to him,
so there is no appropriation of cultural memories. Its meaning is differ-
ent. Here is what the bag has written on it:

Bodega Papo
Radio Ruido Broadcast

The nuyorican rendered out of focus in New York belongs
to two worlds, but neither is his true homeland. He represents
the prototype of a cultural hybridization of an orphaned
culture. Here, resides his differences, interests, strengths
and weaknesses. A problem easy to understand, but
difficult to resolve, is how to function parallel to a US
society while preserving that culture that defines his
personality. El Nuyorican has created an alternative
universe whose identity develops as a result of his life's
daily activities. Action and language are his simultaneous
realities, since actions create the necessity for verbal
expression. His vehicle of communication is a mixture of
two languages found in his environment. Spanish and
English equals Spanglish. This is an alternative language
not a deformity since it does not adopt from either language
but adapts them. Spanglish digests words from both
languages, chews and regurgitates them; changed but
perfectly suited for the requiremenst of a new situation. As in
the case of the Nation of Aztlan* which developed a language
based on the regional chicano / mejicano / indigenous
reality, the nuyorican regional spanglish sandwitch is
spiced with jibaro / yoruba and street jive. Spanglish is in
fact a linguistic Art Brut. It is created according to the needs

and the speed with which each individual can associate these terms. It is a language which is more creative than the academic one. Its rules are independent of decisions made in academic halls. It is a living and changing language. Language is a product of the community, something which comes with its own existence. Radio Ruido pretends only to gather manifestations of Spanglish in its proper expression.

*Parallel State to El Spirit Republic of Puerto Rico

Translated into English for the benefit of the monolingual reader.

IS: The text is a poem entitled "Spanglish Language Sandwich Analysis." It was written by Adál. To me it seems inspired in the work of Pedro Pietri, an influential Nuyorican playwright and poet who wrote *Puerto Rican Obituary*, co-founded the Nuyorican Poets Café in New York City, and collaborated with Adál in a traveling installation known as *Blueprints of a Nation*, which is a kind of conceptual universe—that is, a nonexistent reality—that surges as a response to the refusal of the U.S. government to recognize the actual needs of Puerto Ricans in the twenty-first century. This alternative country has its own map, currency, stamps, time zone, and so on.

JG: This poem in the work suggests to me that, like Rey, Adál is concerned with the hybridity of his identity and how language is part of that hybridity. The very title of the piece points to an issue that is very different from that of the Rey, although both pieces involve issues of ethnicity— Puerto Rican and Cuban. But Adál's work is not meant as a recovery, but rather as a question about the Puerto Rican culture in an Anglo-American context, where Spanglish, rather than English or Spanish, is the language.

IS: The fact that Adál's piece is called *Spanglish Sandwich Bodega Bag* is significant. As you know, I've devoted a generous portion of my life to understanding this linguistic phenomenon, Spanglish. Where does it come from? What does it represent? Why does Spanglish generate so much animosity among some well-educated people?

Spanglish is a language in formation. It results from the contact of two

standard languages, Spanish and English. By calling it a language in formation, do I mean that it is a fully formed vehicle of communication? It surely is a recognizable code but it doesn't have syntactical rules the way standard languages do. In other words, there are still numerous says to spell a particular word or to build a sentence. There are also different types of Spanglish, for instance Chicano Spanglish, Nuyorican Spanglish, Cuban American Spanglish, and so on. What attracts me to the phenomenon is its sheer vitality, the jazzy quality it exudes. Improvisation is the law of the land among Spanglish speakers. The fact that other Spanglish speakers understand what is being said is proof that an epistemological encounter is taking place.

Adál's title is made of four letters: a noun, modified by three adjectives, each of which supersedes the previous one. This, the artist suggests, is observably a bag. Not only a bag but a bodega bag, meaning the type of common paper bag used in bodegas to hold an item after it is purchased. That item is often a sandwich. But Adál adds Spanglish to all this, meaning that the sandwich is probably a symbol of the encounter between two cultures, Anglo and Hispanic. Or, as we're implying, not the sandwich but the bag is what the piece is about, that is, what its symbolism invokes.

JG: I think the bag symbolizes Adál, it is Adál. For what is a bag? It is an artifact that we use to hold other things. And what is a human being but a skin bag that holds all kinds of things inside it? I am not speaking about flesh, bones, and organs necessarily, although it does hold these, but, more important, perhaps it holds all that a person is in addition to its body: memories, desires, ambitions, disillusionments, experiences, everything that makes us up. Here we have a bag that is brown, that is colored in some way, like most Latinos and most Puerto Ricans, and it has writing on it. Writing, words, are of the essence, because it is through language that we think about the world and ourselves. So there is language on the bag and it is a mixed language, not a regular language, like Spanish or English. There is not a Royal Academy or an OED of it. It is a bridge language between two poles that are pulling on what Adál is, his American side and his Puerto Rican side. That the language is Spanglish is significant, for it means that the foundation of what is written is English, with some additions and modification from Spanish. Adál is fundamentally Nuyorican. He is a hybrid, a platypus, as I used to call myself years ago.

Because he, like me, and like you, is a mixture of various things. It is too bad that the bag cannot hold something soupy, because if it did I could use the metaphor of the *ajiaco*, the stew that symbolizes a Cuban.

But what is it that holds the bag and its contents together? It is difficult to say. It would appear to be the bag itself, which has parts that are glued and put together so as to hold things. But I do not think it is our skin that holds us. So perhaps the bag cannot be identified with the skin, but with something more organic, the whole that is put together by what we think of as ourselves, our real skin, which is not a physical object, like our outward skin, but a mental construction that holds us. Note that the writing is on the surface of the bag in Adál's piece.

Now, bags are delicate, they can easily break. We can fill them with air and explode them. Or we can load them with so much stuff that they will come apart. Or they can get wet and the paper will just break into pieces. So we must be careful with the bags we are. Adál is telling us that he is sensitive and delicate. He cannot be thrown around, punched, and abused, because he might break, even though he is also tough, as a bag is.

Something else is important in a bag: it hides its contents. Adál's bag is not made out of cellophane. That would expose its contents to the inspection of an audience. The paper bag is not transparent or even translucent. It does not let light pass through it and it hides the inside of itself, just like we do with our customs and expressions. Who knows really who we are? We put on a show, but the real I stays hidden. The only one who can access me is I. So we live among bags just like ourselves, all closed, so as not to show who we really are. Everything important about ourselves is in the closet, as they say about gays. But can a bag open up by itself? It does not seem possible. Bags are opened by others. So perhaps there is also another dimension to the bag that we need to take into account to understand what Adál is telling us, namely, that it shows that only others can open us, although in order to do it without tearing us apart, the opening has to follow a procedure and be carefully done. Otherwise the bag breaks, and then we no longer have a bag. We have instead all kinds of other things, spilled out, in disorder, with remnants of the paper that originally constituted the bag.

IS: I love your idea that we're bags. I couldn't agree with you more. This thought brings us back to the reflection we had earlier about identity.

Who am I? I ask the question every minute, every hour, every day of my life, not necessarily in an active way but in an existential way. What constitutes my "self"? How am I different from those around me? And in what sense is my self an updatable (that is, a changing) condition? For every time I ask myself the question, I know I've already answered it in a number of ways, each of them pertinent to the moment in which I was at the time. Now that I ask the question, the answer will be different because the moment in which I'm asking it isn't the same from those preceding it. At the same time, my answers have a unifying characteristic because they are always mine and I tend to respond to questions in a particular way.

Anyway, asking the question now, after hearing your comment on Adál's art, I think of the self as a bag into which all sorts of ingredients (biological and experiential) are thrown in. The juxtaposition of those ingredients is, by definition, unique to the individual. No two persons are alike, not only in terms of talents but also in development. Even a pair of identical twins evolve in ways resulting from their separate paths. I like the metaphor of the self as a bag. I'm not sure, as you suggest, that only others can open that bag. We can also open it ourselves. In any case, the bag is a depository. Think of the self before birth as an empty bag and of life as a series of insertions of various ingredients into that bag.

JG: If you remember, we started early on talking about the self as a kind of plurality when we were discussing Brito's *Conversation*. The common idea that we are one thing does not account for what we know of ourselves. Hume thought that we were no more than the bundle of our experiences or sensations. I think we are more than that, for a bundle needs to hold together, and what holds it? The metaphor of the bag helps to do justice to the idea of our plurality or bundle and for the need to have something that holds it. It seems that there have to be boundaries that separate us from others. And the bag suggests that it is something strong and at the same time delicate, and something that hides but also reveals. Remember the painting by Rey in which the grease from the chicharrones stained the bag, revealing at least part of its contents. But Adál's bag has writing on it, so we must not forget it, for that reveals another aspect of the metaphor.

IS: Let me go back to the issue of language, then. Adál's art is about Spanglish. That is, it's about hybridity. If we were to connect hybridity to the

metaphor of the bag, I would be prompted to think that the shaping of every bag—the development of the self—happens thanks to serendipity. Improvisation is crucial in life. We are who we are because of the accidental nature of our path. I use the word *accident* not to mean interruption but to invoke chance. What I like about Spanglish is the degree to which chance defines it as an hybrid code of communication. I said before that no two Spanglish speakers are alike in the way they express themselves. Truth is, no two English (or Spanish, or French, or German, or Hebrew) speakers are alike either, for no two people are identical. Yet when speaking English, there's a standard code we comply with that includes syntactical rules, a set vocabulary, etc. Spanglish, instead, is in a state of flux. It's rules are open-ended and its lexicon is ever expanding. There's a certain freedom in it and to it that an English speaker doesn't have. What kind of freedom is that? The freedom to improvise. Or, put in another way, the freedom to make mistakes without anyone describing them as mistakes. A colleague of mine once told me that no teachers are needed in correcting Spanglish because everything is allowed in it. She isn't right, of course. It's true that the tolerance of mistakes—if that's what they are, although they aren't called that—is considerably higher. But not everything is allowed. For instance, one cannot include an out-of-the-blue Japanese word in a Spanglish sentence. Communication needs to happen between Spanglish speakers, meaning that they have to understand each other.

Wrapping up my point, Adál's invocation of Spanglish makes the idea of the self as a bag immensely appealing to me because of the improvisational nature of the self. We become ourselves through a strange interplay between fate and coincidence. I like the title we gave to this chapter: "Twisted Tongue." Spanglish is the result of the twisting of standard tongues. It is also twisted in its baroque way of depicting the world. And it is twisted in its improvisational impetus.

JG: I am not a great believer in fate, because I think it is subordinated to chance. Chance seems to rule the world. Have you ever seen Woody Allen's movie *Match Point*? It is all about how the main character gets away with murder, thanks to the chance fate of a ring. And then there is the Uncertainty Principle in physics, according to which the more you know about certain aspects of an atomic particle the less you know about certain other aspects of it. Why do I take my feet from my mother and my

heart from my father? Genetics is a roulette, and the real chance begins; living parents or dead ones, wealth or poverty, Cuba or the United States. Life is a roll of the dice from beginning to end, in spite of the signs for a destiny and what appears to be a well established path ahead of us. And, yes, in part this is because of the plural nature of the our selves and the endless possibilities that this opens.

IS: The last topic I want us to contemplate in connection with Adál's bag is the question at the heart of contemporary art, one we've only partially alluded to when we talked about graffiti. Does a simple paper bag with a written inscription on it constitute a work of art? Well, yes and no. If I found that bag on a street in New York, I wouldn't think of it as aesthetically pleasing. On the contrary, I would see it as trash. Yet the very same object placed in a museum becomes a fountain of contemplation and reflection. Art isn't what the artist does alone; it's how society packages it, where it places it, and how it labels it. This statement has unavoidable consequences. One of them is that anything and everything might be considered art if packaged in the proper way. The corollary of this is that there's a difference between potential art and an actual act. An actual act is that which is already seen by society as artistic, whereas potential art is what one day might be packaged as art. Again, potential art is everything. After I die, I might be cremated one day and my ashes placed in an urn in a gallery. The urn might not be aesthetically attractive, but the artist, whoever she might be, might write a caption near it that says: "The consequences of thought." To be honest, I would like this piece of art. It would say much about my quest, about the bag that is my "self," the ingredients it contains, the dreams I've had throughout my life. In the end, we're all insignificant, no matter what our aspirations have produced.

JG: Unfortunately, I am sure I will be dead before you, so I will miss this great piece of art to which you refer, but I do love the idea of getting back to the question of what art is at the very end of our discussions. I think it is particularly appropriate that we take it up at the end, because it will serve to put some other things we have said about art in perspective. So, after all that hesitation in one of our previous conversations when I proposed to deal with this question, you could not help to come back to it. And not only that, but you offer a solution!

One of the things I think important when discussing this most vexing issue is to keep in mind the approaches that have been used in trying to come up with a satisfactory answer to what art is and what distinguishes it from everything else. When philosophers discuss this topic, they usually have in mind the identification of what they call necessary and sufficient conditions, although some like to talk instead about definitions, and others speak about properties, among other things. Whatever terminology they use, the goal is the same, they want to establish what art is, what makes something to be art rather than something else.

The difficulties appear insurmountable, particularly after the revolutionary changes that have taken place in art in the twentieth century. Imagine the reaction of Greek and Renaissance artists and critics if one were to have claimed that the installations that today are the rage are art. A pile of bricks art? A urinal art? A shark in formaldehyde art? Or Adál's *Spanglish Sandwich Bag*? Even what have now become rather conventional pieces, such as Picasso's *Guernica*, would have shocked them.

As I see it, there are two different attitudes people adopt with respect to this question. Some think the question is unanswerable, although they may differ as to why, for some hold it is because it has no answer, whereas others think there may be an answer to it but not one to which we can have access. Consider, for example, a Wittgensteinian approach in which the term *art*, like other terms of its kind, is applied on the basis of family resemblance, rather than on the bases of particular properties that all the things to which the term is applied share. Or think of the Kantian approach, in which the thing in itself is beyond our powers of cognition insofar as whatever we know is filtered through an a priori grid we cannot avoid.

On the other hand, others think that the question is answerable, but they differ in the answer. The answers tend to be motivated by two conflicting aims. Some seek to have a very inclusive view of art, so inclusive that anything can, or should, be considered art, although often they qualify this position in various ways. I think a version of this position is the one you are advocating: everything can become art, although not everything is art. For others, the aim is not to extend the notion of art as widely as possible, but rather to restrict it so that it actually excludes some things that have been, or are considered, art. This is the case with someone like Tolstoy, who excluded from the category works that we generally consider to be not just art, but some of the greatest art ever produced.

I am sympathetic to your position, although with one qualification. Only objects considered by someone to be artifacts capable of producing an aesthetic experience are art. This excludes natural objects, objects that are not considered to be artifacts by anyone, and objects that are not considered to be able to produce an aesthetic experience by anyone. Thus we can exclude a sunset or a pebble on the beach, although we are able to include a photograph of a sunset, a sunset as seen by someone, or a pebble I have picked up from the beach and placed on the mantel of the fireplace. Why? Because in all cases the result, that is, the photograph of the sunset, the view of the sunset, or the pebble on the mantel, is an artifact insofar as it has been modified, or its context modified, by someone with a view toward producing or enhancing an aesthetic experience.

This is a very general, one might even want to say formal, conception of art. It does not actually tell us what is and what is not art. Indeed, it is very broad insofar as anything artifactual can be, although it might not be, art, which is what you claimed. However, it is not too broad, because it excludes items falling into the categories mentioned, such as the sunset that no one has seen or photographed, or the pebble no one has picked and put on a mantel. Still some might want to argue that this is not enough. After all, we would like to know whether Tolstoy, Renaissance artists, and the philosophers of ancient Greece would be right if they were to exclude installations, sharks in formaldehyde, urinals, *Guernica*, and Adál's bag from the category art.

Here is the rub. I believe that the idea that we can go beyond my stipulation is the result of a misunderstanding of the kind of thing that art is. I said that a condition of art is that it be considered artifactual by someone, which points to the all important source of art. Art is a product of human intentional activity guided by design. Art is the product of human history and therefore historical, and as such, an understanding of it has to take into account that history. And history is particular and contextual. This means that art is fundamentally historical and contextual, and what is or is not art can be determined only under historical conditions. The question of whether a particular object is art or not, considered *sub specie aeternitatis*, is nonsense. This is a thought that I think coheres with much of what we have said in our conversations, and perhaps it is a good point at which to stop.

THIRTEEN PLUS ONE

Ilan Stavans: I want to tell you about a dream I had a couple nights ago. The dream is connected with the conversations you and I have been engaging in. Let me first say that recently I've been having dreams that are far more peaceful that the ones I had in my late forties. I turned fifty not long ago. I was excited about this benchmark because I'm officially middle-age. I look at middle-age as a settled, reflective time. I no longer have the fears I had when I was twenty: Will I be able to make my dreams come true? Or the anxieties that came in my thirties: Will my children grow up healthily? Will I be satisfied with what I do on a daily basis? And will I have enough time to do everything I want to accomplish? Now I have the capacity to look back and appreciate what has come before and look at the future not as a test but as a surplus, recognizing that whatever comes from here on is a bonus.

In the dream, I saw my childhood house in Mexico City. I haven't been in that house for over twenty-five years. My parents sold it shortly after I immigrated to the United States. In my dream, the house is inhabited by people I don't know or care to know. I entered the living room after

walking through a long pathway. At first I didn't know it was my house. I couldn't recognize its features: everything looked different. But after a while I understood where I was. That recognition brought along a feeling of tranquility. Soon a tall man approached me. He looked like a neighbor I used to have who lived a few houses away. I'm not sure if he was an American of if he was Mexican and his wife was American. In any case, I knew one of the two was from the United States. When I was in my teens I was very friendly with this neighbor. He and his wife had two daughters. The family owned a house in Cuernavaca to which he would sometimes invite me. I would take with me countless books and use the vacation to read. And to shoot various guns and rifles, because my neighbor had a collection of weapons. He would make fun of me as an intellectual who didn't have the courage to shoot a gun. So one of his objectives was to teach me how to feel comfortable with one.

Ironically, I knew that my neighbor was also a transvestite. By night, especially on the weekends, he would disappear—not only in Cuernavaca but in Mexico City—and spend time at various gay bars. Anyway, in my dream it was the neighbor who greeted me in my own living room. He smiled the way he used to smile every time I shot one of his riffles. And then he showed me a piece of art he had just acquired. In order to see it, I needed to go into the basement. Now, my childhood house didn't have a basement. I knew this in the dream. Still, I followed him through a door that led to a descending staircase. Once we were in the basement, my neighbor turned the light on. The room was full of paintings covered with white cloths. He approached one of the paintings and uncovered it. The image I saw was stunning: it had a hut in which a very old lady sat next to a makeshift fire. She had a canoe nearby. The canoe was covered with butterflies of all colors. Every so often, the lady would stand up, capture one of the butterflies, and throw it into the fire.

I was amazed by the fact that the painting allowed for some movement. I said so to my neighbor. He offered a consenting smile. Then he took one of his rifles and shot the very old lady. After he had done it, he looked at me again and smiled. "Don't worry!" he said. "There are plenty of butterflies to replace her. They'll help us with our pain."

At that moment I woke up.

I don't know what the dream means. (I have written about my neigh-

bor in "El misterio de Raúl Berra," included in the previously mentioned *Lengua fresca*.) I'm not interested in Freudian analysis. However, I was shaken by the speed with which my neighbor reacted and the viciousness of his reaction. He killed the old lady without remorse. His response suggested that she was replaceable—in this case, with butterflies.

Why am I telling you all this? The dream is significant to me on a number of levels that affect our discussion. Art is an expression of the imagination. Dreams are too. One could argue that art is the manifestation of our dreams. Except that our own dreams are the product of our personal dilemmas. Those dreams disappear the moment we wake up. In a work of art, we witness a guided tour of someone else's dreams, or a representation of those dreams, since all dreams are intangible in and of themselves unless the artist represents them.

The conception of art you and I have been discussing is rather static. What we see on the canvas is fixed. That is, movement might be insinuated into the depiction but movement per se doesn't occur anymore. Television, cinema, the Internet all insert movement into action. Some contemporary artists who use technology are producing moving artistic images. This makes me think of the *Harry Potter* series, which, by the way, is an astounding feat of imagination. At Hogwarts, the boarding school—the full name is *Hogwarts School of Witchcraft and Wizardry*—there are numerous paintings hanging near the staircases. The depiction in those paintings is in constant movement. I like this gallery by J. K. Rowling: never static, as if it were a hologram.

Through my dream, I've been prompted to think about the thirteen pieces of art we've talked about as frozen in time and space. Of course, the viewer—each of us, in this case—changes in a Heraclitean way, so the paintings change as well. But in physical terms, our subject has been immovable. There's something antiquated about this, something old-fashioned.

Jorge Gracia: The issue you are raising concerns the object of an interpretation. As you know, interpretation is a topic dear to me, and the status of the object of interpretation is essential in any theory that would claim to account for it and establish standards of interpretive legitimacy. We already discussed interpretation itself, but now you are raising the question of the

object of interpretation, what I like to call the *interpretandum*. Is it something fixed, unchanging, or is it something changing?

The answer is that it is both changing and unchanging. Neither Heraclitus nor Parmenides make sense apart from each other. For the first, the world was in a constant process of change: "One cannot step in the same river twice." And for the second it was always permanent: "What is is, and what is not is not." Neither of these views accounts for the change and permanence that characterize the reality to which we are exposed every day. This is what Aristotle saw and tried to correct with an analysis that showed how everything has an aspect of permanence and continuity and an aspect of change and discontinuity. I am certainly in some ways the same person that married my wife at Bond Chapel, at the University of Chicago, in 1966, but I am also different in some other ways. This is evident when I look at myself in a mirror today and when I compare what the mirror tells me and a picture of me on the year of our marriage. Yes, I am the same but I am also different. To say that I am exactly the same as I was is a mistake, and to say that I am someone entirely different is wrongheaded.

The same point can be made about the works we have discussed in these conversations. First of all, we need to keep in mind that we have only been considering reproductions of these works. Indeed, in some cases, the works, such as Serrano's *Piss Christ*, do not exist as they originally were, so what we have in front of us is a copy of a nonexistent original. Perhaps, as Plato might have said, even more than that: a copy of a copy of a copy of a copy. Figure that one out! Second, we should consider that the image has been put in a context, and context influences the objects that are placed in it, although different contexts act on those objects differently. The images of the visual artworks we have used will appear different in most cases, depending on whether they are presented on white or colored backgrounds, also whether they are framed or unframed. The use of the title of the works also influences how they appear to us, observers and interpreters. Remember what I said about a word like *fire* above, and the different meanings it acquires depending on the context in which it is uttered. A work of art is not different from the word *fire*.

Indeed, even the order in which we have placed the works affects their significance and how an interpreter will look at them, and how the other

works are understood and interpreted. Originally we had tentatively placed Brito's *Conversation* first. Because this work has a strong focus on personal identity, putting it first would have most likely created for us a conceptual framework that would have affected and influenced how we would see and interpret the remaining works of art. But then you suggested that we put the de la Torre brothers' piece first, and that surely has had some effect on how we have interpreted other pieces, insofar as that piece is not so much about personal identity as about social identity and has a strong Latino flavor.

Another factor that has influenced what we have thought about in connection with the artworks is the titles we have given the different chapters. These, just like the titles the artists gave the pieces, created a fold that indicated a direction to follow. Not that we always did, but it was there, nonetheless.

The fact that the works are part of a collection of thirteen, all by Latino artists who were born, who reside, or who have resided in the United States (some are deceased), except for one, also suggests an interpretive direction. It makes us look at them from a certain perspective, predisposing us to find common ethnic grounds in them.

In addition, we have to consider the interpreters, that is, you and I, for we are also part of the interpretive context. We come from backgrounds that are both similar and different, and these are the cauldrons in which our interpretations develop. The backgrounds provide us with points of view that make us see different things, as well as common things, in the works.

In short, the works are in a flux of possibilities that are realized in the interpretations we have provided. But flux is not all there is. Heraclitus does not win this battle, because, as I noted before, a pure Heraclitean understanding makes as little sense as a pure Parmenidean one. Parmenides has a place, too. Change requires something that changes, and so we must acknowledge that, in addition to the changes, there is something common, something constant to provide and account for continuity. There is something in the images that is the same, in spite of the flux in which they are immersed. Without that sameness, we could not even say anything about the images. When we talk about Bedia's *Siguiendo su instinto*, we are talking about a work of art that is different from Basquiat's *Untitled (Skull)* and Azaceta's *Slaughter*.

IS: Our thirteen conversations have provided an arching narrative. That is, the dialogue we've engaged in has ended up uniting these disparate images with each other. In truth, these images are autonomous. They were never created to be part of this thirteen-part series we've composed. The artists never knew each other. Were they invited to somehow be in the same room, I doubt they would have much to say to one another, at least a number of them. That's because their essences are quite different. It is we, you and I, who have brought them together. Is the narrative that emerges from these conversations a unified, coherent one? Well, it doesn't look as if we've made the thirteen paintings coalesce into a "moving image," a kind of movie made of thirteen frames. Instead, we have allowed thought to interweave what we consider to be the message in these paintings. What I'm saying, Jorge, is that in the end the narrative is about us. In the conversation we had about Adál, I imagined myself dead, cremated, and placed in an urn, and said that my remains—ashes, that's all!—could be seen as art. I'm now approaching the same thought from another perspective. You and I are the characters in this storyline. It is our thinking process, the connections we've made, the insights we've had, that provide the thread to the process. And as the characters, we ourselves are a painting: a moving painting, like the one presented in my dream, or maybe a painting made of how we look at Latino art. We are the thirteen-plus-one piece in this gallery.

What does our painting, the painting that contains us, say about who we are? Maybe that we're restless voyeurs, that we approach the world through the mind's eye, that we think that we see and we see that we think.

JG: I like the idea that the collection of art pieces that we have used as foundations, or perhaps excuses, for our discussions is completed with a fourteenth piece that you and I have provided. However, I think that it is not we who are that piece, but rather what we have produced, namely the texts of these discussions. The foundations of our dialogues were not the artists themselves. We have not often discussed them, their lives, or their ideas, but rather focused on the works we have chosen. Of course, the works are theirs, and therefore in exploring those works we have also explored and perhaps revealed dimensions of the artists themselves. It

is a long-standing view that what one creates expresses what one is. Indeed, as I believe I mentioned before, this is the basis for the arguments for the existence and nature of God. As the argument goes, the existence of the universe requires a maker, a creator of it, and the kind of creator it requires is also revealed by the kind of product the universe is.

I am not sure the argument works for God, but it certainly works for humans. The kind of creation someone makes tells us quite a bit about the creator, who he or she is, his or her talents, and his or her history, although there are limits to the inferences we can draw. We can infer that El Greco had some kind of visual affliction, and from some of Kahlo's works we can infer her unhappiness. But I am not certain that Ramírez's drawings tell us that he was mentally ill and unhappy, or that from most of Picasso's works we can infer that he was a womanizer. There are limits to what the works tell us about the artists. But this is fine, because the works under inspection are artistic creations, not the artists themselves.

The conversations we have added to the images of the works of art we have engaged tell quite a bit about who we are and what we think, and they reveal grounds on which one could infer the thought processes that led us to say what we did. But the thought processes behind those texts are nowhere to be found; they are terra incognita for anyone but us. We are not directly present in this book. Like the artists, we are the creators of the object presented to readers, which in our case is a text. We are only the object of exploration indirectly.

The other question open for discussion is whether our text can qualify as the fourteenth piece insofar as it is not a work of visual art. I am not even sure that it is art at all. Whether it is or not depends on what makes something art, a question that has haunted us all along and we finally took up in the last conversation. If I am right about what I say there, then our text is neither a work of visual art nor even a work of art, for it is not considered by anyone to be an artifact with aesthetic qualities. Still, one thing is certain, namely, that this chapter is, like the pieces of visual art we have engaged in this book, an interpretandum, and as such it can complete the list of items that can become the object of a discussion.

IS: I want to get back to something I said in the prologue. After asking why we chose thirteen paintings produced by artists of Latino background,

I suggested that we chose them because this is the world (the Hispanic world) that we know best. We could have chosen a Matisse, a Rembrandt, a Rousseau, a Modigliani, perhaps even a Velázquez and a Picasso. Instead, we chose art made by people like us: Hispanic yet U.S. born. Are these works better or worse than those on the list we didn't choose? It doesn't matter. There is already so much commentary on works on the better-known list it would be less exciting, for me at least, to reflect on them. The selection we made isn't only intimately connected to us. It also feels new, fresh, and immediate. By this I don't mean to say that I'm interested in the shock of the new, at least not in this case. I'm attracted to an art that is an expression of my surroundings and that exists in conversation with the past, the present, and the future.

JG: I agree entirely with you for the reasons you mention and also some others. One of these others is that what we know best and what interests us most constitutes the most effective medium to explore universal problems and ideas. The particular is the key to the universal. This is one reason that literature and art are generally excellent vehicles for understanding universal principles. Some philosophers and writers make the mistake of forgetting the particular in order to get at the universal. As a result, their musings are abstract, general, and devoid of the context that could have given them life.

The particular is the instantiation of the universal. No one has ever seen blue or felt love. We always see this instance of blue and feel this particular love for someone. Only after we have been in touch with the particular can we try to generalize to the universal. After knowing this or that particular human being, we are able to know something about humans in general. The particular is necessary for an understanding of the universal because the universal does not exist in reality, only particulars do. Universals exist only in our minds, as generalizations gathered from particulars, or in the world instantiated in particulars. And although philosophy and philosophers often forget this truth, art and artists seldom, if ever, do. Artists always work with particular objects, things they mix and shape to construct something new, a new particular object. Visual art is especially tied to the here and now, to the concrete, to the particular. It is for this reason that it serves us well to understand the universal of which it is an instance.

At the very beginning of our conversations, I said it would be a miracle for us to carry out a dialogue that would result in true understanding. How could we bridge the gap between us, and between what we think and what we say? How could we effectively communicate? Only a miracle could do it! Yet, I think these conversations have shown that the miracle has happened, although it was not a supernatural power or enlightenment that did it. The works of art made it possible. They were a bridge between us, the foundation of our thoughts, and the link between our discourses, precisely because they were particular, that to which we have immediate access in our lives.

THE ARTISTS

Adál (Adal Maldonado) was born in Utuado, Puerto Rico, in 1948. Moving to
New York City at the age of seventeen, he is part of the Nuyorican cultural
movement that has sought to give expression to the Puerto Rican iden-
tity in New York that manifests itself through music, literature, and art.
He trained as a photographer and master printer at the San Francisco Art
Institute in the 1970s. In 1975, he founded, along with Alex Coleman, the
Foto Gallery, in Soho, New York City. This gallery is devoted to photog-
raphy and photo-derived works as a fine-arts medium. Adál has explored
identity issues, due to his complex experience of double identity. He is
the creator, along with the poet-playwright Reverendo Pedro Pietri, of El
Puerto Rican Embassy, a concept already established by Ambassador Ed-
uardo Figueroa, who founded an imaginary world called El Spirit Repub-
lic of Puerto Rico, in 1979. Adál and Pietri developed the concept further
in the mid-1990s, creating Puerto Rican "passports," writing a manifesto
and a National Anthem in Spanglish, and appointing ambassadors for
the arts. Adál is known for his photographic portraits and self-portraits,
which offer an ironic, often sarcastic view. In 1995, he created a series

of twenty computer-generated portraits entitled *Out of Focus Nuyoricans*. The series includes out-of-focus headshots of both well-known cultural figures, such as the musician Tito Puente and artists Pepón Osorio and Antonio Martorell, and everyday people, such as an old man who plays dominoes in Adál's neighborhood. His work is infused with an activism projected in installations and performances.

Luis Cruz Azaceta was born in 1942, in Marianao, which is a suburb of Havana. His parents were of Basque and Asturian origins. *Azaceta* means "from A to Z" in the Basque alphabet. He came to the United States in the early sixties, in the first exodus resulting from Castro's revolution. He came alone, and the rest of his family joined him several years later. He settled in New York City, where he attended the School of Visual Arts, and currently resides in New Orleans. Among the many honors Azaceta has received are fellowships from the Guggenheim Foundation, the National Endowment for the Arts, and the New York Foundation for the Arts. His work has a strong character that occasionally borders on the shocking. A cartoon-like quality often reveals ties to popular culture and the long tradition of drawing and satire characteristic of much Cuban art, but Azaceta adds an element of suffering and pain that deepens the impact of the art, making it transcend particular cultures and circumstances. A good portion of the work explores the phenomenon of exile, emigration, and cultural dislocation, effectively employing the context of the *balsas* (rafts) used by the Cubans who, in desperation, have risked their lives to cross the channel that separates the island from the United States. More recently, Azaceta has been exploring labyrinths and journeys by concentrating on venues of travel such as airports and terminals, using them as symbols of the human existential predicament.

Jean-Michel Basquiat was an American artist born in Brooklyn, New York, in 1960. His father was Haitian and his mother Puerto Rican. In his short but intense life, we can identify three main stages. Between the late 1970s and 1982, Basquiat started his career as a graffiti artist, painting in the metro and around the SoHo area, in New York City. During this time, his graffiti symbols mixed with traditional, primitive symbols such as masks, skeletons, and skulls. From 1982 to 1985, his art was full of

revolutionary words and concepts; voodoo, archaic, and totemic images; portraits of black heroes, such as musicians, writers, boxers, and basketball players; and references to the consumption-driven American society. Finally, from 1986 to 1988, his art gained more sophistication and complexity in terms of context and the use of figures. He began to use ancient techniques adopted from cultures such as those of the Aztecs, Greeks, Egyptians, and other African and European traditions. Despite his beginnings in graffiti, he argued that his work was no other than painting: "I have always painted." His work has been exhibited internationally. He had more than forty solo exhibitions and more than one hundred group exhibitions. A friend of Andy Warhol, Basquiat was a drug addict who suffered from depression. He died on August 12, 1988, of a heroin overdose at his art studio in New York City. He was twenty-seven years old. In 1996, Julian Schnabel made the movie *Basquiat*, based on his life.

José Bedia was born in Havana in 1959. He emigrated to Mexico in 1991, and in 1993 to the United States. He settled, and still resides, in Miami. He graduated in 1976 from the Escuela de Artes Plásticas San Alejandro, and in 1981 from the Instituto Superior de Arte. In 1978 he began participating in collective exhibitions and since then has received numerous awards, including the Gran Premio del Salón de Paisaje, in 1982, from the Museo Nacional de Bellas Artes de La Habana; Premio de la II Bienale de la Habana, in 1986; a Guggenheim Memorial Foundation International Fellowship, in 1994; and the First Prize for Excellence in Painting in IX Biennal of Beijing, in 2010. Bedia's work reveals a strong interest in anthropology, particularly regarding what he calls original religions from Africa and pre-Columbian Americas. He incorporates the imagery of Santería's syncretistic linkage of African and European religions and cultures into his works. Scenes of ritual sacrifice and mystery recur. He has traveled widely, collecting artifacts from all over the world, which he later uses in his art. His drawings and paintings are generally characterized by a simplicity of line that echoes the creations of Native Americans. The use of color is sparse and the design uncomplicated.

María Brito was born in Havana in 1947. She immigrated to the United States in 1961, as part of the Peter Pan Operation, in which Cuban children were

sent to the United States through the auspices of the Catholic Church. She received a BA from the University of Miami (1969), a BBA from Florida International University (1976), and an MFA from the University of Miami (1979). Brito began exhibiting in Miami in 1978. Her first exhibition was at the Twentieth Annual M. Allen Horn Memorial Competition and Exhibition, Museum of Art, Fort Lauderdale. She has received several prestigious awards, including a Florida Arts Council Fellowship (1979), a Cintas Foundation Fellowship from the International Institute of Education in New York City (1981), an Artist-in-Residence Fellowship from the Djerassi Foundation (1983), a National Endowment for the Arts Fellowship (1984), a Pollock-Krasner Foundation Grant (1990), a South Florida Consortium Fellowship (1992), a Virgina A. Groot Foundation Grant (1994), and an Individual Artist Fellowship from the Florida Department of State (1996). Brito's work is focused on representing states of mind and on the roles that individuals are forced to play under the pressures that family, culture, and society bring to bear on them. A special emphasis of her work is the place of women in Cuban and American cultures. She works in a variety of media, including sculpture, installations, ceramics, drawing, and painting.

María Magdalena Campos-Pons was born in Matanzas, Cuba, in 1959. She taught painting and aesthetics at the Instituto Superior de Arte, Havana, from 1986 to 1989. After immigrating to the United States, she curated the Displacement Art Project at the Institute of Contemporary Art, Boston. From 1995 to 1996 she taught at the Massachusetts College of Art and currently teaches at the School of Fine Arts, Boston. She has received numerous awards and fellowships, including honorable mention at the XVIII Cagnes-sur-Mer Painting Competition, in France; a painting fellowship at the Banff Center for the Arts, Alberta, Canada, in 1990; a Foreign Visiting Artist Grant in Media Arts from the Canada Council; a Bunting Fellowship at the Radcliffe Research and Study Center; an Art Reach Award from the National Congress of Art and Design, Salt Lake City; and the Rappaport Prize in 2007. She has had solo shows at MOMA, the Venice Biennale, the Johannesburg Biennal, the First Liverpool Biennal, and the Dak'ART Biennal, Senegal. The retrospective *Everything Is Separated by Water: María Magdalena Campos-Pons* opened in Indianapolis in

2006 and traveled to the Bass Museum, in Miami. Much of her work has explored her racial past through motifs she finds in her family background, although more recently she has turned to discussions of sexuality and culture. The work ranges from painting, mixed media, performance, and installations to photography.

The brothers **Einar** and **Jamex de la Torre** were born in Guadalajara, Mexico, and moved to California in 1972. Both attended the University of California, Long Beach. James was born in 1960, Einar in 1963. Their workshop is in Ensenada, Mexico. They are famous for their work with glass. Jamex started lampworking glass in 1977, Einar in 1980. Between 1981 and 1997, they owned and operated a flame-worked glass-figure business. Yet their artistic contribution goes far beyond glass. Combining the complex art of blown glass with materials as diverse as barbecue grills, metal racks, and leather, the two brothers create massive installations that defy notions of traditional art and good taste. They use humor as a hook to capture the attention of the people. They view their works of art as an onion: "There are several layers to peel and keep discovering." Exploring Mexican and Chicano religion, history, and popular culture, their work has been exhibited internationally and the Museum of Glass, Tacoma; Arizona State University Art Museum; the San Diego Museum of Contemporary Art; the Kanazu Museum, Kanazu, Japan; the Fisher Gallery Museum at the University of Southern California; Tucson Museum of Art; and the Mexican Fine Art Center Museum, Chicago. They live in Ensenada, Mexico, and San Diego.

BEAR_TCK, formerly known as elbearone, is the pseudonym of a self-taught Uruguayan graffiti artist who lives in Spain. Active since 1988, BEAR_TCK is also known as Bear TCK for his involvement with the group the Crime Kings. With the group, he paints large graffiti murals, developing skills in freehand aerosol. He has experimented with surfaces as varied as ballroom walls, pharmacy gates, celebration tents, and balcony walls, among others. A large selection of his work can be found in Mostoles, a city belonging to the autonomous community of Madrid. He is inspired to paint hip-hop and Chicano culture, which come to BEAR_TCK through Spanish rap.

Carmen Lomas Garza was born in Kingsville, Texas, in 1948. Inspired by her parents activism within the American GI Forum, Lomas Garza joined the Chicano movement of the 1960s and 1970s. This movement inspired her to depict special and everyday events in the lives of Mexican Americans, depictions based on her memories of and experiences in South Texas. Her goal has been to create images that would elicit recognition and appreciation among Mexican Americans and that would serve as a source of education for others not familiar with the culture. She attempts to achieve this goal through paintings, prints, and installations for the Day of the Dead, as well as through paper and metal cutouts that instill pride in the history and culture of American society. She is a graduate of the Texas Arts and Industry University, Juarez-Lincoln/Antioch Graduate School, and San Francisco State University, where she earned her MA in 1981. Lomas Garza is a recipient of numerous awards and has exhibited her work in galleries and museums across the United States. In March 2007, the Los Angeles Unified School District Board approved the community's nomination of the name Carmen Lomas Garza Primary Center for their new primary school. This great honor comes as a result of teachers' using her children's bilingual picture books for curriculum development since the first book was published in 1990. The majority of the student population is first-, second-, or third-generation Mexican American.

Francisco Oller was born in Bayamón, Puerto Rico, in 1833, and died in San Juan in 1917. At eleven he began to study art under the tutelage of Juan Cleto Noa, a painter who had an art academy in San Juan. When he was eighteen, he moved to Madrid, where he studied painting at the Royal Academy of San Fernando. In 1858, he moved to Paris, and eventually enrolled to study art in the Louvre under the direction of Gustave Courbet. A year later, he participated in an exhibition that included works by Renoir and Monet, among others, and still later became the teacher of Cézanne for a short time. In 1865, he founded the Free Academy of Art of Puerto Rico and in 1884 an art school for young women that later became the Universidad Nacional. In 1872 he was named official painter of the Royal Court of Amadeo I. Oller is considered an impressionist painter. His major themes are taken from Puerto Rico, its people, and culture. *El velorio* is considered one of his most important masterpieces. The town

of Castaño, in Puerto Rico, named a high school after him, and the City of New York renamed ps 61, in the Bronx, ps Francisco Oller. In addition, there is a Francisco Oller and Diego Rivera Museum in Buffalo, New York, as well as a Francisco Oller Museum located in Bayamón.

Martín Ramírez was born in Mexico, in 1895. He immigrated to the United States from Tepatitlán in 1925, and became institutionalized in 1931 at Stockton State Hospital, in California, where he was diagnosed as a catatonic schizophrenic. In 1948, he was moved to DeWitt State Hospital, in Auburn, California, and it was there that he created the artwork that has made him posthumously famous. Tarmo Pasto, a professor of psychology and art, found him there and began to save his works. Other works were saved by the director of DeWitt State Hospital and his grandson. Fewer than five hundred works are extant. Ramírez used whatever materials were available to him, such as brown paper bags, book pages glued together with a paste made from potatoes and saliva, and any paper scraps that came his way. His motifs, which he often rendered in the tradition of Mexican folk art, consisted mostly of trains and tunnels, but he also pictured cowboys, landscapes, madonnas, and abstract patterns. Since his death, in 1963, Ramírez's drawings and collages have become some of the most highly valued works of outsider art. In January 2007, the American Folk Museum, in New York City, had a major retrospective of Ramírez's work, featuring a third of the three hundred works known to exist at the time.

Andres Serrano, half Honduran, half Afrocuban, was born in New York City in 1950. He was educated at the Brooklyn Museum Art School in the late 1960s. His art practice was delayed for several years after he became caught up with drugs and the harsh street life of New York's urban poor. At age twenty-eight, Serrano began working at various straight jobs, including a position as an assistant art director at an advertising firm. While he enjoyed this work, he still wished to pursue an art career full-time. Insecure about his technical abilities, he focused on photography, but he always thought of himself as an artist using photography. He was not interested in documenting "reality," but in creating his own. His work has often been regarded as having a sacrilegious quality. It includes religious

images juxtaposed with feces and bodily fluids. Along with the work of Robert Mapplethorpe, Serrano's art, which has been exhibited internationally and is indisputably controversial, became the subject of a censorship campaign by senators Jesse Helms and Alphonse D'Amato, who attacked his work as offensive. The controversy was framed as part of the freedom of speech debate. In other works, portraits of Ku Klux Klan members and dead bodies mutilated or in the process of decay confront viewers with more discomforting images of violence and death. But even these retain a certain seductive quality. Drawing from the lexicon of advertising, fashion, and even pornography, Serrano's photographs aestheticize their subject matter and are some of the most arresting images in contemporary photography.

Mariana Yampolsky was born in Chicago in 1925 and died in 2001. Her father was a Russian-Jewish sculptor who immigrated to the United States to escape anti-Semitism. She received a BA from the University of Chicago in 1944. Her father died the same year and she and her mother moved to New York City. Yampolsky later went to Mexico to study. She stayed there permanently, becoming a Mexican citizen in 1954. She began her work in photography in 1948, initially to record her personal travels and the activities of the Taller de Gráfica Popular (People's Graphic Workshop) in the 1940s and 1950s. This was an organization dedicated to creating and promoting art with a political slant, especially antifascism, for the masses. She was a printmaker with the group until 1960. She studied photography at the San Carlos Academy. For three years in the late 1960s, she traveled Mexico's rural areas to photograph for the Fondo de la Plástica Mexicana publishing house. From the 1970s to the 1990s, her photographs, often in black and white, were shown in solo exhibitions in the Netherlands, England, and Mexico. They follow the tradition of Manuel Álvarez Bravo and Tina Modotti, depicting working-class Mexicans in honest, unadulterated ways. Over her lifetime, Yampolsky took over 66,000 photographs. The Instituto Nacional de Bellas Artes honored her work in 2012. In addition, the Mariana Yampolsky Foundation was founded to honor her memory and to promote her life's work.

INDEX

ordinary language philosophy, 179
Otra, La (Delgado painting), 164